Painter 12 for Photographers

Dedicated to Doreen

Painter 12 for Photographers

Creating painterly images step by step

Martin Addison

ELSEVIER

AMSTERDAM • BOSTON • HEIDELBERG • LONDON • NEW YORK • OXFORD
PARIS • SAN DIEGO • SAN FRANCISCO • SINGAPORE • SYDNEY • TOKYO

Focal Press is an imprint of Elsevier

Focal Press is an imprint of Elsevier
The Boulevard, Langford Lane, Kidlington, Oxford, OX5 1GB
225 Wyman Street, Waltham, MA 02451, USA

First published 2012

Notices
Knowledge and best practice in this field are constantly changing. As new research and experience broaden our understanding, changes in research methods, professional practices, or medical treatment may become necessary.

Practitioners and researchers must always rely on their own experience and knowledge in evaluating and using any information, methods, compounds, or experiments described herein. In using such information or methods they should be mindful of their own safety and the safety of others, including parties for whom they have a professional responsibility.

To the fullest extent of the law, neither the Publisher nor the authors, contributors, or editors, assume any liability for any injury and/or damage to persons or property as a matter of products liability, negligence or otherwise, or from any use or operation of any methods, products, instructions, or ideas contained in the material herein.

British Library Cataloguing in Publication Data
A catalogue record for this book is available from the British Library

Library of Congress Number: 2011935548

ISBN: 978-0-240-52271-5

For information on all Focal Press publications
visit our website at: www.focalpress.com

Typeset by MPS Limited, a Macmillan Company, Chennai, India
www.macmillansolutions.com

Printed and bound in Italy

12 13 14 15 10 9 8 7 6 5 4 3 2 1

Contents

Contents

Contents

Contents

Contents

Foreword

Digital painting for me has been a long journey beginning with learning Corel Painter software many versions back almost twelve years ago. In the early days the most important and hardest step was the first one of learning the software. It was only after being comfortable with the software that I was free to paint and explore different styles of painting smoothly and easily.

When I found Martin's book it opened up a whole new resource for learning Painter. With this book he has outdone himself and adds so much information. It is a complete reference, from the installation of Painter to creating brushes, through painting basics and gives the user options to explore more complicated techniques also. It even explains textures and final printing techniques.

Painter 12 is a complete overhaul of the software from the interface to the management of brushes. It is unsurpassed as the complete digital painting program and has many new features. Martin takes on the challenge of documenting these features and how to use them quickly and in an artistic manner. Whether you are new to Painter or a seasoned pro this is the one book you must have.

The lessons are easy to follow and the detailed step by step organization of the materials will have even the newest user digitally painting quickly. Martin has covered everything an artist wishing to paint from photo reference could possibly need to know. Many books focus on Painter from the artist's point of view; *Painter 12 for Photographers* is the only one to focus on the photographic aspect while retaining the art information.

I wish when I started using Painter back in version 6 I had a book like this. The entire "learning curve" would have been so much easier and faster if I had a book written in this manner.

So for me, the journey continues and expands my vision of how to take advantage of the new technology. Reading this book will make you feel like you have a Corel Painter Master looking over your shoulder and anticipating your next question. It will be one of your most well-loved books in your collection.

Enjoy the Journey!

Marilyn Sholin
Corel Painter Master
Author, Artist & Educator
Asheville, NC
http://www.marilynsholin.com

Introduction

Who is this book for?

Whether you are new to digital imaging or are already familiar with Painter and other graphics programs, I am confident that this book will help you to expand your creative abilities and make many brilliant new pictures from your photographs.

As the title suggests, this book is aimed solely at photographers of all types.

For the professional photographer there are techniques which can turn a standard portrait into a premium priced product which is unique and desirable.

If you are a serious amateur photographer you can learn how to make pictures which are subtle or powerful according to your intentions and which are very different from work produced by many others.

For the casual photographer who would like to turn family snapshots into painterly pictures suitable for hanging on the wall, there are simple step by step demonstrations to guide you from the original photograph to the finished picture.

What's special about this book?

There are other books which teach you how to use Painter from an artist's point of view, but this is the only one to focus solely on the photographic aspect. This approach has the great advantage that everything in the book is relevant and useful to photographers.

Painter 12 for Photographers progresses step by step from very simple techniques to more advanced technical expertise. Throughout the book the many illustrations are intended to provide ideas and inspiration combined with clear instructions to make the very best of your own image.

The purpose of this book is to give you a sound knowledge of the tools which Painter provides and of the techniques needed to use them. There is a wide range of skills to be learned and this book guides you through them in a simple, logical and exciting way. Of course this is only the starting point; good technique does not ensure that you make a good picture, but it is essential to master this first. Once that is done your own imagination and personal style will lead you to make the great pictures that you are visualizing.

All the image files for the step by step examples are available to download from www.painterforphotographers.com; I recommend that you use these images first and then try out the technique on your own photographs.

Why use Painter?

Photography is about documenting the reality around us, the photographer deciding how to interpret that reality through the choice of lenses, viewpoint and composition. Sometimes, however, this reality is not enough, it doesn't reflect the feelings that we originally experienced. This is not surprising, of course, as the conditions have changed, the sensory pleasure has been lost, the smells, sounds and atmosphere are all gone and all we now have is a one-dimensional piece of film, print or electronic image.

So we often want to take our picture further to better reflect what we felt at the time and to communicate this to the viewer who has no recall of the original experience.

This is where the fabulous Corel Painter program comes in; it is quite unique in the way it replicates traditional media and gives us the opportunity to take our pictures into another dimension altogether, revealing the hauntingly beautiful, mysterious and alluring world of the imagination.

What's in *Painter 12 for Photographers*?

The Introductory Chapters

What's New in Painter 12 is an overview of all the new features; there are so many changes in this update that I have devoted a complete chapter to them and have still only scratched the surface.

First Steps in Cloning shows the process through which we transform photographs from their original state to a new and exciting existence. Even at this early stage of the book, you will be able to make beautifully soft images and we are still only on the second chapter! Also included in this chapter is a complete tutorial taking the picture from a camera and including all the stages up to and including printing the finished picture.

The Reference Chapters

Painter 12 Basics is a look at the Painter interface, and includes how to use the main tools and palettes plus hints and tips on how to get the best out of the program. It also gives help to Photoshop users in understanding the differences between the two programs. If you have used Painter before you could skim this section and just read those sections which have changed in Painter 12.

Choosing Brushes illustrates every one of the main brush categories and explains how they differ. Brushes are at the heart of everything in Painter, and understanding which brush to use and how it works is crucial to working creatively. Examples of finished pictures are provided as a source of ideas and

inspiration. There are more detailed step by step tutorials to download from the website, together with the source photographs to enable you to make these pictures yourself.

Customizing Brushes shows how the standard brushes can be customized using the Brush Control panels. There are a great number of control panels where brushes can be customized and some of the most useful panels and options are described in detail. Instructions on how to download the many extra brushes from the Corel website are also included.

Using Color shows how to select colors and how to use the many adjustment menus to enhance the tone and color in your pictures. Creative hand-tinting and toning are also covered here.

Paper Textures are an essential part of using Painter, they provide depth and texture to the picture and the program has hundreds to choose from. This chapter explains what textures are and how to use them while cloning, also how to apply the same textures at the end of the painting process. Instructions on how to download the extra papers from the website are also included.

The Creative Chapters

Montage shows how images can be combined creatively to produce stunning new effects. Detailed tutorials show you the techniques necessary to merge images using cloning from several images and using layers.

Portraits are always very popular and in this chapter many different brushes and techniques are used to create pictures of children and adults.

Animals are another popular subject for the artist and a variety of photographs of animals are the starting point for pictures using a variety of brushes.

Landscapes cover a range of different views and the varied tutorials cover many different interpretations.

Special Effects include everything from simulating burnt paper to making kaleidoscopic images. This section is great fun and packed full of colorful examples.

What should I know before I start?

This book has been written on a PC and all the screen shots reflect that platform. Painter operates virtually identically on both PC and Macintosh computers. Keyboard shortcuts are of course different, the Control key on Windows becomes the Command key on the Mackintosh, and likewise the Alt becomes the Option key.

FIG 1 The Reset icon on the Properties bar, this resets the current brush to its default settings. It also works for all other tools.

FIG 2 This symbol confirms that the tutorial files are available to download from www.painterforphotographers.com.

If you have used Painter before and are following my step by step instructions it may be advisable to return the brush to its default settings before you begin or it may not react as predicted. To do this, click the icon of a brush and arrow on the Properties bar (Figure 1).

Always remember to save your picture regularly to avoid losing work, it is also good practice to work on a copy of your picture and keep the original safe.

Painter for Photographers Website

www.painterforphotographers.com

This website contains all the support materials needed to complete the tutorials in this book and contains:

Step by Step Original Photographs

All the original photographs are included for you to work through the step by step exercises in *Painter 12 for Photographers*. Also included are many other photographs that are used throughout the book to illustrate techniques so that you can follow the examples at home. The images are mostly full size files so the brush sizes will be similar when you create pictures from your own photographs.

Video Tutorials

More than two hours of video tutorials for many of the techniques described in the book are on the website to download. These are a valuable insight into the way I work and support the information in this book.

pdf Files

Extended and more detailed versions of the tutorials in Chapter 4 are included as pdf files. These are fully illustrated and explain the process with much more detail than is possible in the limited space of the printed book. They can be viewed on screen or printed; I recommend that these are used in preference to the brief instructions in the book.

Resources and Help

www.painterforphotographers.com

Painterforphotographers is my website, which contains additional step by step techniques, galleries, information and links to other Painter sites, plus amendments to this book if necessary.

www.corel.com

The home site of Corel is where you can find information on the latest versions of Painter, updates and training. Look out in particular for the Painter Canvas, a regular newsletter which has tutorials and news about Painter.

www.painterfactory.com

This is a dedicated Painter community run by Corel which has forums for sharing artwork, getting help and communicating with other Painter users.

www.marilynsholin.com/blog

Marilyn Sholin's blog website has a gallery of pictures made in Painter together with links to resources and news about Painter events.

www.permajet.com

A supplier of some excellent inkjet papers which are suitable for painterly pictures.

martin@painterforphotographers.co.uk

I would be happy to receive comments regarding the contents of this book, if you would like to contact me, please send an e-mail to the above address.

Acknowledgements

I would like to thank the following people for their help in the making of this book.

Several photographers have kindly allowed me to use some of their photographs and I would like to thank the following:

Carol Addison for her photographs of Jack, Jesse and Toby.

Clive Haynes for his photograph of Haydon, the 'Harley Man.'

Bob Oakley for his photographs of Annabel.

Paul Mann for his photographs 'Baby' and 'What's That?'

Ian Martin for his photographs of 'Amy' and 'Party Girl.'

Pam Turner for her photograph of Jimmy.

Brian Eacock for his photograph 'When I Grow Up.'

Also the following people for allowing me to use photographs of them or their family:

Lucy, Devika, Sharon, Julie, Haydon, Gerry, Annabel, Toby, Tim and Ellie, Jack and Jesse, Chrissie Rucker and Hilary Roberts.

Sara Scott, Lisa Jones and Valerie Geary of Focal Press for their encouragement and assistance at all stages of the book.

Steve Szoczei at Corel for doing the technical checking.

Marilyn Sholin for writing the Foreword.

Permajet Ltd of Warwick UK (www.permajet.com) for providing me with a range of their excellent inkjet papers and ink systems.

Most of all to my wife Doreen for not only letting me use several of her photographs, but also for her unfailing support and encouragement, not to mention keeping me working on the book!

What's New in Painter 12

There is so much new in Painter 12 that I have devoted a separate chapter to cover just the key changes. The interface has a new more modern look, with tabbed palettes and panels and a new customizable Toolbox.

There are of course the new brushes, three new brush categories including Real Watercolor and Real Wet Oils which replicate traditional art materials. Gel brushes can use the new merge modes as in Photoshop, as can the six new Airbrushes. There are several new control panels for brushes to add further customization. Mirror and Kaleidoscope painting has been added and is something to play with and have fun.

Cloning has received a new look with a new Clone Source panel and new ways of working. Custom palettes, New Image and Open dialog boxes are improved as are Workspaces, Media Libraries, Smart Blur, Layer enhancements, performance improvements and so much more.

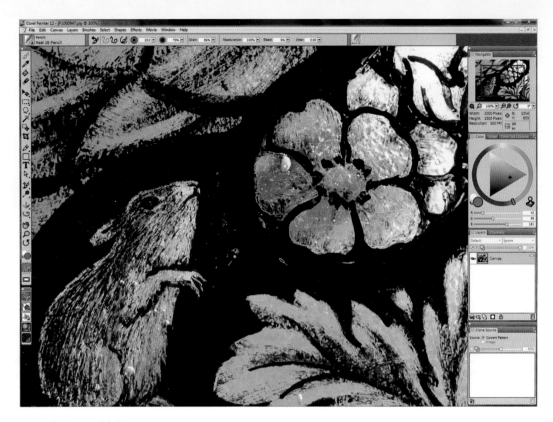

FIG 1.2 The Painter 12 default workspace.

FIG 1.3 The Toolbox in single and double column form, and in horizontal form on the right.

The Painter 12 Interface

The most obvious change apparent in Painter 12 is the interface, it has had a major redesign as you can see above, the palettes (individual palettes are now called panels) look more modern and are stacked in tabbed form. This allows the individual panels to be stacked in groups (called palettes), which gives a greater degree of customization, so important when there are over 50 panels and palettes in Painter 12.

The Toolbox has been redesigned with new icons and, rather more important, you can now choose from several display styles, vertical or horizontal and in one column or two. The shortcut to the Papers is on the Toolbox, but the shortcuts for patterns, nozzles, gradients, looks and weaves now have their own panel shown in Figure 1.4.

A new addition is the Navigator panel which can be used to move around the picture when it is enlarged and includes the controls for Tracing Paper, Impasto, Grids and Selections which were previously on the edge of the open document. It includes several options for changing the display on screen plus what was previously in the Info palette.

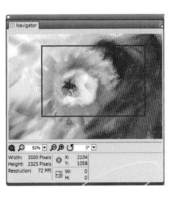

FIG 1.4 The Media shortcuts panel and the Navigator panel.

The Library palettes have been redesigned and have been split in two, with the active item in one panel with all the controls, while the libraries are in another panel. This means that several libraries can be included and the previews can now be seen. Organizing and creating your own library is also much easier. Additional papers, nozzles, etc. have been added to the panels. Paper Libraries can also be chosen from the flyout in the Papers panel, highlighted in Figure 1.5.

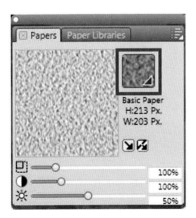

FIG 1.5 The Papers and Paper Libraries panels.

Performance

Every new version of Painter brings speed and quality improvements and Painter 12 is no exception, it supports all the latest Windows and Mac operating systems including 64 bit support for Windows and multi-core processing for brushes. Painter 12 also renders smoother looking images when zooming in and is faster when zooming out.

Palettes and Panels

The Open dialog is much improved with the file structure on the left and large previews of RIFF and JPEG files on the right; the preview shown is on Windows 7 and may vary on earlier versions or different platforms.

FIG 1.6 The Open dialog box.

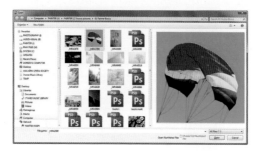

The New Image dialog box has been upgraded and now allows more options and customizing including selecting the paper color and paper texture.

FIG 1.7 The updated New Image dialog box.

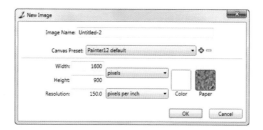

The Temporal Colors floating palette has been introduced to allow easy access to colors without the need to have the standard Colors panel on screen. You can bring it on screen with the shortcut Ctrl/Cmd+Alt/Opt+1.

FIG 1.8 The Temporal Colors palette.

Smart Blur has been added to the Effects menu, this softens the image by smoothing out colors and details.

The Help files have been redesigned and are web based to ensure that they are completely up-to-date, a copy is also installed on your computer to use when off-line, they are much improved on the previous files and well worth checking when you get stuck.

New Ways of Cloning

Cloning has changed in Painter 12 and there is no need to keep the original source picture open on the desktop. If you save as a RIFF file the clone image will remember the document from which you were cloning and it can be saved and opened again with the information intact. There is also a new panel where you can see what your cloning source is. This makes it much easier to clone from multiple sources; as you can see in Figure 1.9, there are four clone sources active and you can easily switch from one to another.

FIG 1.9 The new Clone Source panel showing four clone sources.

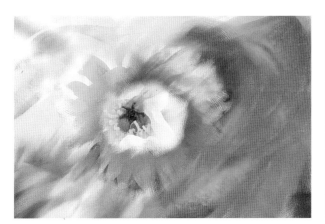
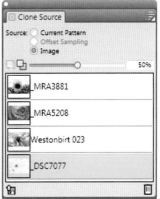

Workspaces

Workspaces have been improved and there are six sample workspaces created by Painter users available to download from the Corel website (see the Customizing brushes chapter for details on how to download extra content). I recommend that you download these and also look at the videos in which the Painter artists explain the workspaces they have created. They will almost certainly give you ideas on how to create your own workspace. Remember that brushes and palettes created in one workspace will not be available in another unless you manually copy the content into your system files.

FIG 1.10 Two of the new Workspaces available to download; the Creativity Workspace on the left and the Photoshop Workspace on the right.

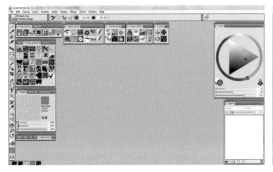

Brush Reorganization

Selecting Brushes

The method of selecting brushes has changed with a new Brush Selector panel which makes brushes quicker to select. You can customize the view so that you see the brushes as lists or as icons and dab types. You can select the options in the Brush Selector panel options menu.

FIG 1.11 Two of the different layouts for the Select Brushes panel.

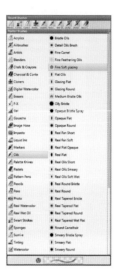
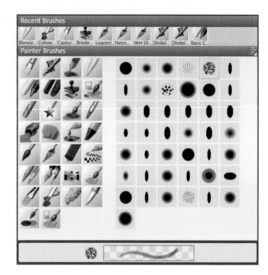

Recent Brushes

The Recent Brushes display replaces the Tracker palette and is shown both on the Properties bar and at the top of the Brush Selector. It is great improvement which works well and I find very useful.

FIG 1.12 The new Recent Brushes panel.

New Brush Control Panels

There are several new control panels in addition to those already mentioned.

The Brush Calibration panel (Window>Brush Control Panels>Brush Calibration) lets you calibrate individual brush variants to match your stroke strength in the same way as Brush Tracking does for all the brushes. For that particular brush, this setting will override the one set in the Preferences dialog.

The Dab Profile panel consists of the display from the Painter 11 Size palette and will update as you change the settings in any of the other panels.

The Computed Circular panel lets you change the settings for any brush which uses this brush dab.

FIG 1.13 Three new brush control panels.

Brushes Reorganization

The brushes have been reorganized in Painter 12, the ever-growing list of categories has been reduced and several categories combined to remove some of the smaller ones. A table showing where the brushes have gone is shown below.

Category	Moved to
Art Pens	Gouache, Markers, Oils, Pastels and Pens
Artist Oils	Acrylics, Blenders, Impasto, Palette Knives and Oils
Calligraphy	Pens
Colored Pencils	Pencils
Conte	Charcoal and Conte
Crayons	Chalk and Crayons
Distortion	F-X
Felt Pens	Markers
Oil Pastels	Pastels
Real Bristle	Oils and Blenders

Custom Palettes

Custom Palettes have been upgraded and are now much more flexible. The Shift key must be held when dragging icons to a palette, which makes it less prone to unintentional creation.

FIG 1.14 A custom palette.

New Brushes

There are always new brushes in every new Painter program, but this upgrade has a veritable feast with two major new natural media brush categories, a new Gel brush category, six new Airbrushes plus several new panels for customizing the brushes. In addition the brush categories have undergone a complete update with both the way they are selected and the organization of the brush categories.

Real Watercolor

This new watercolor brush category joins the Watercolor and Digital Watercolor to offer yet more natural media characteristics. There is a dedicated control panel in which you can customize the brush, water, pigment and wind force to change how the brushes react with the paper.

FIG 1.15 Real Watercolor brushes.

Real Wet Oils

The Real Wet Oils flow as wet oil and are similar to the Artist Oils brushes. This category also has its own control panel.

FIG 1.16 Real Wet Oils brushes.

Gel Brushes

The Gel category allows the brushes to use the new merge mode and stroke opacity options which have been added to the General panel. These allow the brushes to paint using blending modes as in Photoshop which includes some very useful modes such as Lighten and Darken. These modes can also be used on many other brushes in Painter, not just this category.

FIG 1.17 Gel brushes.

Airbrushes

The new Digital Airbrushes also use the new merge modes and are similar to the airbrush in Photoshop. These brushes are very useful for painting on layer masks as they include soft or hard edge variants, most of the brushes build up opacity with each stroke.

FIG 1.18 New Digital Airbrushes.

Mirror Painting

Mirror painting mode allows you to create a symmetrical painting, at first sight this looks more suitable for painting from scratch rather than using photographs; however, a closer inspection reveals quite a lot of photographic opportunities. What is certain is that Mirror painting and its companion Kaleidoscope painting is a lot of fun and that must be a good thing!

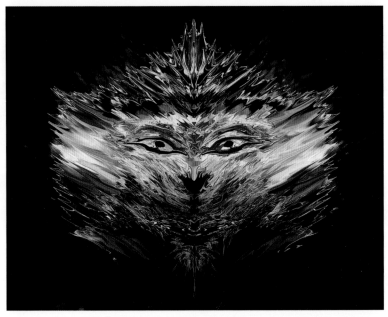

FIG 1.19 Mirror painting, the final picture on the right with the original photograph and painting stages shown below.

When Mirror painting is used as a clone it doesn't mirror the picture, it mirrors the brush strokes but the picture remains the same. What makes it interesting is when you use a brush with very distinctive marks; here are a few to try:

Palette Knives>Loaded Palette Knife.

Liquid Ink>Depth Bristle and Graphic Camel.

Artists>Impressionist and Auto Van Gogh.

F/X>Furry brush and Distorto to blend and pull.

This is definitely a feature to play with, I had a lot of fun creating the picture above. It started with a picture of a fairground at night, I worked on it with the Loaded Palette Knife and Impressionist brush on several layers then pulled the shapes out with the F/X Distorto and finally added a few brush marks and pulled them into a face. The original picture and some of the layers are shown in Figure 1.19.

Kaleidoscope Painting

FIG 1.20 The Kaleidoscope controls on the Properties bar.

Kaleidoscope painting works like Mirror painting, but introduces more mirror planes to the image. The Mirror and Kaleidoscope tool is in the Toolbox near the bottom. Click the tool and in the Properties bar select either Mirror or Kaleidoscope which are the second and third icons from the left. The first icon is the reset tool as usual. Set the number of planes in the first option box and rotate the grid in the next box if required. The final icon hides the guidelines while painting. Click the brush icon in the toolbox to start painting.

The illustrations in Figure 1.21 show some of the different settings.

FIG 1.21 Some of the many designs possible with Mirror and Kaleidoscope painting.

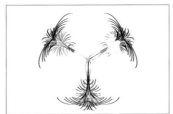
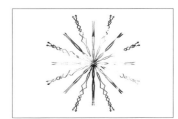

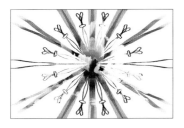
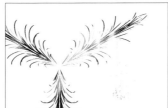

Top row from left to right: mirror painting, three and eight plane painting.

Bottom row: Twelve plane, three plane with center point offset and multiple kaleidoscopes in one document.

The images in Figure 1.22 show how this tool can be used to create textured backgrounds as a base for other images.

FIG 1.22 Using the tool to create textured backgrounds.

First Steps in Cloning

This chapter starts with several simple cloning tutorials to get you started quickly and to help you understand some of the different ways in which pictures can be created from photographs. All the source pictures which you need to use for tutorials throughout the book can be downloaded from www.painterforphotographers.com.

The final tutorial in this chapter is a longer step by step tutorial which starts with a digital photograph and shows how to prepare the picture prior to cloning, the cloning itself, tonal and texture adjustments, through to printing on an inkjet printer.

As you work through the steps you will cover all the main areas in Painter and if you are new to Painter this is a great place to start. More detailed information on the Painter interface and tools can be found in the Painter Basics chapter, while lots more information on brushes are in the Choosing Brushes and Customizing Brushes chapters.

Soft Cloner: A Simple Clone

This first tutorial uses the Soft Cloner from the Cloners brush category, all the brushes in this category are set up for cloning without any adaptation, a good place for a beginner to start. The Soft Cloner is a brush which is used a considerable amount while cloning, as it produces a gentle but accurate copy of the original photograph; apart from using it as the main brush as here, it is valuable to add more detail back into many pictures where the brush being used distorts the original.

1. Open 'Rose petals.'

FIG 2.2 The original photograph.

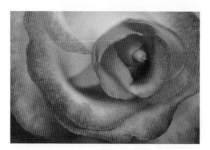

2. File>Quick Clone, this produces a new document which is empty but is linked to an image of your photograph. It will show an overlay called Tracing Paper which is there to help you start painting, but is not actually part of the picture.
3. Select the Cloners>Soft Cloner brush, size 237 opacity 5%.

FIG 2.3 The picture at Step 4.

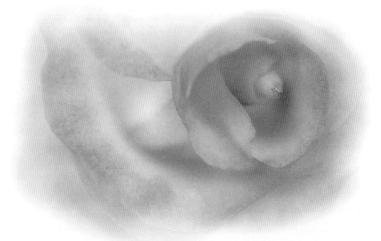

4. The Tracing Paper overlay will be active after you create a clone copy, paint in the picture in the center and then turn the Tracing Paper off (Ctrl/Cmd+T is the keyboard shortcut). The Tracing Paper is very helpful when you first start a picture, but then it obscures your brush strokes so turn if off as soon as you know where to paint. Try turning the paper on and off using the shortcut, which is a toggle action.

5. Paint the rest of the picture very lightly, keep the brush on the paper rather than making lots of separate brush strokes, this helps to keep the picture very smooth. Don't paint right to the edge, leave the outer areas white and allow the color to blend gently into the background.

6. Paint the center again, bringing more color and density to the center of the flower. This brush will add more density every time you paint over an area again and this is why, when making a gentle picture like this, it is better to start off with a large brush at a low opacity to lightly show the entire picture and then build up the areas which are the center of interest.

7. Increase the brush opacity to 20% and paint the main areas once again to get to the density that looks right.

That completes the tutorial; it is deliberately short and simple to get you started and to understand how the cloning process works. Remember to save at regular intervals whenever you use Painter.

FIG 2.4 The completed picture.

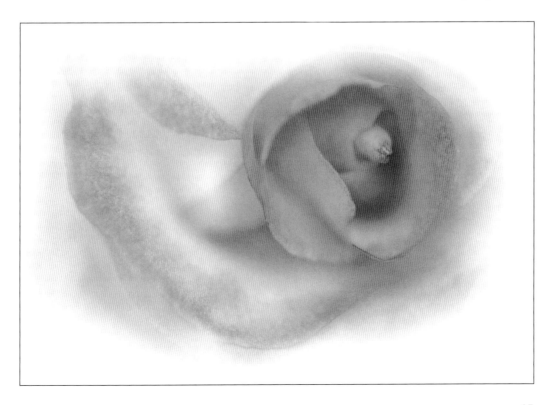

Acrylics: A Smeary Brush

This is a very different brush to the last one; the Soft Cloner gave a very clear finish whereas this brush will smear the picture. Starting with large brushes and progressing to smaller ones is a very useful way of creating pictures, the larger sizes add the rough painterly effect while smaller sizes bring back detail in the more important areas.

1. Open 'Young Rider.'

FIG 2.5 The original photograph.

FIG 2.6 The Color panel with the Clone Color icon highlighted.

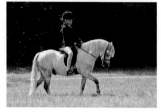

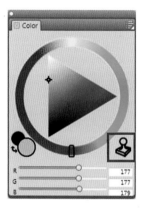

2. File>Quick Clone.
3. Select the Acrylics>Real Wet brush, size 125 opacity 100%.
4. Open the Color panel and click the Clone Color icon (bottom right in the panel), this will change the Color wheel to monochrome which indicates that the brush is now cloning (see Figure 2.8). This step is essential to change the brush from painting color to using the original photograph as the source. With the exception of brushes in the Cloners and Smart Stroke brush categories, virtually all other brushes need to have this change made before you start cloning.
5. Paint the whole picture using quick brush strokes, keep the brush on the canvas and keep painting without lifting the brush very often. This will result in a rough underpainting as shown in Figure 2.7.

FIG 2.7 The painting at Steps 5 and 7.

6. Reduce the brush size to 32 and paint the horse and rider, turning the Tracing Paper on and off to see the result. The brush paints better when it is kept on the paper as before, but this time it needs to be moved more slowly and with much smaller brush strokes in order to reveal the detail. Make sure that you follow the lines and shapes present in the picture. Turn the Tracing Paper on and off as necessary.

7. Reduce the brush size to 10 and make the picture larger on the screen. Paint the face and head with care; this should be distinct whereas much of the rest of the picture can be more painterly.

8. If you find getting the face clear is difficult, go to the Cloners>Soft Cloner, size 13 opacity 20% and paint just the face.

9. Return to the Acrylics>Real Wet brush, size 65 and opacity 50% and paint the grass using vertical brush strokes upwards from the bottom of the picture. The low opacity will just give a hint that it is grass. Do the same higher up where there is a line of bright green.

10. Look at all the picture and finish off any areas that look too rough, but don't bring back every detail, or it will look like your original photograph!

FIG 2.8 The Color panel after the Clone Color has been selected.

FIG 2.9 The completed photograph.

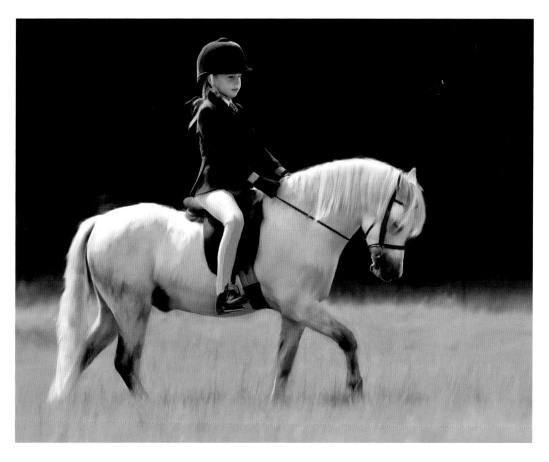

Chalks: Using Paper Grain

When painting traditionally, the paper chosen plays an important part of the final presentation and when using Painter you can replicate this to some extent by incorporating paper textures in your picture. The Paper Textures chapter will help you understand the different options and ways of applying paper textures and this tutorial is included to give you an insight into how the process works.

1. Open 'Arcade.'

FIG 2.10 The original photograph.

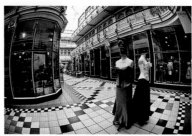

FIG 2.11 The General panel with the Method and Subcategory options and the Grain slider highlighted.

2. File>Quick Clone.
3. Select the Chalk and Crayons>Square Chalk brush, size 163 opacity 20%.
4. Open the General panel (Window>Brush Control Panels>General), this will bring a lot of panels on screen; you just need the General one. Select Cloning in the Method box and Grainy Hard Cover Cloning in the Subcategory box. This will change the brush to work as a cloner, but in a different way to the previous tutorial, this method will show the grain very clearly and will result in a very clear clone copy.
5. Still in the General panel, change the Grain slider to 7%, with this brush the lower the grain setting, the more the grain is shown, this varies depending on the brush so you need to experiment with each brush you use to find the best setting. The General panel is shown in Figure 2.11.
6. Open the Papers panel (Window>Paper Panels>Papers), two tabbed panels will appear on screen, the Papers and the Paper Libraries panels.

FIG 2.12 The picture at Step 8.

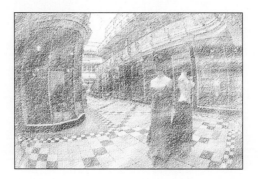

7. In the Paper Libraries panel click the French Watercolor paper, and then in the Papers panel increase the Paper Scale slider (the top one) to 260%. This increases the size of the paper texture, this is really too large for this picture, but it will allow you to see the result clearly.

8. Clone the whole picture, when you turn the Tracing Paper off you will be able to see the grain very clearly due to the low brush opacity and grain setting, the picture will be fairly light at this stage and dominated by the textures, as in Figure 2.12.

9. In the General panel increase the Grain to 8% and the opacity to 50% and paint the mannequins and the central area. The small increase in the Grain setting plus the opacity change will make a big difference to the density of color.

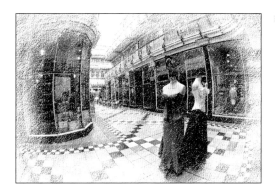

FIG 2.13 The picture at Step 9.

10. Increase the Grain setting to 10% and paint over the central area again to bring in more detail, and then change the brush size to 75 and the Grain to 15% and paint the two mannequins. As you can see, the increased grain setting does not show any paper texture.

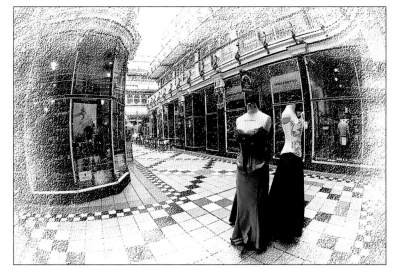

FIG 2.14 The completed photograph.

Smart-Strokes: Auto-Painting

Auto-Painting makes cloning from photographs quick and easy, the process is explained in more detail in the Painter Basics chapter and this tutorial introduces you to the concept.

1. Open 'Woodland Stream.'
2. File>Quick Clone. Turn the Tracing Paper off (Ctrl/Cmd+T).

FIG 2.15 The original photograph.

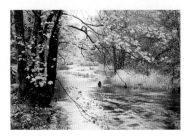

FIG 2.16 The Auto-Painting palette.

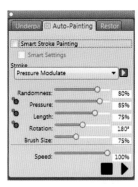

3. Select the Smart-Strokes>Sponge Dense, size 120 opacity 82%.
4. Open the Auto-Painting panel (Window>Auto-Painting Panels>Auto-Painting) as shown in Figure 2.16.
5. Ensure that the top two boxes are not ticked then click the Play button (bottom right) and watch the Auto-Painting do its job, click Stop after a few seconds. The great value of Auto-Painting is that it can create an underpainting for your picture very quickly. The sponge brush you are using is very fast, other brushes are much slower. In this example various sizes of brush strokes are applied on top of each other, these could be applied to individual layers if required, this would give additional flexibility in blending the brush sizes.
6. Reduce the brush size to 60 and press Play just for a few seconds, enough to have a mixture of brush sizes.
7. Reduce the brush size to 30 and press Play just for a few seconds, enough to have a mixture of brush sizes as before.
8. Reduce the brush size to 15 and press Play just for a few seconds, enough to have a mixture of brush sizes as before.

FIG 2.17 The picture at Steps 5 and 6.

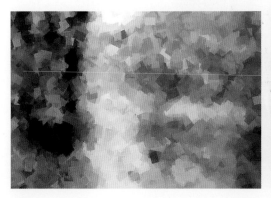

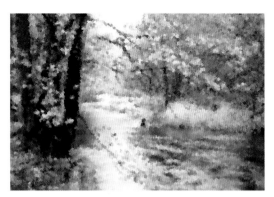
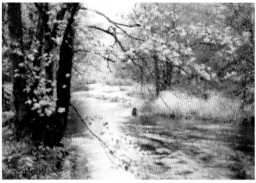

FIG 2.18 The picture at Steps 7 and 8.

9. Create a new layer, open the Restoration panel, this is in the same palette as Auto-Painting, and select the Soft Edge Cloner Brush icon which is a shortcut to the Soft Cloner. Using size 50 opacity 50%, paint over the main branches to remove some of the fuzziness. Bring back any other areas you think need better clarity, but don't overdo it. You can lower the opacity of the layer if necessary.

You can use Auto-Painting with almost any brush in Painter, remember to click the Clone Color option if you are using brushes other than from the Cloners and Smart-Strokes brush categories.

FIG 2.19 The completed photograph.

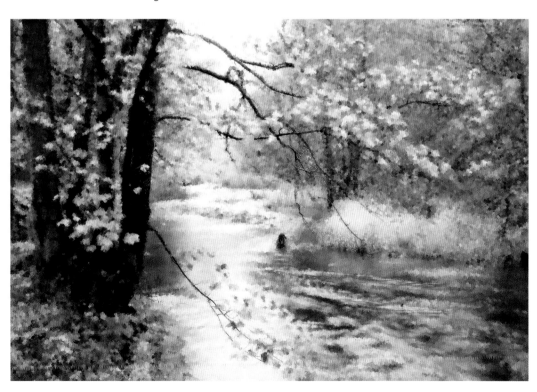

From Camera to Print
Opening Painter 12 for the First Time

Figure 2.20 shows the Painter 12 workspace when you open it for the first time. If you have played with Painter and want to start again from the defaults you should hold down the Shift key while you open Painter, this will give you the option of resetting all the workspaces to default. Resetting the workspaces is a useful tip if you run into technical problems with the program.

FIG 2.20 The Painter 12 workspace as it first appears.

Before you start, a quick guide to where various things are, on the left is the Toolbox with the tools arranged in a single column, below that are the Media Selectors where you can choose gradients and other presets. At the very top is the Menu bar which has many drop down menus for various functions.

Beneath the File bar are three panels, the first on the left is the Brush Selector, click the brush icon and a drop down menu showing the huge range of brushes will appear as shown in Figure 2.22. The brush categories are shown in icon form on the left with the brush variants on the right. I find the icons hard to identify so I recommend that you change the icons to text, less pretty but easier to use, especially for beginners. To do this you need to open the panel options menu; this is the icon top right, shown highlighted in Figure 2.22. When you click the icon a drop down menu appears, select Category Display and then Categories as List. The display will then look like Figure 2.22 on the right.

FIG 2.21 The default arrangement of panels and palettes.

On the right are the panels and palettes, a panel refers to a single control panel, whereas several of these stacked together are called palettes. The default arrangement is shown in Figure 2.21. As you work through this demonstration and the rest of the book, more panels will be brought on screen, some are needed regularly and can be slotted in the display, while others are needed less frequently and can be removed after use. There are over 50 different panels in Painter 12, so you need to keep just a few on the screen otherwise they can take over your screen area. The panels can be found under the Window menu.

FIG 2.22 The Brush Selector panel, with the default display on the left and the text display on the right.

Open the Original Photograph

Most photographs in recent years are likely to have come from a digital camera and therefore will usually be either a JPEG or a RAW file. RAW files are generally the best way to retain all the detail in your picture; however, Painter cannot accept a RAW file, so you will need to convert it to a file format that Painter accepts, such as JPEG or PSD; this can be done in several programs such as Photoshop, Lightroom, Aperture or in the camera-supplied software.

FIG 2.23 The original photograph.

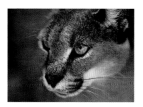

For this demonstration I suggest you use the photograph I have supplied so that you can follow all the steps.

Download my photograph called 'Lynx' (Figure 2.23) from the website. Save it on your computer and then go to File>Open to open it in Painter.

FIG 2.24 The three panels which make up the Auto-Painting palette.

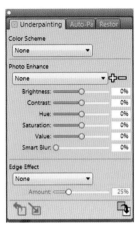

Preparing the Photograph for Cloning

Before you start work on any photograph in Painter you should prepare the picture first, what you need to do will depend on the photograph you are using but might include removing unwanted highlights or objects, changing the contrast or perhaps the color. Although you can do all this as you work or at the end, I find that spending time at the beginning thinking about what you are hoping to achieve and what could cause problems is time well spent. It is the same as trying to get it right in the camera rather than hoping you can put it right in the computer!

You should now have the photograph open, the picture needs very little doing to it, but there are a few adjustments you can make and this can be done easily in what is called the Underpainting panel. This is not on the screen so go to Window>Auto-Painting Panels>Underpainting and the palette of three Auto-Painting panels will appear top right; the palette is shown in Figure 2.24. When you add another panel on screen they will often show as a palette containing several panels which deal with the same subject. You can remove any unwanted panels by clicking on the 'x' alongside the name tab. The whole palette can be removed by clicking the white dot at the top left of the palette.

The Underpainting panel is only one of several ways of adjusting tones and color and is very intuitive to use, some more sophisticated ways are described in the Using Color chapter. The cloning process in Painter tends to result in reducing the color and contrast and often benefits from a boost at the start. Move the sliders to +10% Contrast and +15% Saturation and then click the downward pointing icon at the bottom of the panel to apply the effect. Once you click Apply the sliders zero and you can apply further changes. As is the case with most computer programs, if you make a mistake you can undo it easily by Edit>Undo or the keyboard shortcut Ctrl/Cmd+Z. This is not a toggle action but will continue to undo your previous steps. To Re-Do any step Edit>Re-Do or Ctrl/Cmd+Y.

FIG 2.25 The Auto-Painting palette in collapsed display, double-click the name to open again.

FIG 2.26 The workspace in normal view (left) and full screen view (right).

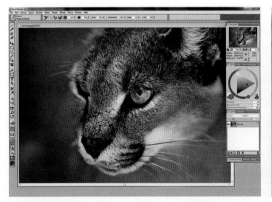
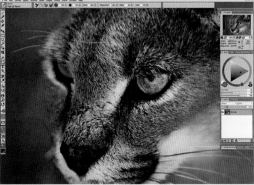

We have finished with the Underpainting palette for the time being, so move it to the bottom of the line of palettes and double-click the Underpainting name, this will reduce the whole palette to a small size as shown in Figure 2.25; this enables you to keep a lot of panels handy without them taking up too much space.

Personally I like to work Full Screen, this means that the picture makes best use of all the screen area as it hides all the headers and edges, the different views can be seen in Figure 2.26, it is particularly helpful when you magnify the picture as you can see in the illustration. Try this now by the keyboard shortcut Ctrl/Cmd+M (or Window>Screen Mode Toggle), this is a toggle action. If you like using Painter in this way you can change the default in the Preferences, see the Painter Basics chapter for more information on setting preferences.

Saving Your Picture

It is always important to save your picture at regular intervals in case of computer failure, it is also important to save it at this stage as you have changed the source photograph and if you want to stop the demonstration and start again at a later date you really need to keep this as a separate version. So File>Save As, give it a new name and save it as a RIFF file.

FIG 2.27 The Save As dialog.

Creating a Clone Copy

The next step is to create a clone copy, so File>Quick Clone, this will produce a new empty document which will look like Figure 2.28. It doesn't look very

FIG 2.28 After selecting Quick Clone.

25

empty as you can see the lynx in reduced visibility; this is the Tracing Paper overlay which allows you to see what you are cloning. Tracing Paper can be turned on and off by using the shortcut Ctrl/Cmd+T or Canvas>Tracing Paper. Try that now and you will see that the document is indeed empty. The original photograph is no longer open as Painter has embedded an image in the new document and will clone from that. Please note that when you close the picture this embedded image is only retained in the file if you have saved it as a RIFF file.

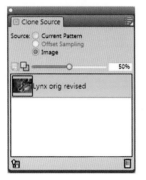

FIG 2.29 The Clone Source panel.

Clone Source Panel

When you created a Quick Clone, the Clone Source panel appeared on screen, as seen in Figure 2.29, and this panel shows you the source of your clone. This panel is used extensively in the Montage chapter when there are several source images.

Selecting a Brush

You need to select a suitable brush for cloning so click the icon in the Brush Selector panel top left of the screen. Select the Cloners brush category, this group of variants is specifically designed to work with photographs and so is a good place to start if you are a newcomer to the program. Select the Soft Cloner variant from the list on the right. The Properties bar which you can see in Figure 2.30 has updated to reflect the settings for that brush and there are three settings to take note of, the first highlighted one from the left is the brush reset icon, this is very useful for putting the settings back to their default settings and I suggest that you do this prior to following any of my instructions in this book. The second highlighted control is the brush size and the third is the brush opacity.

FIG 2.30 The Properties bar.

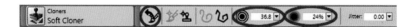

Soft Cloner

Change the brush size to 300 and the opacity to 10% and brush over the central area with the Tracing Paper turned on; you will see it darkening as you paint. Now turn off the Tracing Paper and you will see the result so far, continue painting until the central area is clear but fading out to white at the edges. Tracing paper is invaluable in showing you where to paint, but it also obscures what the result is, so throughout most paintings it is necessary to turn it on and off many times, it is especially useful in the early stages of a clone picture. The picture at this stage is shown in Figure 2.31.

At its most basic, that is what Cloning does; it takes the imagery from the source photograph and reproduces it in the clone document, reinterpreted

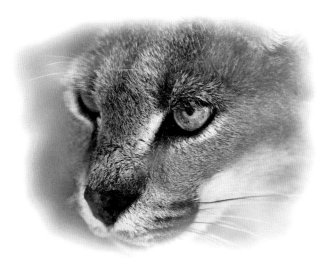

FIG 2.31 The picture after using the Soft Cloner.

through your choice of brush and paper surface. The clone you have just completed might be all you want for a soft delicate effect, but you could do this in many programs so the next step is to do this again, but this time using a brush with a more painterly finish.

Introducing Layers

You could start again with a new Quick Clone, but instead I would like to introduce you to Layers in Painter so that you will paint the next version on a new layer. Before you do so make sure you have saved the picture.

If you are used to using Photoshop or similar programs then you will know how layers work, basically when you look down the list of layers it is like looking through sheets of clear acetate so that if there is a picture on the one layer, it will hide the layer below. More information on Layers is in the Painter Basics chapter.

Select>Select All to copy the Canvas, then go to the Toolbox and select the Layer Adjuster, which is the fifth icon from the top, and click in the main picture. This will lift the picture information from the Canvas and put it onto a newly created layer above.

Hide Layer 1 by clicking on the visibility icon to the left of the layer, create a new layer by clicking the new layer icon, highlighted in Figure 2.32. The new layer will be colored green which shows that it is the active layer, Figure 2.32 shows the layer panel at this point, while the main picture is showing white.

FIG 2.32 The Layers panel after lifting the canvas to a layer and creating a new layer. The new layer icon is highlighted.

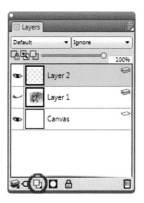

FIG 2.33 The clone after cloning with the Bristle Oils Cloner.

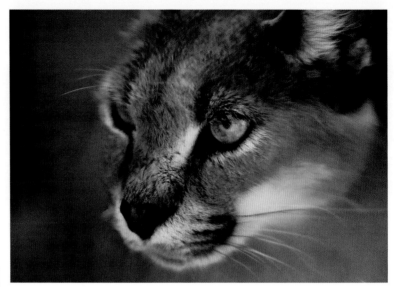

FIG 2.34 The Color panel in painting mode.

Bristle Oils Cloner

Click on the Brush icon in the Toolbox and select the Cloners>Bristle Oils Cloner, brush size 98 opacity 88%. Paint the lynx using quick brush strokes and keep the brush moving. Paint in the general direction of the fur, you will notice that this brush blurs the image, which is typical of the Oily brushes. When you have finished all of the picture go back over the eyes and nose and paint more slowly and you will see the detail become clearer. Paint the whiskers and follow their direction to make them clear.

FIG 2.35 The Color panel in cloning mode.

Impressionist Brush

Select the Artists>Impressionist brush, size 19 opacity 100%.

The previous two brushes were both in the Cloners brush category and were ready for cloning; however, most of the other brushes in Painter are not, so you need to make one change to enable them to clone.

The Color panel should be on your screen, if not open it via Windows>Color panels>Color and click the clone color icon (looks like a rubber stamp), this will change the display from color to shades of gray to indicate that the brush is now in cloning mode. You need to do this with all the brushes except for the Cloners and Smart Stroke brush categories. If you forget to make this change the brush will paint with the current color. Make a new empty layer as previously and turn off the visibility of Layer 2 so that you have a white screen again (apart from Tracing Paper).

Paint the lynx with this brush, it is much smaller than the previous ones used and will take longer, make sure that you follow the lines of the fur carefully. When you have painted the lynx, increase the brush size to 50 and paint the outer areas. You may find that it is easier to paint in the direction of the fur by turning the canvas; you can do this in the Navigator. In this panel you can magnify the picture on screen to see the detail more easily and also rotate the canvas by clicking the circular arrow icon and moving the slider. Figure 2.36 shows the screen with the canvas rotated and the Navigator panel showing the rotation. When you have finished reduce the brush size to 12 and paint over the eyes to bring in greater detail.

FIG 2.36 The Navigator panel and the screen with picture rotated.

FIG 2.37 Brush detail, the one on the right has the opacity of the top layer reduced to 50%.

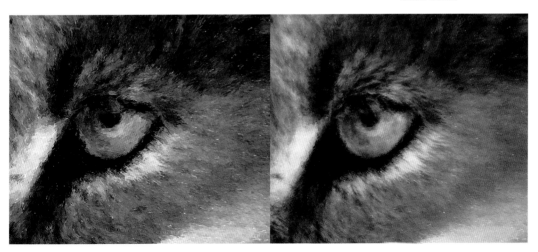

Now you have three layers with clones using three different brushes, turn off the layers in turn and see the differences, there are hundreds of brushes in Painter and each of them will give a slightly different result. You can also blend the layers together; try reducing the opacity of the top layer to 50% which will allow the layer beneath to partially show through. The layer opacity is the slider near the top of the Layers panel.

Adding Extra Texture

Now you have the painting completed it is time to add the finishing touches, this might include adding texture, either based on the picture or a paper texture, improving the tonal range, changing the saturation and sharpening.

Before doing any of the changes mentioned above I strongly suggest that you save the layered picture, then work on a duplicate file and make the changes on that. This ensures that if you should mess it up, you can always go back to the finished painting stage and start again. Another excellent reason for doing this is because adding textures and sharpening are very much dependent on the size you are going to print the picture at, or indeed if you are going to use it as a digital file, so you may have several final versions for different outputs.

File>Save. File>Clone; this will make a new clone copy, but choosing Clone instead of Quick Clone will make a clone copy without removing the picture. Cloning also creates a composite version from the four original layers. You now have a new file on which to make the adjustments.

FIG 2.38 The Correct Colors and Adjust Colors dialog boxes.

Select>All, Edit>Copy, Edit>Paste. This will create a duplicate copy of the canvas, I find it works well to make each adjustment on a separate layer as you can easily compare it with the original picture or reduce the layer opacity if required.

Start with the tonal controls, Effects>Tonal Controls>Correct Colors, move the contrast slider to 12% to add more punch to the picture.

With the top layer active, make another copy layer by right-clicking the layer and selecting Duplicate. Then select Effects>Tonal Controls>Adjust Colors and increase the saturation by 10%.

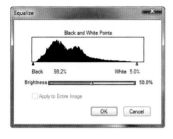 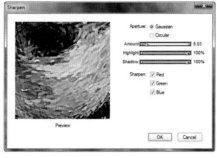

FIG 2.39 The Equalize and Sharpen dialog boxes.

With the top layer active, make another copy layer. Effects>Tonal Controls>Equalize. This controls the darkest and lightest areas and when it first opens it pushes the light and dark areas to maximum amounts, this is usually far too much so bring the Black slider to 99.2 and the White slider to 5.0, this will add more depth and punch to the picture.

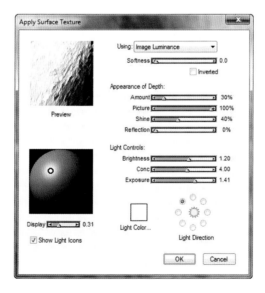

FIG 2.40 Apply Surface Texture dialog box.

With the top layer active, make another duplicate layer. Effects>Focus>Sharpen and move the Amount slider to 8.90.

With the top layer active, make another duplicate layer. Effects>Surface Control> Apply Surface Texture will add a texture to the picture. In the dialog

FIG 2.41 The final Layers panel showing the individual layers.

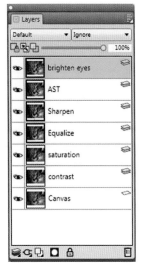

box select Image Luminance in the Using box and move the Amount slider to 30%. The texture is being based on the luminance of the final picture and the amount is difficult to judge by eye, generally keep it fairly low and on a separate layer so that you can reduce it if turns out to be too strong.

Finally the eye needs to have more impact, so duplicate the top layer again and select the Dodge tool in the Toolbox; this is the sixteenth tool from the top. Paint the light areas of the eyes, paint down and out from the iris for the right eye and just lighten the left until the yellow shows. Then hold down the Dodge tool in the Toolbox and select the Burn tool when it appears. Paint the iris to make it darker. Small details like this can make a big difference.

As you can see from the final Layers panel in Figure 2.41 all the layers are separate so they can be removed, because the top layer was being copied each time the effects are cumulative. I have renamed the layers, which can be done by double-clicking on the layer name.

Crop the Picture

Cropping the picture is an important part of the finishing process; a good crop can enhance the presentation. Before you do that, save the layered file then File>Clone to work on a new duplicate version – just in case you change your mind later about the crop. The Crop tool is the tenth down in the Toolbox, simply click and drag in the picture and click inside the image to accept the crop. Figure 2.42 shows three possible crops, portrait, square and landscape, take your choice! You also need to consider the paper on which you are intending to print and whether you want to fill the area or have space around the picture.

FIG 2.42 Three suggestions for cropping.

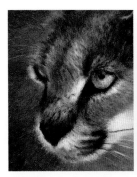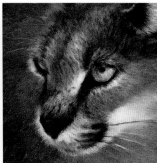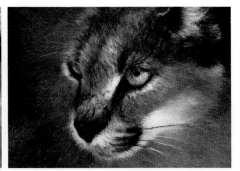

Preparing to Print

The first consideration is how large you want the picture to be, this determines what steps you need to take; for the purposes of this tutorial I am assuming that you will print on A4 paper – roughly 12 × 8.5 inches. To check how large the file is and therefore how large it will print open the Canvas>Resize panel,

as you can see in Figure 2.43 the file size is 45 mb and it will print as large as 43 × 30 cm or about 17 × 12 inches at 240 dpi, this is ample for an A4 print. More information on resizing and printing is in the Painter Basics chapter. One rather small but very important option is at the bottom, the option to Constrain File Size, if it is ticked the file itself will not be changed, just the size it is printed. If left unticked the file will increase or decrease in size and this can ruin your file very easily if you leave it off unintentionally.

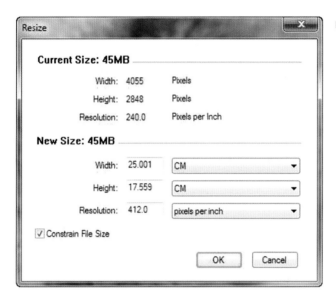

FIG 2.43 The Resize dialog box.

In this case, make sure it is ticked and then change the Width and Height to the size required, 25 × 17.559 cm (about 10 × 7 inches) for an A4 sheet, the printing resolution will change to 412 dpi.

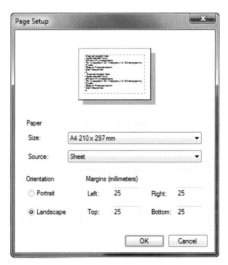

FIG 2.44 The Page Setup dialog box.

33

To print go to File>Page Setup and select the paper size from the drop down list and tick the Landscape option.

The information on printing shows you the dialog boxes on my computer system which is Windows 7 and an Epson 2880 printer, but this will vary depending upon your operating system and your printer. File>Print and the Print dialog box will appear; in the Painter 12 tab (Figure 2.45) there is the option to select the Size to Fit Page option, untick this if you want to print a specific size.

FIG 2.45 The Painter 12 tab in the Print dialog box.

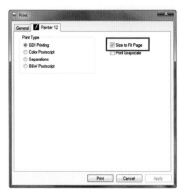

Return to the General tab (Figure 2.46) and highlight the printer you are using and then click Preferences.

FIG 2.46 The General tab in the Print dialog box.

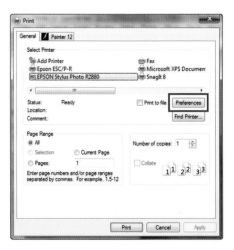

This opens the Printing Preferences dialog box (Figure 2.47). In the Print Quality box, select the quality option you want to use, generally a high quality would be required.

In the Mode option select Custom and in the drop down menu select ICM, then click the Advanced tab alongside. This brings up the ICM dialog (Figure 2.48) and you need to change the ICM mode from Driver ICM (Basic) to Driver ICM (Advanced), this then allows you to access the Image section which was previously grayed out.

You also need to tick the Show All Profiles option to show your profiles.

In the Image section select your Input profile to whatever profile you are using for your computer, in this case it is Adobe RGB, you can leave Intent as it is, then in the Printer Profile drop down menu select the printer paper profile you have previously created. Click OK in both boxes then click Print.

There is more information on color management and profiles in the Painter Basics chapter.

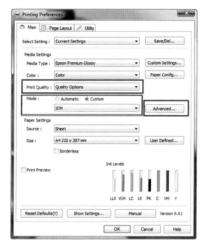

FIG 2.47 The Printing Preferences dialog box.

This is all rather complicated, and although it will be remembered for next time you print it is not very user friendly. You can save presets in the Printing Preferences box, but as a photographer you are probably already using an imaging program so you might prefer to save it as a psd file, open it in Lightroom, Aperture or Photoshop and print from there.

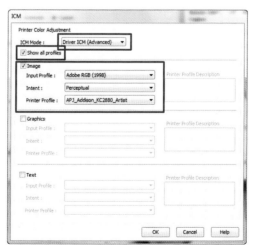

FIG 2.48 The ICM dialog box.

FIG 2.49 The completed picture (overleaf).

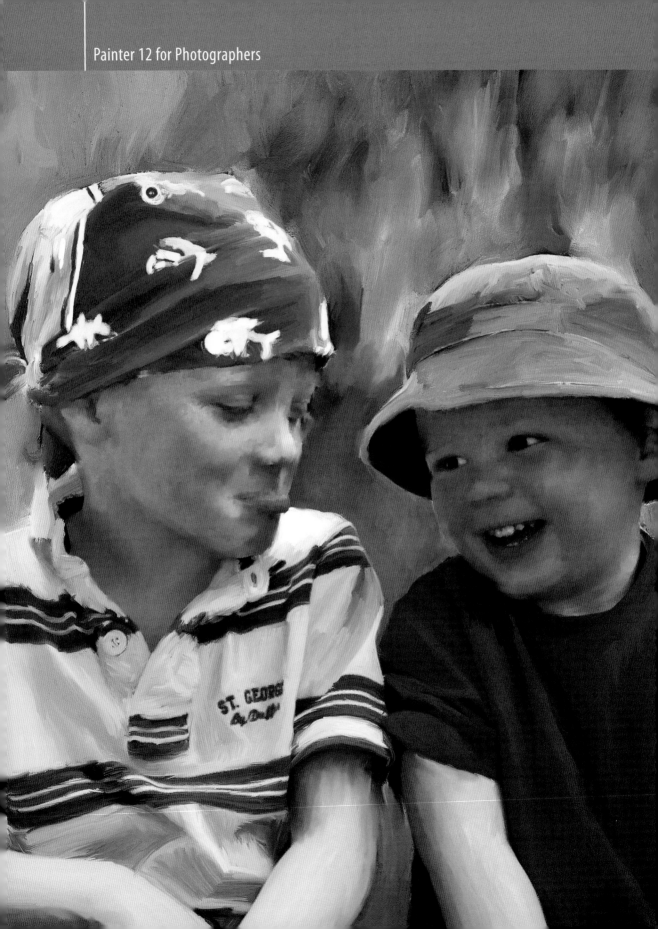

Painter 12 Basics

This chapter covers a lot of information about how to use Painter 12, from the basics of learning the interface to more advanced sections on color management. If you are new to Painter, I recommend that you work through this chapter as this gives you some experience of the interface and key techniques. If you already know Painter you may wish to skim this section or just pick up on the newer features.

The chapter starts with explaining the tools and panels and where to find them, and then goes on to navigating around Painter and how to use selections and layers. Many readers will use Adobe Photoshop so I have included a section highlighting the differences between the two programs; sometimes the naming of techniques and the location of particular commands differs. I recommend that you use a pressure-sensitive pen with Painter and there is a section which covers the basics. The important options in the Painter Preferences are covered, plus sections on printing and color management, essential for getting what you see on the screen to your printer.

FIG 3.2 The Painter 12 Toolbox. The main Toolbox now contains a shortcut to the Papers panel, whereas the other Library panels are in a separate display which is shown alongside.

Tools and Menus

If you would like to work through the features in this chapter I suggest that you download and open the file called 'Stained Glass' from the website.

FIG 3.3 The default workspace.

The Toolbox

The Toolbox is where all the tools are stored and Figure 3.2 shows the new Painter 12 Toolbox, the small triangles alongside the icons indicate that additional related tools are available.

To access the hidden tools click and hold the visible tool and the other options will appear to the side, click the one required. Some of the important tools which are being used in this book are detailed in this chapter and most are very obvious by their icons.

The Toolbox can be displayed in several different ways, as a single line (default) or double column and also in horizontal or vertical positions, the display options are available in the Edit>Preferences>Interface panel.

There are keyboard shortcuts for many of the regularly used tools and others can be customized in the Preferences>Customize Keys menu. A full explanation of all the tools can be found in the Painter program under Help>Help Topics.

The icon at the bottom changes the view to Full Screen, it is a toggle action.

The Menu Bar

The menu bar at the top of the screen allows you to access many of the key functions including Tracing Paper, Selections, Saving, Effects and many more. Don't forget the Help menu, although I cover most things you will need in this book, there is always more to be found there.

The Properties Bar

The Properties bar which is below the Menu bar is a context-sensitive bar which changes to whatever tool is currently active, in the example shown it is relevant to the Brush. One key icon which applies to all brushes is the Reset button which is the first highlighted icon in Figure 3.4. I recommend that you use this prior to following my step by step tutorials as this will ensure any changes you have made to the brush previously will not affect the result. The two other highlighted icons are the brush size and opacity. The other settings will be dealt with in more detail in the Customizing brushes chapter.

FIG 3.4 The Properties bar.

The Brush Selector

The Brush Selector is where the brush is chosen and is dealt with in more depth in Chapters 4 and 5. At the top left of the screen is the Brush Selector. Click the brush icon on the left and the drop down menu will reveal the extensive range of brush categories that are available. When you select the brush category on the left, the range of variants is shown on the right, which makes changing brushes quick. The brush stroke preview at the bottom of the brush selector updates as you hover over a brush variant to give you an idea of what that variant will do when you use it on your image. You can choose several different ways to display this menu by going to the panel options menu, which is highlighted in Figure 3.8 on the next page.

FIG 3.5 The Brush Selector panel plus the extended menu in two of the display modes.

Recently Used Brushes

This panel shows which brushes you have used with the most recent on the left; the older ones drop off the end on the right. This display is situated next to the Properties bar and is duplicated in the extended Brush Selector menu; it will of course be empty when you first open Painter.

FIG 3.6 The Recent Brushes display.

41

FIG 3.7 A selection of panels and palettes in Painter 12.

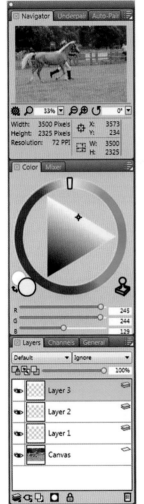

Panels and Palettes

Using and Organizing Panels and Palettes

Panels or palettes? Painter 12 refers to individual control panels as panels but when you group several together, they become palettes. There are over fifty panels in Painter 12 and although they will collapse and stack very neatly they do take up room on the screen that could be used for the image. Fortunately not all are required at the same time, they are easy to organize and unwanted ones can be removed.

To show panels not visible on the screen, go to the Window menu and click on the name of the panel you want. Some of the panels such as Brush Controls are arranged in groups for convenience. To remove a panel from the screen, click the cross in the square on the panel header, or to remove a whole palette, click on the white dot top left.

To expand or collapse a panel, double-click on the name. To move and link panels together click on the panel tab and drag over the tab of another panel and they will dock together; you have to be quite precise when you do this.

What panels you choose to keep on screen depends very much on personal preference and of course on how big a screen you have, I have a basic layout which I save and then open other panels as I need them. You can save your palette layouts, Window>Arrange palettes>Save Layout.

Panel Options Menu

One further note regarding panels. To the right of the panel name is an icon (highlighted in Figure 3.8) which indicates that the panel contains a Panel options menu. This is a further selection of options relevant to that particular panel, click and hold on the icon to see the drop down menu. Many of the panels will be looked at in more detail as you work through the tutorials in the book.

FIG 3.8 The panel options menu showing a drop down list. To the right are brush panels combined into a palette and collapsed to save space.

Creating Custom Palettes

Creating custom palettes can be very useful, some to use on a regular basis and others for a particular picture or project. This is a quick guide to creating a custom palette which also includes menu commands.

Select a brush variant from the Brush Selector, hold down the Shift key and drag it out into the main workspace. A custom menu will be immediately created as shown in Figure 3.9 and you can now add further items to the palette. Select a brush from another brush category, hold the Shift key and drag that onto your new custom palette and position it to the right of the original icon.The icon can be repositioned anywhere on the custom palette, hold down the Shift key and drag the icon to where you want it to be. To delete an icon hold down the Shift key and drag the icon off the palette.

To add a paper texture, open the Paper Libraries panel (Window>Paper Panels>Paper Libraries, hold down the Shift key and drag the paper icon from the panel onto the Custom palette.

Menu commands can also be added, go to Window>Custom Palette>Add Command and the dialog box shown in Figure 3.10 appears. You need to select the name of the palette you are working on. To add the Tracing Paper command, go to Canvas>Tracing Paper then return to the Add Command palette and click OK, the shortcut will appear on the new palette.

To delete or rename custom palettes go to Window>Custom Palette>Organizer, highlight the palette you want to change and click the relevant button. Painter will remember this palette each time you open the program; however, if you have to reinstall the program it may be lost, so to save a really useful palette permanently it should be saved by pressing Export. The Import button will add palettes previously saved. Custom palettes have been upgraded in Painter 12 and you can now hover over the icon with the cursor and the name of the brush will appear; this is a great help to identify brushes. You can also create your own icons, right-click the icon or name and the menu shown in Figure 3.11 appears where you can create or change any icon. Figure 3.12 shows an example of a completed Custom palette.

The improvements in Painter 12 make this feature even more useful as you can add pretty well any command in the program as well as brushes, papers, gradients, tools, links to panels, etc. You can also make several palettes and link them together.

FIG 3.9 A Custom palette with one brush added.

FIG 3.10 Add Command dialog box.

FIG 3.11 Drop down menu.

FIG 3.12 A Custom palette with several shortcuts added, this includes brushes, papers, menu commands and panel display links.

Working in Painter 12

The Navigator

FIG 3.13 The Navigator in use in Painter 12.

FIG 3.14 The Navigator panel.

The Navigator is new to Painter 12 and is a great addition to the program. Not only does it help you to navigate when the picture is magnified, but it also allows you to keep track of the whole picture while working on a detail. It can be enlarged by dragging the lower right corner.

The Navigator also brings together several controls for moving around the picture, the gear wheel gives access to display options while the next few icons are shortcuts for enlarging, reducing and rotating the picture.

Rotating the Canvas

The curving arrow in the Navigator is the Rotate Tool which allows you to rotate the canvas; click the small triangle to the right and move the slider and the picture will rotate, this is very useful as it helps when using directional brush strokes. Double-click the curving arrow icon to return to the regular position. This control is also in the Toolbox.

Don't confuse this with the Rotate Canvas command in the Canvas menu; Rotate Page simply turns the picture around in the same way a traditional artist might move a canvas around to get a better angle. Figure 3.15 shows the rotated canvas and the view in the Navigator panel.

FIG 3.15 Rotating the canvas.

Normal and Full Screen View

In the Normal view the picture is contained within its document window, while the Full Screen view allows the picture to fill the entire screen including behind the palettes and toolbox. Full screen is a good way to work as it allows more freedom to move the image around on screen and removes much of the clutter. The keyboard shortcut is Ctrl/Cmd+M, or click the icon in the Toolbox.

Moving Around the Picture

It is often necessary to enlarge the picture on screen in order to work at a more detailed level. The quickest way of doing this is to use the keyboard shortcuts.

Zoom In (Ctrl/Cmd++) or click the+Magnifier icon in the Navigator, also Window>Zoom In.

Zoom Out (Ctrl/Cmd+−) or click on the minus (−) Magnifier icon in the Navigator, also Window>Zoom Out.

Zoom to Fit (Ctrl/Cmd+0) or Window>Zoom to Fit will show the whole picture on screen.

Actual Size (Ctrl/Cmd+Alt/Opt+0) also Window>Actual Size, this is very useful for checking detail.

Pressing the Spacebar while painting will enable the image to be moved with the cursor, when the Spacebar is released the brush will be active once again.

45

File Handling

Opening a Photograph

Painter accepts several different types of pictures, if you are bringing in pictures from a digital camera, the most common file types are JPEG or TIFF format. If you are importing a picture that has been saved in Adobe Photoshop the file type is likely to be PSD. Painter will happily use all these file types and several others. Painter does have its own file type called RIFF; however, when importing photographs it is not necessary to use this in the majority of cases. Painter is unable to read RAW files, so they will need to be opened first in a RAW reader such as in Photoshop, Lightroom or Aperture.

The Open dialog box has improved a lot in Painter 12; it is now resizable and previews are displayed, this is the dialog box shown in Windows 7, but the display will vary depending upon the operating system in use.

FIG 3.16 The Open dialog box in Windows 7.

File Sizes

Early versions of Painter were notoriously slow in handling large files but recent upgrades have significantly improved in speed and this is no longer an issue with anything but very large files.

The question I am often asked is what file size is the best to use in Painter; there is no simple answer to this as it depends on many different things, in

particular the original capture size and the final print size. Generally file sizes between 10 mb and 30 mb are adequate.

The best way to calculate the ideal file size is to decide upon the planned print size and work back from there. So if the plan is to print on A4 (12 × 8 inch) paper and between 200 and 250 dpi then the ideal size would be between 11 mb and 17 mb; however this is by no means essential and a 17 mb file could easily be printed up to twice that size without significantly losing quality. You can also increase the file size if necessary prior to printing.

For those new to digital capture it is worth mentioning that a photograph taken with a camera that has a 6 mb specification will open up as about 17 mb in Painter, this is because the file is compressed in the camera.

Saving Images

There are three options for saving images available from the File menu.

'Save' will save the image, overwriting the original file.

'Save As' will save a copy under a different name if required.

'Iterative Save' is very useful when you need to keep interim versions of the image showing different stages of completion. Each time the image is saved Painter adds an incremental number to the file, 001 then 002 and so on. This is a very useful option for returning to an earlier stage, and when the image is completed you can delete these interim saves if you no longer require them.

Painter will save images in several file formats, but generally an image should be saved in the same file type in which it was originally opened. In the case of photographs this will usually be PSD if it has come via Photoshop or JPEG if from a digital camera. Images that started as JPEGs should be saved as a PSD or RIFF (see below) while being worked on in Painter, as continually saving in JPEG format will degrade the image quality.

The native file format for Painter is RIFF. If you are only using Painter then this is the file format to use, if you are using Painter in conjunction with Photoshop then Photoshop PSD may be preferred as the files can then be opened directly in Photoshop. RIFF also has some advantages when cloning as the clone source image is embedded in the cloned file.

It is however advantageous, indeed essential to use RIFF when particular brush categories are being used, these are mainly Watercolor, Real Watercolor and Liquid Ink, in RIFF file format these can be saved and reopened at a later date and brush strokes can be edited. Mosaics are another case where it is useful for RIFF to be used for the same reason. If you are a Photoshop user it is easy to think of these as adjustment layers which are permanently editable until the file is flattened. Dynamic Plug-in layers which are available from the bottom of the Layers panel are also similar to Photoshop adjustment layers; they are not editable once the file is saved in any format other than RIFF.

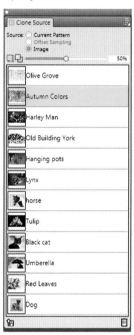

FIG 3.17 The Clone Source panel is new in Painter 12 and the cloned file will contain all the source images embedded into the file. This is one case when saving as a RIFF file is a definite advantage as the embedded files are not saved if the file is saved as anything other than a RIFF.

FIG 3.18 Selection tools.

Selections

Tools

There are many ways to make selections in Painter and the most obvious are in the Toolbox. The Rectangular and Oval selection tools are near the top and just beneath them the Lasso and Polygonal Lasso. The Lasso is very useful for selecting irregular areas while the Polygonal Lasso is better on straight lines. The options on the Properties bar allow you to add to or subtract from existing selections.

FIG 3.19 Properties bar for the selection tools and the Magic Wand.

The Magic Wand will select areas of color; you click on the color in the picture. In addition to adding and subtracting, the Properties bar also has several other controls, the main one being Tolerance, which defines how exact the color selected is to the one chosen; the higher the tolerance, the wider the range of colors selected. Another important control is the contiguous option, if this is active the colors must join to be selected, deselect this option to select all the colors in the picture, irrespective of where they are.

FIG 3.20 The Select menu.

Modifying Selections

Once a selection has been made there are many controls to modify the selection in the Select menu on the Menu bar. Most of the commands are obvious so I will just mention a few. Feather softens the edges of a selection which is useful for when you need to blend one area into another. Modify allows you to make the selection larger (Widen), smaller (Contract), smooth out the edge (Smooth) or create a border (Border) from the selection edge.

Auto Select is an interesting command as you can base the selection on a number of different options including the image luminance and paper; this can produce some interesting blending effects.

Color Select is very useful to select a particular range of colors, click in the picture and adjust the Hue Extents to define the color range and then if desired do the same with the Saturation and Value sliders. The Feather sliders will soften the edges of the chosen values.

FIG 3.21 Auto Select dialog with the selection of source options. The Color Select dialog is on the right.

Saving Selections

If you have created a complex selection it is usually worth saving it in case you want to use it again. Select>Save Selection will bring up the dialog box where you can name it. To use it again, Select>Load Selection will bring on the dialog box where you choose the saved selection from the drop down list.

FIG 3.22 The Save Selection dialog.

Channels

Another way of creating a selection is by using channels, this has the advantage of making the selection using brushes rather than the Lasso, and using this method it is frequently easier to define the edge more accurately.

Open the Channels panel Windows>Channels and click on the New Channel icon, this creates a channel called Alpha 1, you can rename it by right-clicking and going to Channel Attributes. Your picture will now have a red overlay. Select the Airbrushes>Digital Soft Pressure Airbrush and select white in the Colors panel, make sure all the sliders are showing 255 to get a pure white. Paint in the picture what you want selected and you will see the red overlay is removed as you paint. If you make a mistake, change the color to black and paint again, it works like any mask. You can use many different brushes for painting in masks to get varying effects. At this point you can alter the mask in several ways by painting or applying filters, one very useful facility is to soften the edges by applying the Soften filter (Effects>Focus>Soften).

FIG 3.23 The picture with a red mask overlay and the mouse painted out, plus the Channels panel showing the Alpha 1 channel.

FIG 3.24 Effects>Focus>Soften dialog.

When you have finished, click the Load Channel as Selection icon (highlighted in Figure 3.23) and, as you only have one channel, it will select that by default, when you click OK the area you painted will be changed to a selection. Turn off the visibility of the Alpha 1 channel and the red overlay will disappear, you now have a selection within which you can paint or apply effects in the same way as if you had used a lasso. Alpha channels are saved with the file so you can use them again if you need to.

Channels offer many creative opportunities, not only for selections but also for creating textures based on papers, patterns or different images.

FIG 3.25 Preview after applying the Soften filter.

Cloning Techniques

Basic Cloning

Cloning is the method used to create most of the tutorials in this book, it takes information from a source photograph and re-creates it in a new document; the new picture will be altered through the choice of brush and paper surface and the way it is painted. There are two basic ways of creating a clone and you need to start by opening a picture in Painter. The two pictures I used for this are 'Olive Grove' and 'Horse.'

File>Quick Clone will create the new document ready for cloning, it will also copy the image of the original picture and then close it down, all the cloning will be based on this memorized image. What you see on screen is an empty document with a light overlay, the overlay acts as a tracing paper and is not part of the picture, it can be turned on and off by going to Canvas>Tracing Paper. Choose the Cloners>Soft Cloner brush and paint in the picture.

FIG 3.26 The original photographs.

File>Clone does the same as Quick Clone, it memorizes the original image, but instead of creating an empty document, it creates a copy of the original so that you can clone or paint into it rather than onto an empty document, this is useful for blending and copying, and is an alternative way of working.

File>Quick Clone carries out several actions and these may be changed in Edit>Preferences>Quick Clone. Personally I prefer to deselect the Switch to Cloner brushes option and to select the Clone Color option.

In both cases the source image is memorized when the clone document is open in Painter; however, once you close down the picture the memorized image is only saved if you save it as a RIFF file. If you choose to save it as another file type the link will be lost, although it is easy enough to reconnect the images later using the Clone Source panel.

FIG 3.27
1. File>Quick Clone with Tracing Paper.
2. File>Quick Clone with Tracing Paper turned off.
3. File>Clone.

Tracing Paper

Tracing Paper is a semi-transparent overlay of the original picture that allows you to see what you are cloning; this is very useful at many stages of the picture and is usually turned on and off regularly.

Tracing Paper is turned on automatically when the default Quick Clone procedure is used and can be turned on and off at any time by using the

shortcut Ctrl/Cmd+T, the opacity can be altered using the slider in the Clone Source panel. It is important to note that the Tracing Paper is purely there to help you see what you are cloning; it is not part of the picture and will not print.

Clone Source Panel

The Clone Source panel will appear on screen whenever you create a clone and this panel (new to Painter 12) offers considerable flexibility when using more than one clone source.

Open the 'Olive Grove' photograph and File>Quick Clone. The Clone Source panel should appear on screen, if not go to Window>Clone Source. The panel will show your source picture as in Figure 3.28, clone as usual from this source.

To add another clone source, click the Open Source Image icon, highlighted in Figure 3.28, and select Open Source, select the 'Horse' picture and it will appear in the Clone Source list as in Figure 3.29. The active source is highlighted in green, paint from that source, then click on the original source and paint again from there. It is easy to swop between several clone sources.

Should you want the horse in a different place, open the horse picture, copy the canvas to a layer (Select All, then click in the picture with the Layer Adjuster tool), move the layer, then click the Open Source Image icon and select the file name from the list of open files to add the picture again. It will show as the same file name with a version number as in Figure 3.30. You can also use this method to change the contrast, color, etc. Double-click the layer name to rename a clone source. This is also the method to use when re-linking a cloned picture with the source image if you have saved the image in any file type other than RIFF.

FIG 3.28 Clone Source panel with open source image menu.

FIG 3.29 After adding a second clone source.

FIG 3.30 After adding a third clone source.

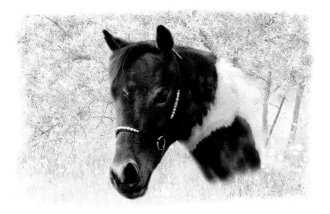

FIG 3.31 The result of using two different clone sources.

FIG 3.32 The Auto-Painting palette.

The Auto-Painting Palette

The Auto-Painting palette provides a process to make fast painterly clones using a large number of brush variants and is a very easy way to get started with cloning photographs. There are three parts to this process, Underpainting, Auto-Painting and Restoration, and each of them have their own control panels.

Underpainting Panel

The Underpainting panel has a range of options which will adjust the appearance of your picture and can be used prior to making a clone or at the end.

The **Color Scheme** options are used to apply an artistic look to a photograph and are usually used before cloning; the various schemes change the color and tonal range in interesting ways.

Figure 3.33 shows the six color schemes.

Top row from the left: Modern, Sketchbook and Watercolor.

Bottom row from the left: Chalk Drawing, Classical and Impressionist.

FIG 3.33 The six color schemes.

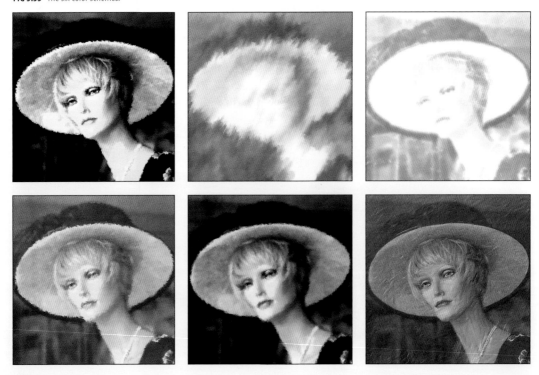

The **Photo Enhance** sliders are an easy way to alter the color and tone of a picture that can be used at any stage of creating an image. There are a number of presets available or you can move the sliders individually; to apply more than one preset, click Apply after each preset.

These effects are often used on the original photograph prior to cloning to brighten the picture, as the cloning process tends to lose some of the original brightness and contrast. Some of the changes can be seen in Figure 3.34.

FIG 3.34 Using the Photo Enhance sliders.

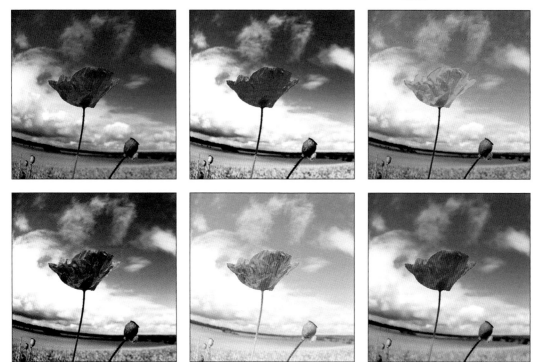

Edge Effects can also be applied from this control panel and some examples of these effects can be seen in Figure 3.35.

FIG 3.35 Using the Edge Effects.

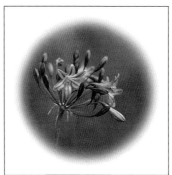
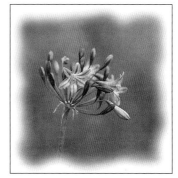

FIG 3.36 The Auto-Painting panel.

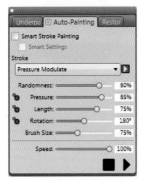

Auto-Painting Panel

The Auto-Painting panel uses an automated process to clone from a photograph; usually extra work needs to be done by hand to finish the picture. Auto-Painting is also very good for providing an underpainting. You can use almost any brush in Auto-Painting, just remember to switch to Clone Color before you start. The Smart Stroke and Cloner brushes will work without adaptation.

The process is quite fast for most brushes but you can test them quickly by making a selection in the clone copy and working only within this area. The Auto-Painting process is started by clicking on the Play icon, the Stop button is next to it. Press the Play button again to resume painting.

The first option is the tick-box for Smart Stroke Painting and in this mode the brush strokes follow the main lines of the photograph, in principle this should be advantageous but the downside is that it creates unpleasant lines in areas without much detail, as you can see in Figure 3.37. This can be overcome by painting over the marks with the same brush.

When the Smart Stroke option is enabled another tick-box will appear below, Smart Settings makes the process even more automated as the brush sizes start large and become progressively smaller as the process continues, so more detail is being revealed. The process stops automatically when the smaller brushes have finished cloning. This will resolve rather more detail but once again it can leave some unpleasant lines.

FIG 3.37 The three main options in the Auto-Painting panel.
Left: No Smart Settings.
Middle: Smart Stroke Painting.
Right: Smart Stroke and Smart Settings.

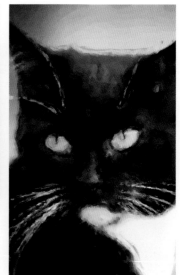

When the Smart Stroke Painting options are not selected other options in the panel become available. The Stroke drop down menu reveals a large choice of brush strokes (Figure 3.38) which will modify the choice of brush selected in the Brush Selector. The brush can be further customized by altering any of the five sliders in the panel.

FIG 3.38 The choice of brush strokes.

FIG 3.39 Three of the brush strokes.
Left: Bearing Rotate.
Center: Circle.
Right: Short Strokes.

Restoration Panel

The Restoration panel makes it easy to restore some of the original photograph to the clone copy. This is useful when the clone needs more clarity, there are two brushes in the panel and the Soft Edge Cloner is generally the brush to use.

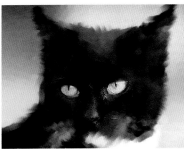

FIG 3.40 Using the Soft Edge Cloner brush in the Restoration panel to bring back the detail in the eyes.

Layers: The Basics

Layers are used throughout this book and are an important part of creating images, if you are used to Photoshop they work in a similar way, but with some differences. Layers can be thought of as clear sheets of acetate stacked on top of the Canvas. The layer stack is being viewed from the top so that when the top layer is full of imagery none of the layers beneath are visible.

The base layer is called the Canvas and cloning will use this by default unless you create a new layer. Generally the reason for using layers is to maintain flexibility so that a picture can be built up in sections and the different layers can be adjusted at the end.

FIG 3.41 The Layers panel showing the various types of layers.

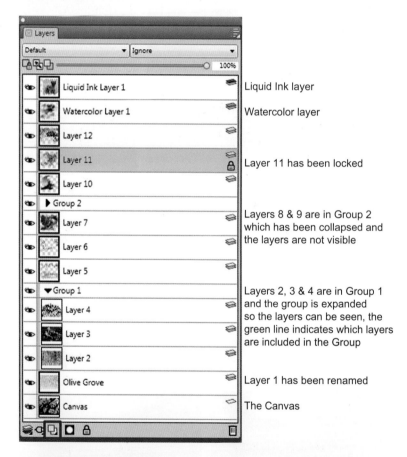

The best way to create a new layer is to click the New Layer icon, highlighted in Figure 3.41 at the bottom of the Layers panel; that then becomes the active layer on which to paint or make adjustments. You can always tell which layer is the active layer, as it is highlighted in green. Most brushes use a standard layer but Watercolor, Real Watercolor and Liquid Ink brushes need special layers

which are automatically created when the brush is used. If you need to create one of these special layers, click and hold the New Layer icon and select the type required from the drop down menu.

The eye to the left of each layer controls the visibility and these can be switched on and off. Layers can be renamed by double-clicking on the default name and deleted by clicking the trash can.

Merging and Grouping Layers

I recommend that you keep the layers intact while working on a picture as this allows maximum flexibility; however when you need to merge layers the Layer panel options menu is highlighted in Figure 3.43 and contains the necessary commands. Select Collapse Layers to merge two or more layers into one, select them by using the shift or Ctrl/Cmd keys. Drop will merge the active layer or layers with the canvas. Drop All will merge all the layers and combine them with the canvas.

Another command in this menu is for creating groups of layers; this is rather like keeping them in folders and is very useful when you are using a lot of layers. Hold down the shift or control key, click on the layers you want to keep together and select Group Layers from the Layer Commands menu. The resulting group takes up very little space and can be opened again by clicking the triangle on the left of the group.

Duplicating and Locking Layers

It is often very useful to copy layers, particularly when you want to apply effects such as sharpening or adding textures, a copy layer allows you to make an adjustment and then reduce the layer opacity to fine tune without affecting your completed painting. To make a copy of a layer, right-click the layer and select duplicate.

To make a copy of the Canvas, Select>All, Edit>Copy, Edit>Paste in Place.

The shortcut sequence for this is Ctrl/Cmd+A, Ctrl/Cmd+C, Ctrl/Cmd+V.

Locking a layer is useful to prevent accidental erasure or painting on the wrong layer, simply click the lock icon at the bottom, click again to unlock.

FIG 3.42 The Layers panel options menu.

FIG 3.43 The Layers panel with the Layers panel options menu highlighted.

Layers: Blending

Layer Opacity

Layers can be integrated with each other in various ways and one of the most important is by altering the opacity of a layer. The slider at the top of the panel controls the opacity; reducing the opacity allows the layer below to be seen. Figure 3.44 shows the result of reducing the opacity of the top layer to 25% and 75%, therefore partially revealing the layer beneath.

FIG 3.44 The Layers panel showing layer 1 with the opacity slider at 25% (left) and 75% (right).

Layer Masks

Sometimes you need to hide or reveal only parts of a layer and for this you use Layer Masks. To create a layer mask, first activate the relevant layer, and then click the mask icon at the bottom of the panel; you cannot add a mask to the canvas. The mask appears next to the layer and you will need to click on the mask in the panel to make it active, it is important to remember to do this otherwise you may paint on your layer by accident.

Masks work on the principle that areas painted with black on the mask will hide whatever is on the layer and therefore reveal the layer below. If you paint with gray it will partially reveal the layer below.

Figure 3.45 shows the Layers panel with an active mask, together with what the resulting image looks like.

FIG 3.45 Using a layer mask on layer 1.

There is another way to use a layer mask and that is to create the layer mask and then select black in the Color panel and Edit>Fill>Fill with Current Color. This hides the whole of the layer; you can then paint in the layer using white which will reveal the layer below, the opposite of the method previously described. This is useful when you only need to reveal a small part of the layer.

Right-click the mask icon for options to delete, disable or apply the mask.

Preserve Transparency and Pick Up Underlying Color

The Preserve Transparency option is turned on and off by clicking the small icon near the top of the panel (Figure 3.46) and is used when you need to paint over something on a layer without painting over the transparent areas as well. An example of this would be overpainting a color on the content; this can be seen in Figure 3.47.

Click the next icon along and you will be able to pick up color from the layer below when painting. This means that you can blend a color on one layer while taking the color from the layer beneath with a brush such as the palette knife. This is a technique which is very useful when cloning.

FIG 3.46 The Preserve Transparency and Pick Up Underlying Color check boxes.

FIG 3.47 Preserve Transparency allows you to paint on the content of a layer and not the empty areas.
Left: Original.
Center: Preserve Transparency not selected.
Right: Preserve Transparency selected.

Layer Composite Method and Depth

The two options at the top of the panel are the Layer Composite Method and Layer Composite Depth (highlighted in Figure 3.48) and they control how layers interact with each other. The Layer Composite Depth affects only brushes which use Impasto, which show depth by adding shadows to the brush strokes. The options alter the way the depth is shown.

The Layer Composite Method controls how a layer will interact with the layer beneath and offers a lot of creative opportunities when using multi-layered files.

This is extremely useful when making montages as it allows you to mix image layers in ways that are not possible with any other method. The examples on the following three pages will provide an insight into how each composite method works. The effect of the composite method will differ considerably depending upon the content of the two layers that are combined; the opacity setting will also change the appearance. Both images are on the website.

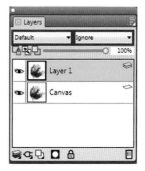

FIG 3.48 Layer Composite Method and Layer Composite Depth.

Original (underneath)

Original (on top)

Default

Gel

Colorize

Reverse-Out

Shadow Map

Magic Combine

Pseudocolor

Normal

Dissolve (at 50% opacity)

Multiply

Screen

Overlay

Soft Light

Hard Light

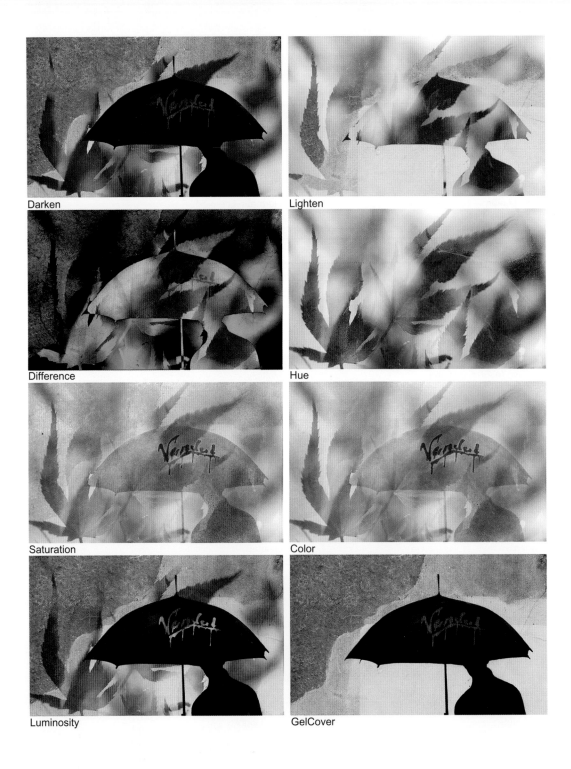

Darken

Lighten

Difference

Hue

Saturation

Color

Luminosity

GelCover

Photoshop: Painter 12

This book has been written so that no knowledge of any other program is necessary; however, many readers will already be very familiar with Adobe Photoshop as it is the premier professional image editing program. Therefore this section explains the main differences between the two programs, how the name for the same procedure differs, an explanation of how files can be interchanged, the consequences of doing so and some workarounds to make life easier.

Terminology and Usage

Photoshop	Painter 12	Comments
Actions	Scripts	Work in a similar way
Background	Canvas	Similar but does not always work in the same way
Background Color	Not available	What looks like the Background Color is actually the Additional Color which is used for two color brushes
Color Picker	Color Panel	Single-click in Toolbox in Photoshop Ctrl/Cmd+1 in Painter
Duplicate Background	No option – see right for workaround	Activate Canvas, Select>All, Edit>Copy, Edit>Paste in Place to make a copy at the top of the layer stack
Duplicate Layer	Duplicate Layer	Right-click layer in Painter
Flatten Image	Drop All	Available from the Layers panel options menu
Foreground Color	Foreground Color	This works in the same way
Filters menu	Effects menu	Filters are in the Effects menu
Image adjustments menu	Effects menu	Image adjustments are in the Effects menu
Layer Blending Mode	Layer Composite Method	Works in the same way but not all layer modes are compatible, see below for more details
Merge Visible	Collapse	Select all the layers to be merged by holding down the Ctrl/Cmd key and clicking on each layer. Open the Layer options menu in the Layers panel and select Collapse Layers

File Compatibility

Photoshop to Painter 12	
Adjustment layers	Effect ignored, opens as an empty layer
Alpha channels	Compatible
Layer	Compatible
Layer blend modes	The modes which open correctly are: Normal, Dissolve, Darken, Multiply, Lighten, Screen, Overlay, Soft Light, Hard Light, Difference, Hue, Saturation, Color and Luminosity. All other layer blend modes will change to Default.
Layer effects	Ignored
Layer masks	Compatible
Layer groups	Compatible
Smart layers	Converts to normal layer
Text layers	Converts to normal layer

Painter 12 to Photoshop	
Alpha channels	Compatible
Dynamic Plug-in layers	Converts to normal layer
Layer	Compatible
Layer Composite Methods	The Methods with identical names in both programs stay the same, the methods specific to Painter change as below: Gel to Normal Colorize to Color Reverse Out to Normal Shadow Map to Multiply Magic Combine to Lighten GelCover to Normal
Layer groups	Compatible
Layer masks	Compatible
Liquid Ink layers	Converts to normal layer
Mosaics	Converts to normal layer
Text layers	Converts to normal layer
Watercolor layers	Converts to normal layer

Tools

Photoshop	Painter 12	Comments
Eyedropper	Dropper	Same usage
Hand	Grabber	Same usage but has an additional tool to rotate the canvas
Move tool	Layer Adjuster	Same usage
None	Selection Adjuster	Photoshop has the command under the Select menu
Rectangular Selection	Marquee	Same usage

Some Useful Keyboard Shortcuts in Painter 12

Change Brush Size	Ctrl/Cmd+Alt/Opt and drag in the document, the circle shows the brush size
Increase Brush Size (Incremental)	Square Brackets—Left (The incremental amount can be set in Preferences>General)
Decrease Brush Size (Incremental)	Square Brackets—Right
Change between active documents on screen	Ctrl/Cmd+Tab
Select All	Ctrl/Cmd+A
Deselect	Ctrl/Cmd+D
Copy	Ctrl/Cmd+C
Paste	Ctrl/Cmd+Shift+V (pastes into the center of the layer)
Paste in Place	Ctrl/Cmd+V (pastes in the same place as original)
Save	Ctrl/Cmd+S
Save As	Ctrl/Cmd+Shift+S
Incremental Save	Ctrl/Cmd+Alt/Opt+S
Undo	Ctrl/Cmd+Z
Re-Do	Ctrl/Cmd+Y
Tracing Paper	Ctrl/Cmd+T
Adjust Brush Opacity	Numbers on keyboard i.e., 2 for 20%

Remember that you can change any keyboard shortcut and create your own in the Edit>Preferences>Customize Keys

Setting up Preferences

There are a number of important and useful settings to be found in the Edit>Preferences menu, the preferences are split into several panels.

General

The General heading has just two options you may wish to change: Create Backup on Save creates an extra copy of each file; personally I don't use this as I save regularly and find all the extra files a nuisance. Brush size increments control the amount of increase or decrease in brush size when the square brackets keyboard shortcut is used.

Interface

There are some important options here, the Cursor Type changes the appearance of the cursor on screen, I use the default, but you may want to try some of the other options. The Default or Full Screen view option is here, I usually prefer the Full Screen view. Also here are the Toolbox display options; it is worth trying a few layouts to see what suits you best.

Performance

In this dialog box the number of steps of 'undo' that Painter will remember is specified. The decision on the number to set will be based largely on the amount of RAM that is installed on the computer. The higher the number, the more flexible the undo is, but the downside is that this uses more memory as Painter remembers all the undo steps. Painter 12 now allows the number to go to 255, but you will need a computer with a lot of memory to make full use of this!

Quick Clone

The Quick Clone has some important options which reflect the new way that Painter 12 handles cloning.

Close Source Image: Painter 12 no longer requires you to keep the source image on screen as it copies the original to memory and clones from that. You can keep this ticked unless you need to alter the original during cloning.

Open Clone Source Panel: I find this useful to have on screen.

The other options, Clear Canvas, Turn on Tracing Paper and Clone Color I usually leave ticked but I untick the Switch to Cloner Brushes option.

Customize Keys

For those people, like myself, who use keyboard shortcuts a lot the Customize Keys option is superb. It allows shortcuts to be made for all the main functions in Painter and you can also change the default ones if you wish. It is particularly useful if you use another program, such as Photoshop for instance, as you can use the same shortcuts in both programs.

FIG 3.50 The Customize Keys panel.

To bring up the dialog box, go to Edit>Preferences>Customize Keys; Figure 3.50 shows the dialog box. It is all very easy to follow, but here is an example of how to make a shortcut for the Revert option (which has the function key F12 in Photoshop).

Open the dialog box and click on the plus sign to the left of the word File, this will bring up the list of commands in the File menu. Highlight Revert and as you will see there is no shortcut allocated to it. Press the F12 key to set this as the shortcut, make any more shortcuts in the same way then press OK to accept all the changes you have made. It is that simple.

As well as commands in the menu bar, keyboard shortcuts can be set for the panel menus and tools. Change the option in the Shortcuts dialog box to access the other areas.

The changes you have made will be saved for immediate and ongoing use, but if you have to reload the program they may be lost, you can therefore save your own set by pressing the save icon. You can also save and load different sets for specific types of usage.

Using a Wacom Tablet

A graphic tablet with a pressure-sensitive stylus is a must to obtain the full potential from the brushes in Painter. Wacom are the leading brand of tablets and have a large range from small to very large sizes. I use both the A5 (6 × 8 inch) and A4 sizes; the A5 is large enough to have ample room for brush strokes yet does not take up too much space on the desktop, while the A4 is great for detailed work. You can set up the button configuration for your pressure-sensitive pen once the software has been installed on your computer, the controls can be accessed via the Control Panel for Windows or in System Preferences on Mac computers.

All the brush and opacity settings used throughout this book are for use with a graphic tablet. If you are using a mouse you may need to reduce the specified opacities quite considerably.

FIG 3.51 Wacom Intuos tablets. *Picture ©Wacom Europe.*

Brush Tracking

Brush Tracking is a control within Painter to adjust the sensitivity of the pen to suit your own hand. In the Edit menu go to Preferences and select Brush Tracking.

Make a few sample strokes pressing at various intensities in the Scratch Pad as in Figure 3.52, and Painter will automatically adjust the pen sensitivity to your own hand pressure. It is good practice to make strokes using variations in pressure and speed which is comfortable to ensure you get the full range of both. It is also a good idea to revisit the brush tracking frequently as at different times you may feel differently, with more or less pressure, faster or slower, so if you go into this and make a few strokes to let Painter know how you are feeling it will react better to your hand at any given time.

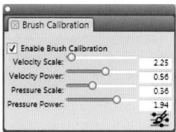

FIG 3.52 The Brush Tracking panel in the Preferences and the Brush Calibration panel.

Brush Calibration for Individual Brushes

It is often preferable to use a different pressure or sensitivity when using a different brush and Painter 12 has introduced a new brush calibration facility to allow this. When set, this sensitivity setting will override the global settings for that brush only.

Select the brush and go to Window>Brush Control Panels>Brush Calibration. Tick the check box, click the icon bottom right and the brush tracking panel appears, this is the same dialog as the one via Preferences.

Make a few sample strokes pressing at various intensities in the Scratch Pad and Painter will automatically adjust the pen sensitivity to your own hand pressure for that particular brush.

You can also adjust the sliders to fine tune the settings.

Customize Workspace

The ability to create and save custom workspaces and to share created workspaces with other people can be very useful. For more advanced users this can be particularly useful when you want to do a particular type of work, for instance you may want to create a workspace for cloning pictures in which you have particular papers or brush libraries on view while others are hidden.

FIG 3.53 Naming a new workspace.

To create a new workspace, arrange the palettes and tools how you want them, go to Window>Workspace>New Workspace and give your new workspace a name (Figure 3.53). You can also import and export workspaces via the Window>Workspace menu.

There are several different workspaces available to download for Painter 12, see the 'What's New in Painter 12' chapter for more information.

Printing Preparation

Sharpening

Before printing it is usually necessary to sharpen the picture. This can be done in Painter by going to Effects>Focus>Sharpen. Select the Gaussian option, as this generally gives the best result, and adjust the sliders.

The amount controls the overall level of sharpening while the other two sliders restrict the sharpening to either the highlights or the shadows. The tick boxes will also restrict the effect to one of the three color channels.

FIG 3.54 The Sharpen dialog.

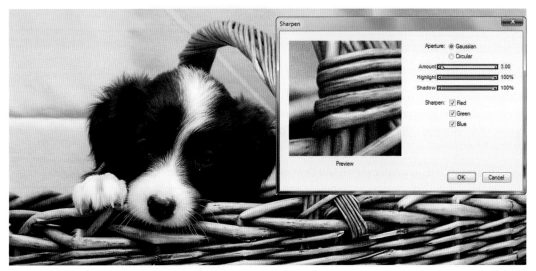

The amount of sharpening required will vary from picture to picture and often is not required at all. I prefer to keep the sharpening to a minimum as over-sharpening can easily ruin a fine picture.

The best way to apply sharpening is at the very end when the picture is finished, make a new copy of the file and give it a different name (add sharpened to the file name). Drop all of the layers if necessary and make a copy of the canvas (Select>All, Edit>Copy, Edit>Paste in Place) and sharpen that layer. Adjust the layer opacity to reduce the sharpening if required.

The amount of sharpening will also depend on the file size, the print size and the surface being printed on. The larger the file and print size the more sharpening will normally be required. If you are printing on a textured finish such as canvas the sharpening can be stronger than on a smooth paper. It is impossible to give specific amounts for these so experience and test prints are the way to learn how much sharpening needs to be applied.

Preparing to Print

When you are ready to print you need to check the printing dpi and set the dimensions. Go to Canvas>Resize and the current sizes of the image are shown, as in Figure 3.56. In this example the picture will print at 7.29 × 4.57 inches at a resolution of 240 dots per inch (dpi).

To print this at a larger size without changing the file, tick the Constrain File Size box and change the dimensions to the size you want to print.

To print go to File>Print and the printer dialog box will appear where you can set the paper size and printing options, this dialog box will vary depending upon the operating system and printer you are using.

FIG 3.55 Page Setup dialog.

Increasing the File Size

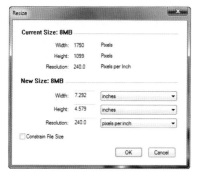 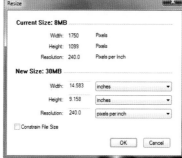

FIG 3.56 Increasing the file size.

If the resolution drops too low you may need to resize the file; in this case remove the tick from the Constrain File Size box and enter the new print size, you will see that in Figure 3.56 increasing the print size to 14.58 × 9.15 inches will increase the file size from 8 mb to 30 mb. The resolution required for printing will vary considerably depending on what size and which surface you are printing on, 240 dpi is a good resolution for an inkjet printer, but you can use less than this, particularly if you are printing on a textured art surface.

There are other ways in which to resize the picture, Photoshop has more sophisticated ways of doing this and there are many independent programs such as Genuine Fractals which can be purchased which have a wider range of options.

FIG 3.57 Increasing the canvas size.

Adding Space Around a Picture

There are times when you would like to add extra space around a picture and this is where Canvas>Canvas Size is needed. Add the number of pixels you want to add to each size and white space will be added.

Color Management

What is Color Management?

Color management is a process that lets you predict and control color reproduction, regardless of the source or destination of the image. For example, a monitor displays a different set of colors than those that a printer will reproduce, so you may see colors on your screen that cannot be printed. If you want to reduce color discrepancies, you should use color management to ensure a more accurate color representation when an image is viewed, modified, or printed.

FIG 3.58 Spyder 3 – one of several devices to calibrate your monitor or printer.

During the digital imaging process, different tools are used to capture, modify, and print images. In a typical workflow, you capture an image by using a digital camera, upload the image to a computer, modify the image in a photo editing application and then use a printer. Each of these devices has a different way of interpreting color. In addition, each has its own range of available colors (called a color space) which is a set of numbers that define how each color is represented. One number in the color space of a digital camera may represent a different shade in the color space of a monitor. As a result, when an image moves through the workflow, the colors get lost in translation and are not accurately reproduced. A color management system is designed to improve the communication of color values in the workflow.

A color management system uses color profiles to translate the color values between the various devices; this ensures more accurate color reproduction in the final print. Color profiles contain the data that the color management system requires to translate colors. Many generic color profiles are available for different brands of monitors, scanners, digital cameras and printers.

Profiling your Monitor

This is the first step to managing your colors correctly; unless you know that what you are seeing on your screen is correct then you are unlikely to get the correct colors on your print. Devices such as the Spyder and Eye One are available at a modest cost and will do the job very well.

Profiling your Printer

Each printer and every different paper needs to be profiled separately, but although you can purchase equipment for creating these profiles they unfortunately tend to be rather expensive and there are other ways to obtain profiles. You could get a specialist company to make the profiles for you, but one of the cheapest methods is to check the website of the paper or printer manufacturer, often they will have downloads available for the specific printer/paper combination required. These are generic profiles; this means

that they are based on your printer as manufactured, but not on your personal printer which may vary from machine to machine.

Many inkjet paper suppliers will produce color profiles for you and this is an excellent option as the resulting profile will be specific to your computer/printer. In many cases this is provided at low cost or in some cases for nothing, provided you use their paper.

Color Management in Painter 12

Before starting work in Painter you should set up the color management options in Painter available from the Canvas menu. The dialog box can be seen in Figure 3.59 and the main options are discussed below.

Default RGB profile: If you are planning to print your pictures on an inkjet I would recommend that you choose Adobe RGB (1998), rather than the default sRGB, as this has a wider color range. However, if your camera uses sRGB and you only show your pictures on the web, then the default may be better. The CMYK setting is usually only used for commercial use so your commercial printer will advise you which option to use.

FIG 3.59 The Color Management settings.

The next set of options defines what happens when you open an existing picture in Painter, I would recommend leaving these boxes on the default settings unless you have a reason for changing them.

The same applies to the final two options, if you want to understand more about Rendering Intent you can find more in the Painter Help files.

Viewing the Effect of Profiles

Soft-Proofing

Soft-proofing lets you generate an on screen preview of what the image will look like when it's reproduced. This technique simulates the 'hard-proofing' stage in a traditional printing workflow. However, unlike hard-proofing, soft-proofing lets you look at the final result without committing ink to paper. For example, you can preview what the printed image will look like when a specific brand of printer and paper is used.

FIG 3.60 The Color Proofing dialog plus the drop down list of profiles.

To see what your picture will look like when printed go to Canvas>Color Proofing Settings and in the Simulate Device box select the color profile for your own printer and paper combination (Figure 3.60). As mentioned earlier, to use this facility you must have obtained profiles for your printer and installed them in your system. You will need a different profile for every type of paper you use with each printer. If you have ticked the Turn on Color Proofing Mode box, as soon as you click OK your picture will be shown as a close approximation of how it will look when printed. You can turn this preview on and off by clicking Canvas>Color Proofing Mode. If you use this regularly I suggest you assign a keyboard shortcut to toggle this on and off quickly.

The examples in Figure 3.61 show the difference between the version on the left and the one on the right which shows the effect of the profile, in this case a low contrast art paper. With the limitations of printing this may not be apparent in the book, but you can try it for yourself to see the difference.

FIG 3.61 Soft Proofing, the one on the right is simulating the profile.

Applying and Changing Profiles

Under the Canvas menu are two options for handling profiles.

The **Assign Profile** option allows you to assign a profile to a document which has none, for Painter to handle colors correctly it is better for all documents to have profiles. The dialog box gives you the option to use the default profile or to select a different one (Figure 3.62).

FIG 3.62 Assign Profile dialog.

The **Convert to Profile** option allows you to change a document to a different profile or rendering intent. Remember that changing the assigned profile will change the colors permanently (Figure 3.63).

FIG 3.63 Convert to Profile dialog.

FIG 3.64 Viewing the same texture at different screen enlargements.

Problems with Printing Textures

A well-selected texture can considerably enhance the final appearance of a picture; however, it can also spoil the picture if applied incorrectly. The main problem is trying to assess how the picture and texture will actually print, often the picture will look really good on screen, but when printed it will look quite different. There are a number of reasons for this and it is worth bearing the following issues in mind when deciding upon a paper texture.

Viewing on Screen

One of the biggest barriers to deciding on a texture is the difficulty of assessing the result on the computer screen.

The reason for this problem is that the computer screen is made up of a fixed number of pixels so when we try to show the whole picture on screen it can only show as many pixels as the screen resolution. All the other pixels in your file will be hidden. This does not normally cause a problem, but when a regular pattern such as a paper texture is applied the screen pixels interact with the pixels in the picture and can create an interference pattern.

To avoid this problem you need to view the picture so that each pixel in the file is shown as one pixel on screen. This can be done by going to Window>Actual Size or by using the keyboard shortcut Ctrl/Cmd+Alt/Opt+0 (zero). This will show how the texture will look more accurately, the problem then is that you can see only a small part of the picture, particularly if you are using a large file.

Although it will not completely solve the problem, one way to avoid some of these problems is to stick to certain enlargement ratios; you will get less interference patterns when you use 75%, 50% and 25% views.

One final word on the subject of screen viewing, these interference patterns are only a screen based artefact, they will not actually print unless you can see them at Actual Pixels size in which case they probably will.

How File Sizes Affect Paper Textures

The actual size of the picture on which you apply the texture will, to a large degree, determine the size of the paper texture which you choose in the Papers panel. In Figure 3.65 the Linen Canvas texture has been applied to two pictures, one is a 62 mb file and the other is just 4 mb. As you can see, the texture is very overpowering on the 4 mb picture but barely visible on the other. Another variation here is that the illustrations have been printed in this book at another resolution so the effect may not show correctly, but the difference should be apparent.

How Print Sizes Affect Paper Textures

The size at which the final picture will be printed will also affect the texture. If you are using a canvas texture then the texture should ideally be somewhere close to the size of a real canvas texture. Looking at the two pictures in Figure 3.65 it should be obvious that to print the 4 mb file up to an A3 (16 × 12 inch) size would result in the print having a texture which is too coarse and distracting, quite apart from the issues of the quality of a small file.

FIG 3.65 Texture applied to a 4 mb file (left) and a 62 mb file (right).

Resampling Files with Paper Textures

When you have a small file which you need to print larger than originally anticipated it is often useful to resample the file upwards to improve the print quality. However, a word of warning, should you plan to do this with a picture that has a paper texture applied, don't! In nearly all cases it will result in unsightly lines in the print due to the pattern being repeated, rather like the screen examples shown. If possible you should resample the file upwards and then apply the paper texture afterwards, which is why I recommend that you apply textures on a copy layer or duplicate image.

Choosing Brushes

When faced with the hundreds of brushes which come with Painter, how do you know which one to choose? This large chapter devotes two pages to every brush category in Painter 12 and can be used as a valuable reference for when you are unsure about which brush to use for a particular painting.

Each two page layout contains:

An overview of the brush category.

A finished picture made with brushes from the brush category.

An abridged step by step example of how it was created.

Examples of eight different variations from the category.

In addition to the abridged step by step instructions included in this chapter, there are more detailed instructions with many additional illustrations available from the website. I recommend that you use these in preference to the ones in the book. The files are in pdf format and can be viewed on screen or printed for reference. The step by step instructions amount to over 100 additional pages of instructions and illustrations. In addition, the printed brush samples in the book are duplicated in the pdf which allows them to be viewed on screen at a much larger size. The original photographs for all these pictures are also on the website so that you can follow the instructions exactly.

Painter 12 for Photographers.
© 2012 Martin Addison. Published by Elsevier Ltd. All rights reserved.

Selecting Brushes in Painter 12

Before you start checking the brush categories, it is worth being aware of the terminology used in Painter to describe each brush. The category and variant name will usually give a good idea of what to expect, so this is a brief overview of what the names mean.

First Select the Category

The category name gives the first clue, most of them are easily recognizable, airbrush, oil, watercolor, chalk, pencils, and they speak for themselves. Variants such as Chalk and Conte have hard finishes and are good for picking up paper textures.

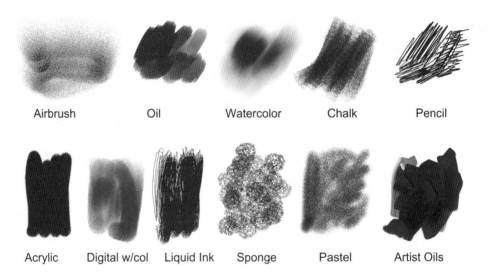

Airbrush Oil Watercolor Chalk Pencil

Acrylic Digital w/col Liquid Ink Sponge Pastel Artist Oils

Understanding the Shape

These are also fairly obvious; flat, round, square, tapered, pointed, thick, calligraphic and so on. Another way of recognizing the shape is to check the dab preview in the Brush Selector which will show you the basic shape of the brush.

Flat Round Square Tapered Pointed Thick Calligraphic

Now for the Texture

The texture has a major impact on the appearance of the brush and the examples below show the main types. Look out for variants named Greasy and Smeary, these will smear the photograph, painting in a similar way to blenders. Camel hair brushes are very smooth while Glazing brushes are set up to paint very gently without hiding what is underneath. The Resist brushes are unique to the Liquid Ink category and are used to protect areas which are not to be painted over. Impasto brushes add a shadow to the brush strokes in order to give a three-dimensional appearance, while Markers are flat and solid.

| Bristle | Soft | Greasy | Camel | Glazing | Smeary |

| Grainy | Marker | Splatter | Impasto | Sparse | Resist |

Blenders for Smoothing and Mixing

There are many diffusers and blenders in various categories and they each have different ways of blending existing paint or imagery in your picture.

When the description says Grainy, then the mix will take on some characteristics of the paper texture currently selected; the Oily and Directional blenders will pull the paint in a particular direction. A soft finish will result from using blenders such as Just Add Water and ones with Soft in their name.

Grainy Oily Soft Rake Directional Add Water Grainy Oils

Acrylics

The Acrylics brush category contains some very useful brushes, many of which display strong brush strokes. The Captured Bristle is one of the most useful brushes in Painter; using it in Grainy Hard Cloning Method at a reduced opacity (say 10%) will give a light but distinctive texture based on the selected paper, while in Clone Color mode, the same opacity will give an attractive smeary finish; try cloning with Clone Color first and then bringing back detail by changing to Grainy Hard Cloning Method. Six of the brushes from the Painter 11 Artist Oils category have been moved into this brush category, including the two examples at the bottom of the facing page.

FIG 4.2 Old building, York.

Open 'York Street Scene' and make a Quick Clone. Select the Acrylics>Captured Bristle brush, size 90 opacity 100%. Open the General Panel and change the Method to Cloning and the Subcategory to Grainy Hard Cover Cloning. Change the Grain setting to 10%. Select the Charcoal paper from the Papers panel and brush lightly over the main building, leaving the edges white. Reduce the brush size to 20 and paint over the main house, following the lines of the timber beams; if you paint across the black and white panels this brush will smear the black over the white. Don't paint the areas outside of the old building, leave the edge light to emphasize that the house is the main subject.

Full step by step instructions for this picture are on the website.

82

Captured Bristle - Grainy Hard Cover Cloning Method

Captured Bristle - Clone Color

Real Wet Brush - Clone Color

Real Long Bristle - Clone Color

Wet Soft Acrylic - Clone Color

Wet Soft Acrylic - Grainy Hard Cover Cloning Method

Wet Brush - Clone Color

Thick Acrylic Bristle - Clone Color

Airbrushes

Airbrushes used non-digitally often give an ultra smooth finish to an illustration, and for the photographer this is perhaps too smooth and realistic, it is more interesting to use the textural finish of this brush category as shown in the picture below. Airbrushes like Graffiti and Pepper spray give a very rough finish while the Variable Splatter is the most striking and can be utilized to help enhance texture in the background of a picture. Soft airbrushes, which include the Soft Airbrush, Fine Tip Soft Air and the Fine Detail Air, are very smooth. There are six new Digital airbrushes in Painter 12 which paint like the Airbrush in Photoshop.

FIG 4.3 The Old Bible.

This is a very simple and quick picture to make. Make a Quick Clone and select the Broad Wheel Airbrush, size 127 opacity 37%. Click the Clone Color option in the Color panel. Lightly paint over the central parts of the picture to establish the outlines. This brush will spray paint outwards in the direction that your pressure-sensitive pen is held. Use this characteristic and hold the pen inside the area of the book and spray outwards. Change to the Graffiti brush, size 128 and opacity 48%. Click the Clone Color option. Brush over the book to bring more detail to the text. Change to the Fine Spray brush, size 52 and opacity 44%. Click the Clone Color option in the Color panel. Paint over the book to increase the clarity.

Full step by step instructions for this picture are on the website.

Broad Wheel Airbrush - Clone Color

Coarse Spray - Clone Color

Digital Airbrush - Clone Color

Fine Tip Soft - Grainy Hard Cover Cloning Method

Fine Spray - Clone Color

Graffiti - Clone Color

Variable Splatter - Clone Color

Fine Detail Air - Grainy Hard Cover Cloning Method

Artists

This brush category is unusual in the sense that it does not represent a range of brushes of one type, but rather includes a small selection of brushes designed to work in the style of some great painters. Probably the most appealing brush is the Impressionist brush and the picture below was created with this brush, it has a very distinctive texture which emphasizes brush strokes and can be used for many types of picture.

The Sargent brush is ideal for the early stages of a clone, when you want to break up the photographic texture completely and replace it with a mass of rough strokes.

FIG 4.4 Tomatoes.

The Impressionist brush was used for this group of tomatoes and it has given the picture a very strong sense of depth and texture.

Create a Quick Clone and select the Impressionist brush, size 92 and opacity 100%. Click the Clone Color option in the Color panel.

Paint loosely over the tomatoes, leaving the outer area blank.

Change the brush size to 38 and paint over the tomatoes individually, following the shape of the tomatoes and the spaces between them.

Use a size 18 brush to emphasize the stalks and the edges of the tomatoes.

The Impressionist brush is an easy brush to use, but at smaller sizes such as those used in this picture it does take quite a while to complete.

Full step by step instructions for this picture are on the website.

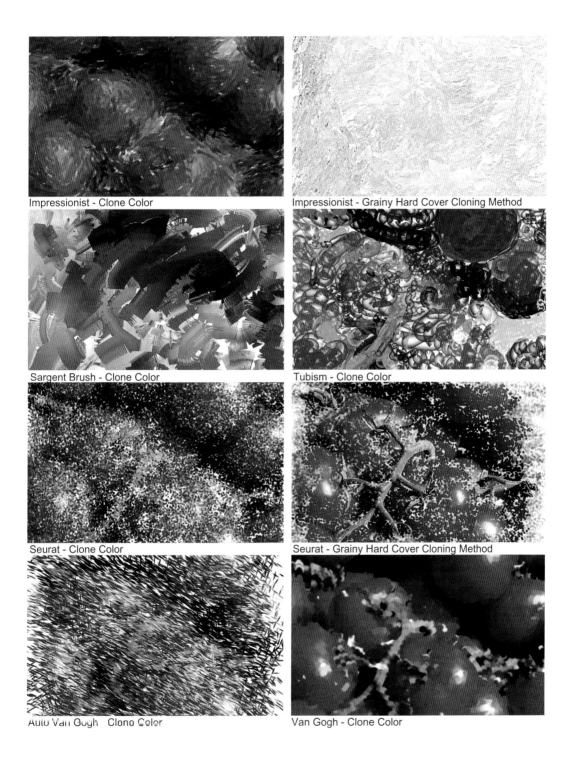

Impressionist - Clone Color

Impressionist - Grainy Hard Cover Cloning Method

Sargent Brush - Clone Color

Tubism - Clone Color

Seurat - Clone Color

Seurat - Grainy Hard Cover Cloning Method

Auto Van Gogh - Clone Color

Van Gogh - Clone Color

Blenders

The Blenders category contains some really useful brushes and they can all be used successfully on photographs. They are not cloning brushes and should be used to paint over photographs leaving a textured finish.

The range is quite wide and contains brushes that will blend softly and others that will create textures which look like oils, pastel and watercolor. Although this category has been created to bring together a range of blenders, there are actually many more scattered throughout the other categories. It is also worth remembering that many regular brushes can be changed into blenders by reducing the Resaturation value to zero and increasing the Bleed value.

FIG 4.5 Blue Pot and Agave.

Create a clone copy and select the Water Rake size 4.5, the opacity will be 100% throughout. Paint the blue background by making short strokes at angles to each other which will create a brushy texture. Paint the plant leaves using various brush sizes between 1.6 and 2.5 depending on the width of the stalk. When painting the stalks it helps to turn the canvas on one side, do this by clicking and holding the Hand symbol in the Toolbox, this will change to a turning icon, then click and drag in the picture to turn the canvas around. Double-click in the center to return to normal orientation.

When painting the panel on the left use brush size 2.5 and follow the colors with the brush, making lots of small movements again to create texture.

Full step by step instructions for this picture are on the website.

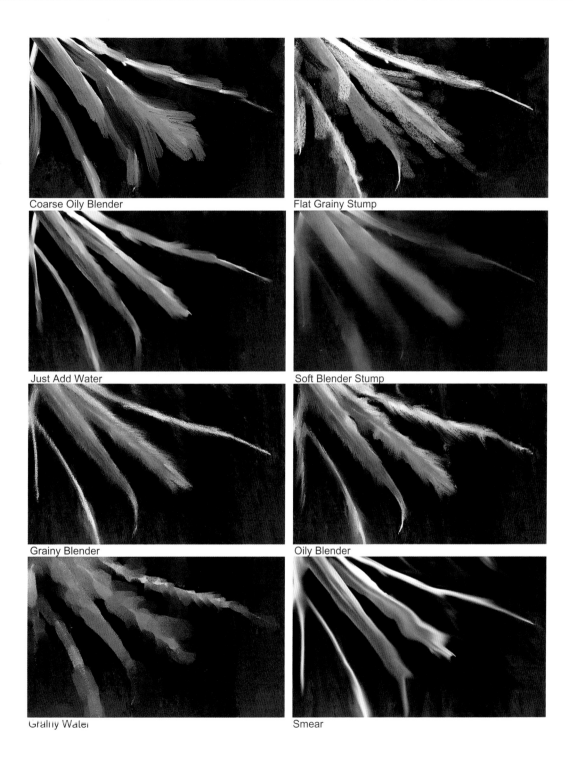

Coarse Oily Blender

Flat Grainy Stump

Just Add Water

Soft Blender Stump

Grainy Blender

Oily Blender

Grainy Water

Smear

Chalk and Crayons

The Chalk brushes are particularly useful for showing the paper texture; the Square Chalk brush is my favourite in this category. All the brushes will work in Clone Color mode and also in Grainy Hard Cover Cloning Method, it is generally necessary to reduce the opacity and reduce the Grain slider to bring out the grain.

Crayons are very difficult to use as cloners because they all use Build-up Method which makes the brush strokes darker as they overlap. You will find that they go to black extremely quickly. The way around this is to change the Method to Cover, which makes them much more manageable.

FIG 4.6 Cathedral Quarry.

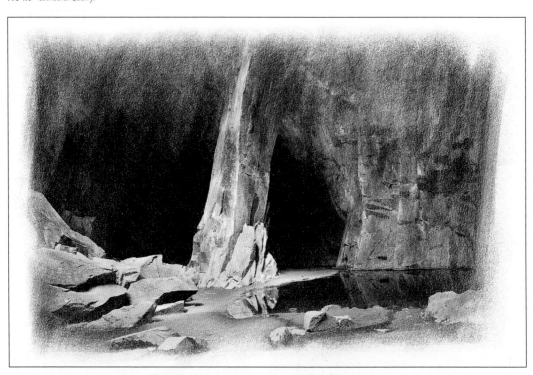

Make a Quick Clone. Select the Charcoal Paper and the Square Chalk brush, size 150 and opacity 33%. Change the Method to Cloning, the Subcategory to Grainy Hard Cover Cloning and the Grain to 7%. Add a texture to the paper. Effects>Surface Control>Apply Surface Texture. Select Paper in the Using box and make the Amount 30%. Paint the picture leaving the edges clear, at this opacity and grain setting everything will be fairly light. Create a new layer and increase the Grain slider to 9%. Paint from the center of the picture gradually bringing in more detail. Follow the lines of the rock, the greatest density should be around the rock support in the center. Create another new layer and increase the grain to 10% and paint the center again.

Full step by step instructions for this picture are on the website.

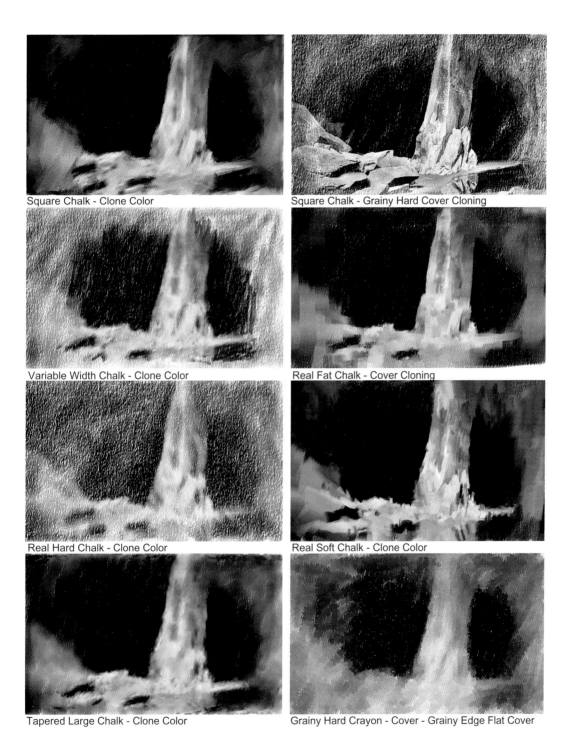

Square Chalk - Clone Color

Square Chalk - Grainy Hard Cover Cloning

Variable Width Chalk - Clone Color

Real Fat Chalk - Cover Cloning

Real Hard Chalk - Clone Color

Real Soft Chalk - Clone Color

Tapered Large Chalk - Clone Color

Grainy Hard Crayon - Cover - Grainy Edge Flat Cover

Charcoal and Conte

In traditional painting Charcoal is usually just black with shades of gray and the examples shown here are just that; however, this being Painter you can of course use these brushes to clone in full color from photographs. In many ways they are similar to the Chalk category in that they are excellent at picking up a paper texture. When used in Clone Color mode it is hard to resolve fine detail, but they do produce some really good rough textures. All the brushes will work in Grainy Hard Cover Cloning method but the brushes do not vary very much in texture. The three Conte bushes work in a similar way to the Charcoal brushes.

FIG 4.7 Trees in charcoal.

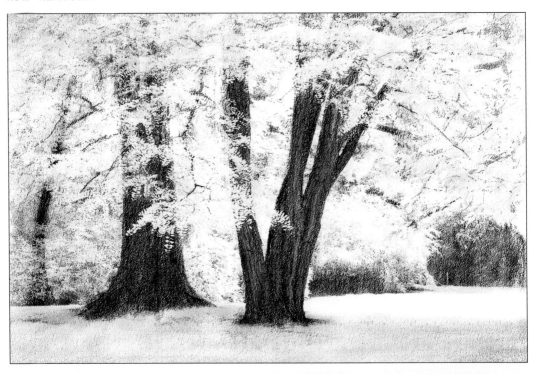

Make a Quick Clone and select the Charcoal brush, size 72 opacity 100% and grain 10%. In the General panel change the Method to Cloning and the Subcategory to Grainy Hard Cover Cloning. Choose the Rough Charcoal paper and paint over the tree trunks to get a good density. Switch to the Soft Charcoal brush, size 78 and change to the Grainy Hard Cover Cloning. Make the opacity 17% and grain 15%. Clone the rest of the picture; this will be softer and lighter than the trunks. Use the Sharp Charcoal Pencil (also in Grainy Hard Cover Cloning method) size 24 opacity 100% and Grain 10% to paint over the tree trunks and smaller branches to darken them further. Return to the Soft Charcoal brush and paint over any areas that require more detail.

Full step by step instructions for this picture are on the website.

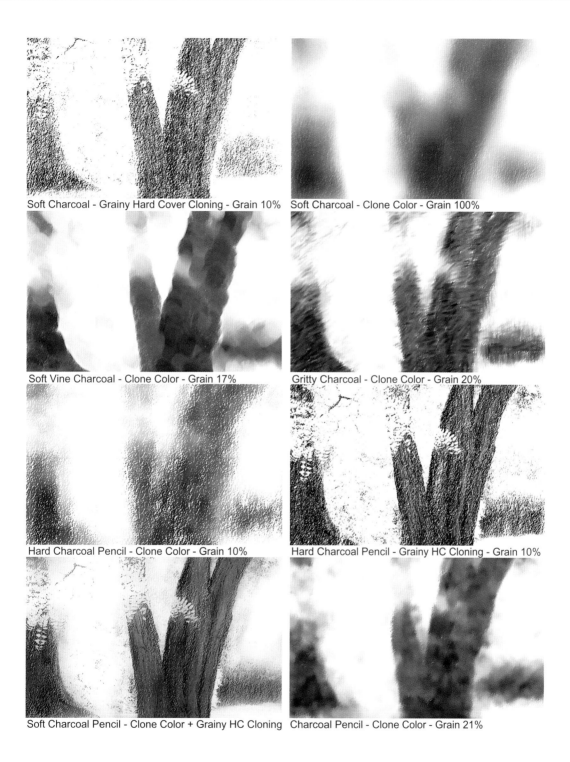

Soft Charcoal - Grainy Hard Cover Cloning - Grain 10% Soft Charcoal - Clone Color - Grain 100%

Soft Vine Charcoal - Clone Color - Grain 17% Gritty Charcoal - Clone Color - Grain 20%

Hard Charcoal Pencil - Clone Color - Grain 10% Hard Charcoal Pencil - Grainy HC Cloning - Grain 10%

Soft Charcoal Pencil - Clone Color + Grainy HC Cloning Charcoal Pencil - Clone Color - Grain 21%

Cloners

If you are new to Painter, this is the ideal place to start cloning from photographs. All the brushes in this category have been created specially for cloning and will work well without any modification. There is a wide variety of finishes, brushes like the Bristle Brush Cloner, Wet Oils Cloner and the Thick Bristle Cloner will drag out the color into attractive textures, they will also react differently depending on the speed at which the brush is moved; try moving the brush fast and it will smear the image, move it very slowly and the clone will appear very clearly. The Soft Cloner is used regularly in conjunction with other brushes to return some detail to a picture.

FIG 4.8 Chickens.

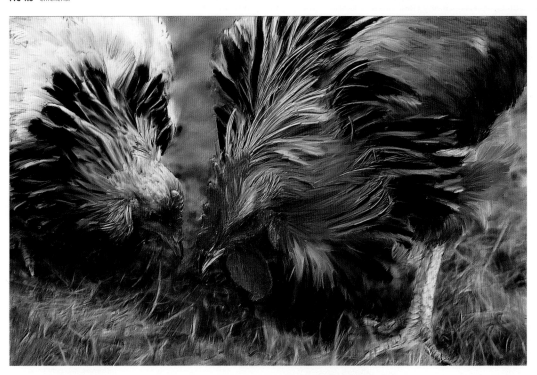

Make a Quick Clone and select the Wet Oils Cloner, brush size 29 opacity 39%. Create a new layer and paint the chickens with the brush strokes tracing the lines of the feathers. Create a new layer and place it under the layer just painted. Change to the Chalk Cloner size 68 opacity 20% and paint the grass; because this is below the top layer you can paint quite freely without affecting the birds. Change the layer opacity to 80%. Create another new layer on top of the previous one, and using the Wet Oils Cloner, size 27 opacity 6%, paint a rough texture over the grass. Create a further layer, just under the chickens' layer and reduce the Wet Oils cloner to size 10 opacity 100% and paint in some tufts of grass.

Full step by step instructions for this picture are on the website.

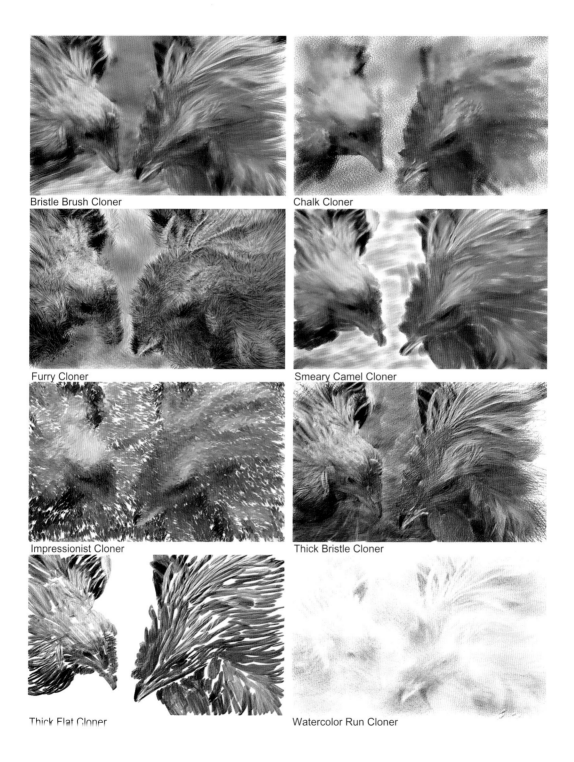

Bristle Brush Cloner

Chalk Cloner

Furry Cloner

Smeary Camel Cloner

Impressionist Cloner

Thick Bristle Cloner

Thick Flat Cloner

Watercolor Run Cloner

Digital Watercolor

When used for painting rather than for cloning these brushes give a beautifully gentle watercolor finish with wonderful translucent colors. Sadly, when used as cloners the effect is lost and at the default settings many of the brushes are harsh and hard to use. The key to using them as cloners is to reduce the opacity right down and to bring in detail by using smaller brushes. The Dry brushes are the easiest to use with photographs as they give a very attractive texture. Several of the blenders will also work as cloners and can give a strong feeling of watercolor, although it is often difficult to resolve much fine detail.

FIG 4.9 Arabian Horse.

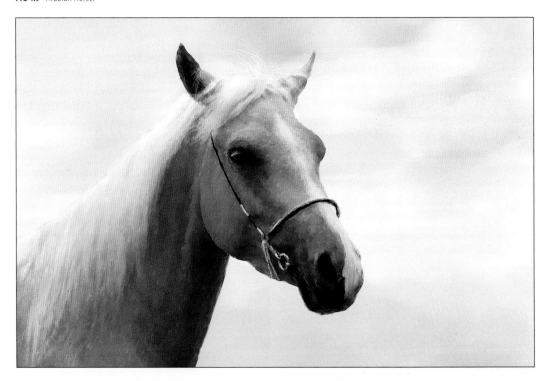

Make a Quick Clone and select the Dry Brush, size 242 opacity 11%. Make a new layer on which to paint the background colors. Choose a very light blue in the Color panel and paint the sky with horizontal brush strokes. Add some white to indicate clouds then paint a light green for the grass. Switch off the visibility of this layer for the moment. Make a new layer, use the Dry Brush again, size 19 opacity 65%, and this time click the Clone Color option in the Color panel. Paint the horse, and then reduce the brush to size 6 opacity 100% and paint the harness. Switch to the Flat Water Blender, size 8.2 opacity 9% in clone color mode and blend in any rough areas. Return to the Dry Brush, size 7 opacity 100% to refine details.

Full step by step instructions for this picture are on the website.

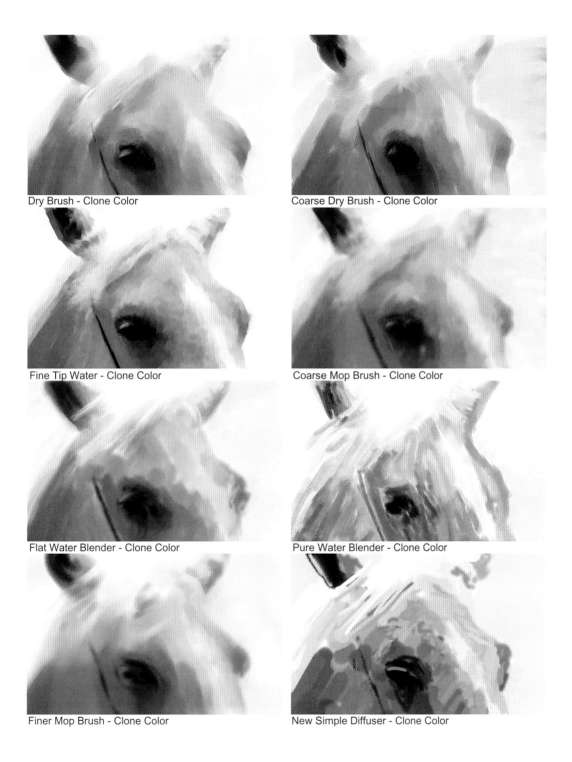

Dry Brush - Clone Color

Coarse Dry Brush - Clone Color

Fine Tip Water - Clone Color

Coarse Mop Brush - Clone Color

Flat Water Blender - Clone Color

Pure Water Blender - Clone Color

Finer Mop Brush - Clone Color

New Simple Diffuser - Clone Color

Erasers

The Erasers are primarily for correcting brush marks made in error and for removing unwanted areas. For the purposes of these examples however, I have looked at the creative possibilities for using erasers for tonal changes and textural overlays. As you can see, they can be used to lighten areas in order to give the picture a very light appearance.

When using the tapered erasers, directional lines can easily be introduced, while the 1 pixel eraser can create a distressed finish. Should you be using a Paper Color other than the default white, you need to remember that erasers will erase to paper color while bleaches always go to white.

FIG 4.10 Tulips.

In Figure 4.10 the eraser has been used to delicately remove all darker areas and lighten the whole picture to create a soft, high key image.

Make a Clone copy and select the Gentle Bleach eraser, size 310 opacity 10%. Using a graphic tablet paint very gently over the picture, concentrating on the outer areas. The whole picture should become much lighter and delicate, but you will find that the yellow at the base of the picture is not affected much by the eraser, so switch to the Erase All Soft eraser, size 234 opacity 6% and gently lighten that area. You need to be careful about burning out any areas to white. Should this happen, change to the Soft Cloner, size around 245 opacity 3% and clone back in from the original picture.

Full step by step instructions for this picture are on the website.

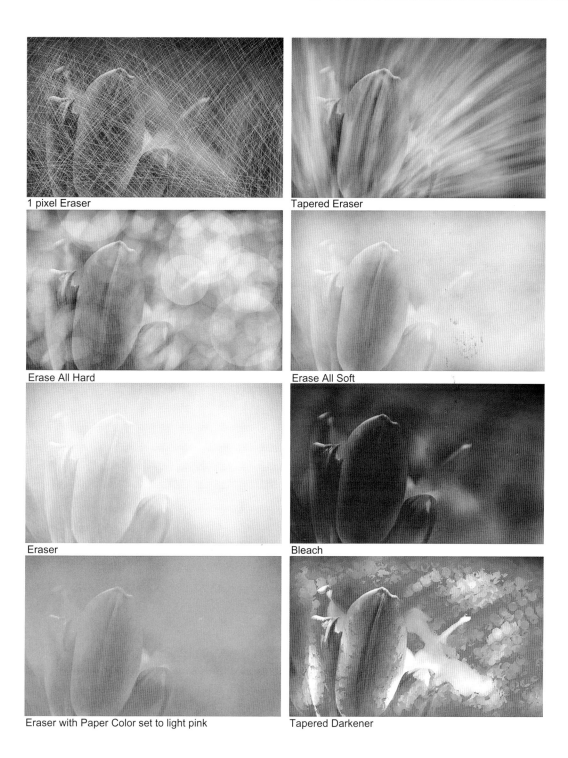

1 pixel Eraser

Tapered Eraser

Erase All Hard

Erase All Soft

Eraser

Bleach

Eraser with Paper Color set to light pink

Tapered Darkener

F-X

As the name indicates, this brush category has lots of special effect brushes and now includes the brushes from the Distortion category. Two of the most attractive and fun ones are the Furry Brush and Hair Spray, these spray out colors from the picture using an airbrush effect. You will find that some of the brushes act as cloners, while others have to be used directly on the picture.

Fairy Dust is a useful brush for adding highlights to a picture, use at low opacity for a subtle result. The Hurricane and Distorto brushes pull and push the image into wild shapes, while the Diffuser can add a subtle softness if used at low opacity.

FIG 4.11 Starry Tulip.

Open 'Tulip' and make a Clone. Select the Diffuser brush, size 35, strength 25%. Paint over the whole flower, following the lines of the petals, this should soften the picture and gently pull the shapes.

Select the Distorto brush, size 15 opacity 0%, gently pull the edges out and also the petals within the flower. Drag the red markings into the white.

Use the Thin Distorto, size 12 strength 100% to drag out some of the edges a bit further. Make a new layer and then choose the Fairy Dust brush, size 38 opacity 80%. Select White in the Color panel and paint stars across the picture, brushing outwards from the center. Create another new layer and add more stars using a larger brush.

Full step by step instructions for this picture are on the website.

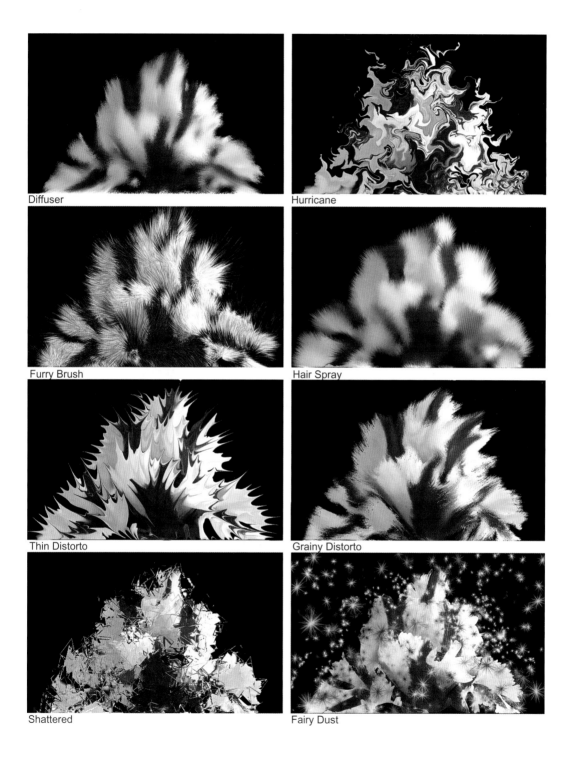

Diffuser

Hurricane

Furry Brush

Hair Spray

Thin Distorto

Grainy Distorto

Shattered

Fairy Dust

Gel

The Gel brush category is new in Painter 12 and the brushes are extremely useful for tinting existing images with color. The default settings allow you to paint tints very easily, for example to warm a face, choose a very light red in the Color panel and paint directly on the image. Alternatively, paint on a layer above and use the Gel Layer Composite Method.

The brushes also use the new Merge Modes which use the same Composite Methods that are available for Layers, such as Lighten and Darken; this gives a lot of flexibility. Used as cloners the brushes are not particularly successful, although the Gel Fractal creates lovely textures suitable for backgrounds.

FIG 4.12 Alert.

Make a Quick Clone. Select the Gel Fractal brush, size 150 opacity 100%. Click the Clone Color option in the Color panel. Paint the blue background very loosely and use the Tracing paper to show you where to paint; try not to paint over the dog. Keep the brush on the paper and paint without lifting the pen; this is to avoid the darker colors when you overpaint. Create a new layer, reduce the brush size to 100 and paint the dog on the new layer.

Create another new layer and swop to the Cloners>Soft Cloner brush, size 130 and opacity 20%. Paint the dog until it becomes clear. To make the background around the dog more solid, create a new layer above the canvas but below the Soft Cloner layer and paint using the Gel Fractal brush.

Full step by step instructions for this picture are on the website.

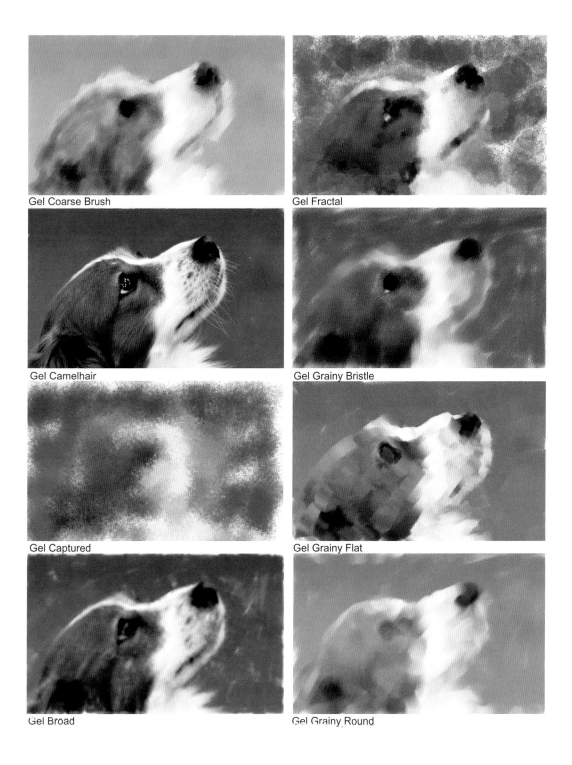

Gel Coarse Brush

Gel Fractal

Gel Camelhair

Gel Grainy Bristle

Gel Captured

Gel Grainy Flat

Gel Broad

Gel Grainy Round

Gouache

The Gouache brushes tend to give rich accurate detail when used as cloners. By reducing the opacity and choosing a suitable paper they will show the paper texture quite clearly. My favourite is the Wet Gouache Round which smears the picture while giving rich colors, as you can see in the picture below. The Feature slider controls how the bristles are separated and increasing the amount will result in the brush marks showing through clearly. The Jitter slider has been substantially increased in the example showing the Detail Opaque brush on the next page, and the result is a very heavily textured finish. The Jitter slider is in the Jitter panel.

FIG 4.13 Hanbury Canal.

Make a Quick Clone and Select the Wet Gouache Round, size 30 opacity 100%. Use the Clone Color option. Clone the picture with the bridge and the surrounding trees, reduce the brush opacity to 13% and clone the lighter trees at the top of the bridge. Continue cloning the remainder of the trees and grass. Keep the brush moving all the time using short strokes in different directions to keep the textures interesting. Increase the brush opacity to 60% and go over the painted areas to bring in more density and detail. Paint the water with the same brush at 60% opacity using horizontal brush strokes. Reduce the brush size to 30 and the opacity to 22% and paint the reflections by making small strokes in a downward direction.

Full step by step instructions for this picture are on the website.

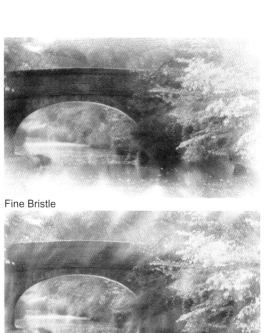

Fine Bristle

Broad Cover Brush - Grain 1% Opacity 1%

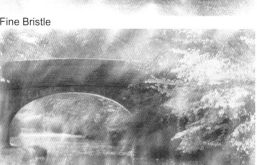

Flat Opaque Gouache - Opacity 4%

Broad Cover Brush - Cloning Method, Grainy Hard Cover

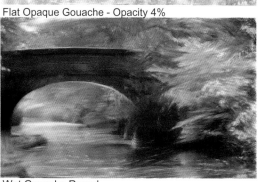

Wet Gouache Round

Wet Gouache Round - Feature 8.8

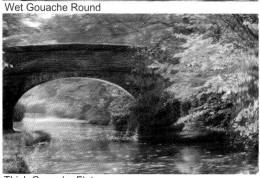

Thick Gouache Flat

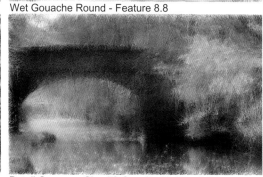

Detail Opaque - Size 52 Opacity 58 Jitter 2.67

Image Hoze

The Image Hoze brush category is unlike any other in Painter, the brush uses images which it sprays onto the canvas in various ways.

The sources for these assembled images are called nozzles. There is a collection included in Painter and they are accessed from the Media Selector. Select the nozzle you plan to use and the Image Hoze brush in the Brush Selector and paint into a document.

The list of brush variants are different ways of applying the images, Linear paints in a line while Spray does exactly what it says. The letters P, R and D refer to Pressure, Random and Direction.

FIG 4.14 Tornado.

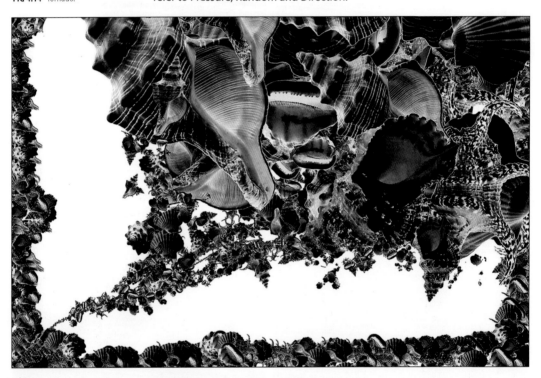

In addition to the Image Hoze nozzles which come with Painter 12 it is also possible to create nozzles with your own images. The picture in Figure 4.14 was created from six photographs of shells, the original photographs are on the website so you can use these to create the picture above if you wish, or you can use your own images. The process of creating nozzles is quite complex but can produce subtle and interesting results. The example created above has been kept quite simple and uses a single rank nozzle. Nozzles can be created with two or three ranks. The steps involved are preparing the original photographs, changing the color to negative, moving the photographs onto layers in a new document, grouping the layers, creating, loading and using the nozzle.

Full step by step instructions for this picture are on the website.

Baby Blue Eyes - Spray-Size-P Angle-B

Gardenias - Spray-Size-P Angle-W

Passionflower Flowers - Spray-Size-P Angle-W

Green Grass Bunch - Spray-Size-W

Paragliders - Linear-Size-P Angle-W

Red Poppies - Spray-Size-P Angle-B

Little Houses - Linear-Size-W

Swallows & Palm Trees - Linear-Size-P

Impasto

Impasto is the term used when paint is applied very thickly and in this brush category all the brushes utilize this feature, but in a variety of ways.

Brushes such as Opaque Flat are normal brushes with the impasto added (this is done by adding highlights and shadows to each brush stroke). Brushes with names like Grain Emboss and Smeary Varnish will work directly on top of photographs to create an embossed effect. The texturizer variants spray on an embossed texture, while Acid Etch does the reverse and cuts into the photograph. Distorto Impasto and Gloopy smear and pull the picture while cloning.

FIG 4.15 Can handle.

This is a very simple picture to make, open the original photograph from the website and make a Quick Clone. Select the Smeary Bristle brush, size 35 opacity 63% and click the Clone Color option. This brush smears the image and at the same time adds a very strong impression of the brush marks and impasto effect. Clone the photograph starting with the handle, follow the lines of the handle using short brush strokes, you will quickly see the effect. Continue with the background, varying the length and direction of the brush strokes to create variety. It is difficult to assess the strength of the impasto effect on screen; the best way is to check the view at 100% enlargement, as less magnified views distort the way the effect is shown.

Full step by step instructions for this picture are on the website.

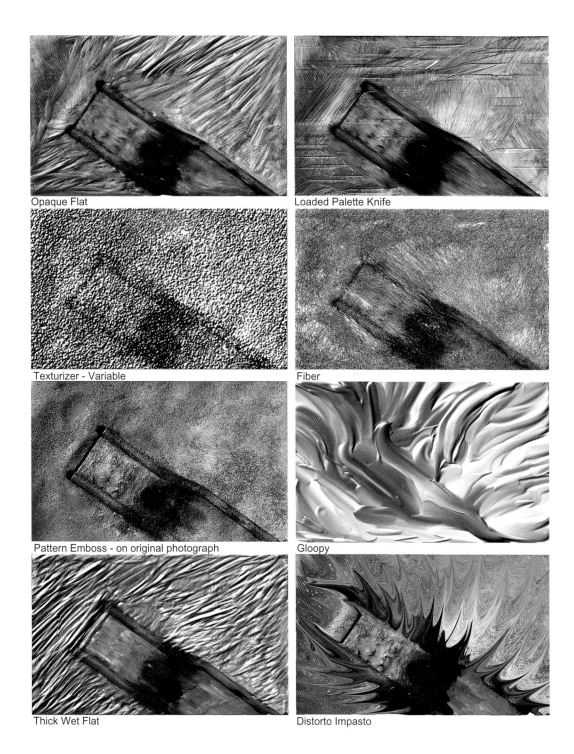

Opaque Flat

Loaded Palette Knife

Texturizer - Variable

Fiber

Pattern Emboss - on original photograph

Gloopy

Thick Wet Flat

Distorto Impasto

Liquid Ink

Liquid Ink is a large group of brushes which replicate the use of ink-based artists' materials. The ink flows very fast and covers the paper quickly and has a graphic appearance.

All Liquid Ink brushes use a special layer and a new Liquid Ink layer is created automatically when you use one of the brushes.

Resist brushes are used to reserve areas where paint is not required, in the same way as masking tape might be used.

Liquid Ink has its own control panel for adjusting the brushes, in particular the amount of ink. If this slider is very high the inks spills over the paper in pools. Try moving some of the sliders and see the result.

FIG 4.16 Handles.

Make a Quick Clone; select the Sparse Bristle brush, size 34.9 opacity 50%. Use the Clone Color option. In common with many of the brushes in this section the brush will have a streaky appearance if you paint lightly. Paint over again and the streaks will disappear, but I prefer the texture, so in this example you will need to paint lightly and leave some white paper showing. Paint the left and right panels first angling the brush strokes to follow the direction of the wood. Continue with the remainder of the wood. When painting the handles allow the brush to spray out over the picture to increase the textural finish.

It is worth experimenting with the sliders in the Liquid Ink panel, they can have a huge effect on the finished picture.

Full step by step instructions for this picture are on the website.

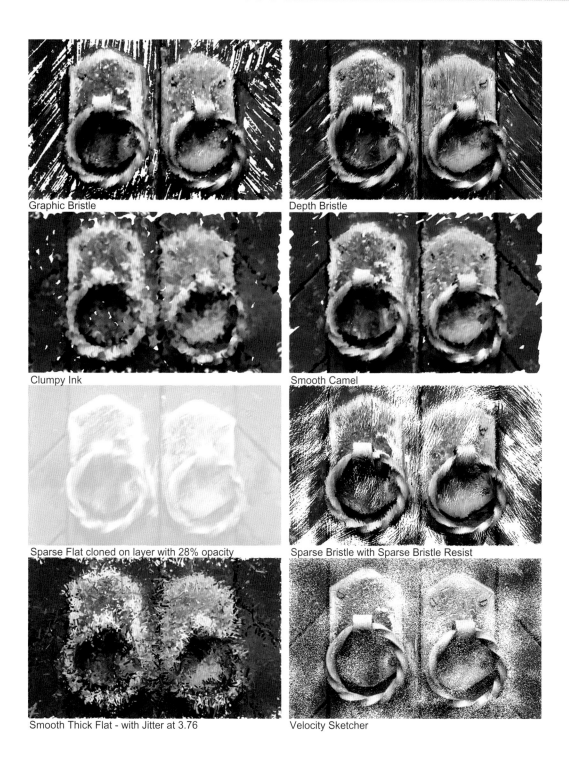

Graphic Bristle

Depth Bristle

Clumpy Ink

Smooth Camel

Sparse Flat cloned on layer with 28% opacity

Sparse Bristle with Sparse Bristle Resist

Smooth Thick Flat - with Jitter at 3.76

Velocity Sketcher

Markers

The brushes in the Markers brush category all feature the properties which you would expect of real world markers; that is, they have flat strokes which build up density when overlapped.

This causes difficulties when used as cloners as each additional brush stroke becomes darker and therefore it is difficult to get a satisfactory clone picture. However, with a bit of perseverance and by altering some settings it is possible to use some of them. In the examples on the right-hand page some of the brushes are on default settings, while others use different settings which can be changed in the General panel.

FIG 4.17 Boots.

Make a Quick Clone. Select the Chisel Tip Marker, size 45 and opacity 30%. Select the clone option in the Color panel. In the General panel, change the Method to Drip and the Subcategory also to Drip. The Drip category makes the brush drag and distort the image. In the Jitter panel move the slider fully to the right, this will break up the image and provide the base for the picture. Paint the whole picture using dabs and short brush strokes.

Make a copy of the canvas (Select>All, Edit>Copy, Edit>Paste in Place).

Return the Jitter slider fully to the left and then in the copy layer paint the boots (brush size 30) following the lines of the picture. With this brush the detail is limited, but the result is interesting and should be easily recognizable.

Full step by step instructions for this picture are on the website.

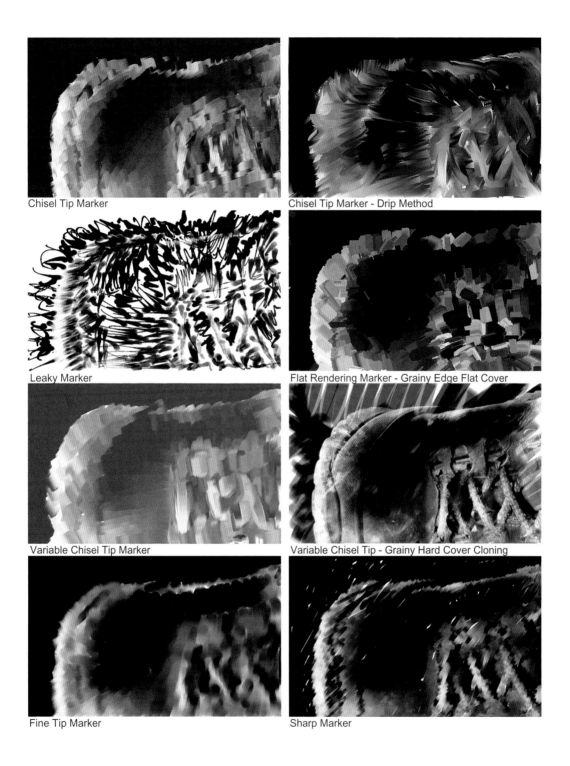

Chisel Tip Marker

Chisel Tip Marker - Drip Method

Leaky Marker

Flat Rendering Marker - Grainy Edge Flat Cover

Variable Chisel Tip Marker

Variable Chisel Tip - Grainy Hard Cover Cloning

Fine Tip Marker

Sharp Marker

113

Oils

The Oils brush category has some very attractive brushes which can be used for cloning photographs. I particularly like the smeary variants, as new brush strokes will merge with paint already placed on the canvas.

The best way to use these brushes for cloning is to paint over the picture first with a smeary brush which will provide the necessary underpainting, then use smaller brushes to bring in more detail. Several brushes such as Thick Oil Flat use an Impasto effect to indicate that a thick paint is being used. All the brushes have that thick, luscious, painterly finish which is the great attraction of traditional oils.

FIG 4.18 Frost on the Malvern Hills.

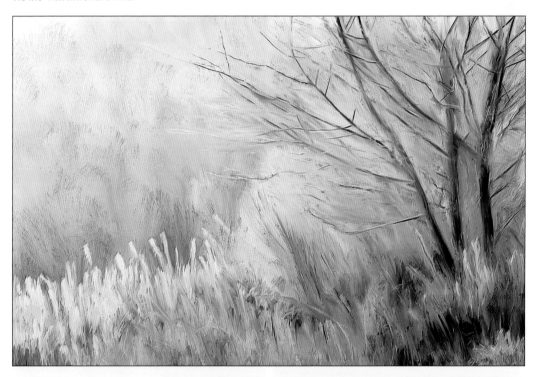

Make a Quick Clone and use the Smeary Bristle Spray size 78 in Clone Color mode to paint over the whole picture, paint downwards on the left then follow the lines of the tree on the right. Change to the Smeary Flat size 32 in Clone Color mode and paint in the seed heads on the left and the grasses at the bottom. Continue with the brush and paint over the branches, following each main branch from the trunk to the end. Use the Bristle Oils brush in Clone Color mode to bring back more detail in the twigs and inside the tree, blend with the Smeary Flat brush at 50% opacity to remove any photographic textures that may be apparent. Return to the Smeary Flat brush size 16 at 100% opacity and paint over the whole of the picture to bring back more detail.

Full step by step instructions for this picture are on the website.

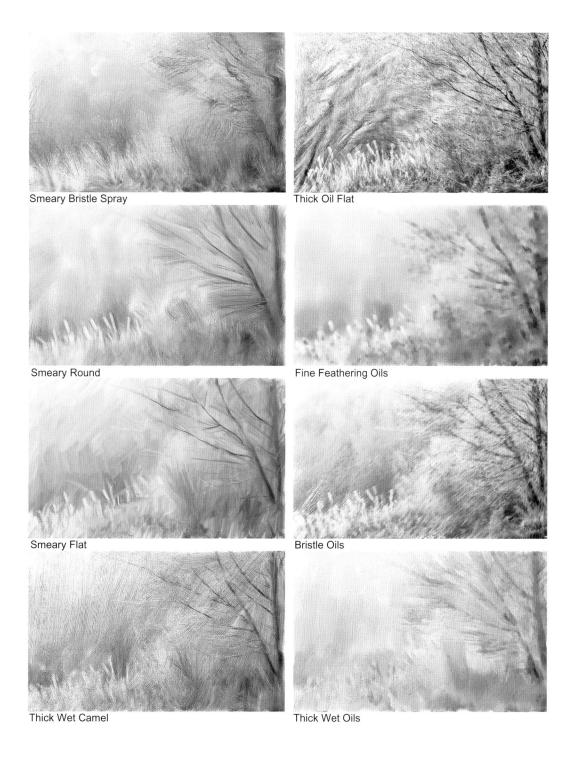

Smeary Bristle Spray

Thick Oil Flat

Smeary Round

Fine Feathering Oils

Smeary Flat

Bristle Oils

Thick Wet Camel

Thick Wet Oils

Palette Knives

This is a small brush category, and in the main the brushes are not ideal for cloning from photographs. The exception is the Loaded Palette Knife which does give a very satisfactory result with some good textures.

All the brushes can be used directly on the top of photographs, in which case they act very much like blenders and can make some great backgrounds prior to cloning in more detail.

Extra depth can be added by changing to Color and Depth in the Impasto panel in the Brush Controls.

FIG 4.19 Rare Breed Hen.

Make a Quick Clone; select the Loaded Palette Knife, brush size 61.4 opacity 30%. Click the Clone Color option in the Color panel. Paint the green background using a variety of brush strokes in different directions. Continue to paint over the top until the background is fairly smooth. Reduce the brush size to 22 and increase the opacity to 100%. Paint the cockerel starting with the head and moving down the feathers. Reduce the brush size to 3.5 and paint the eye. Make the brush size 12.5 and with the opacity still at 100% paint over all the head to bring out detail and definition. Keep the brush moving in the direction of the feathers. Watch out for the feathers which flick out, they need careful painting to keep the shapes correct.

Full step by step instructions for this picture are on the website.

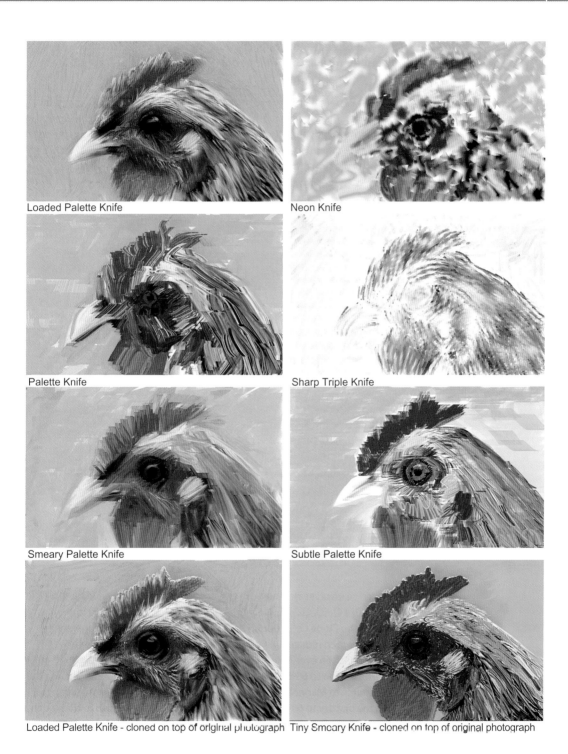

Loaded Palette Knife

Neon Knife

Palette Knife

Sharp Triple Knife

Smeary Palette Knife

Subtle Palette Knife

Loaded Palette Knife - cloned on top of original photograph

Tiny Smeary Knife - cloned on top of original photograph

Pastels

The pastel brushes in this category work very successfully with photographs, the textures are quite beautiful and ideally suited to light delicate pictures such as the one below.

The Artist Pastel Chalk is one of my all time favourite brushes in Painter, but most of the others work extremely well. The hard pastels pick up the paper grain more strongly than the soft pencils, which show the grain primarily on the edges of the brush strokes. I tend to use the Sandy Pastel Paper for these brushes as the gritty texture suits the brush strokes. As the name suggests, the Pencil pastels are for very detailed work.

FIG 4.20 Magnolia.

This picture involves cloning from two separate originals. Open Magnolia A and create a Quick Clone. Select the Square X-Soft Pastel, size 137 and opacity 7%. Click the Clone Color option in the Color panel. Paint the whole picture very lightly then reduce the Resaturation slider to zero and use this as a blender to soften everything. Change the brush size to 30, the opacity to 46% and resaturation to 60%, paint the petals but not the background. Change the clone source to Magnolia B and do the same with that. Reduce the brush size to 8.8 the opacity to 60% and paint over the edges of the petals to clarify the shapes; do this from both originals. Change the brush size to 72 the opacity to 11% and Resaturation to 7%.

Full step by step instructions for this picture are on the website.

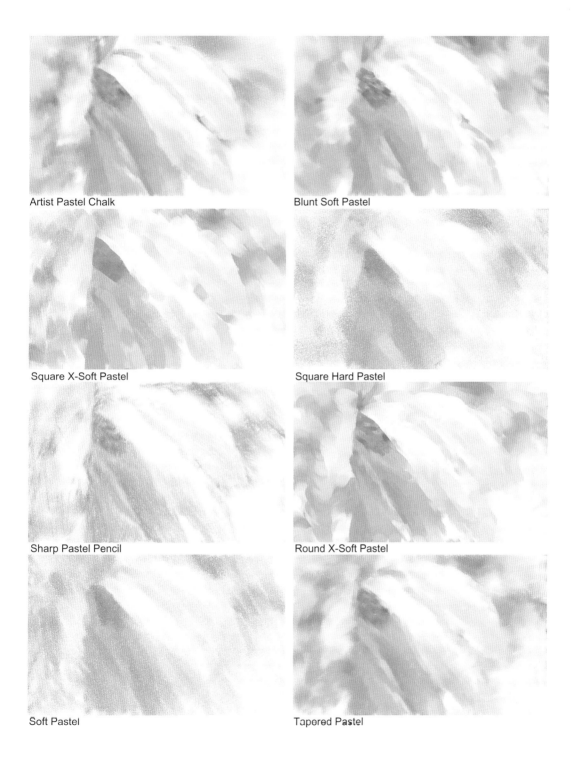

Artist Pastel Chalk

Blunt Soft Pastel

Square X-Soft Pastel

Square Hard Pastel

Sharp Pastel Pencil

Round X-Soft Pastel

Soft Pastel

Tapered Pastel

Pattern Pens

The Pattern Pens use a pattern to paint with, therefore they are of limited use when using direct from photographs.

By default they use the patterns already in the Painter program which can be selected from the Patterns panel, try a few of them as they are quite fun and can certainly be used as part of a design project.

In addition to the default patterns it is easy to make your own from photographs; they can be used for montages or backgrounds. The Pattern Pen Soft Edge is very useful for making backgrounds; capture a subtle pattern and by overpainting at low opacities the result can be very pleasing.

FIG 4.21 Tree fantasy.

Start by creating the pattern to use. Open the file and Select>All. Open the Patterns panel (Window>Media Control Panels>Patterns) and open the panel options menu. Select Capture Pattern, a dialog box opens and asks for a name; leave all the sliders on default settings. In the Patterns panel click on the thumbnail which shows the patterns and from the list select the pattern you have just captured. Now create a new document, File>New and make the dimensions width: 20 cm and height: 13 cm and Resolution 200 pixels per inch. Select the Pattern Pen and paint into the new document, use various sizes. You will immediately notice that if you paint from right to left the trees are vertical while a left to right movement turns the trees upside down.

Full step by step instructions for this picture are on the website.

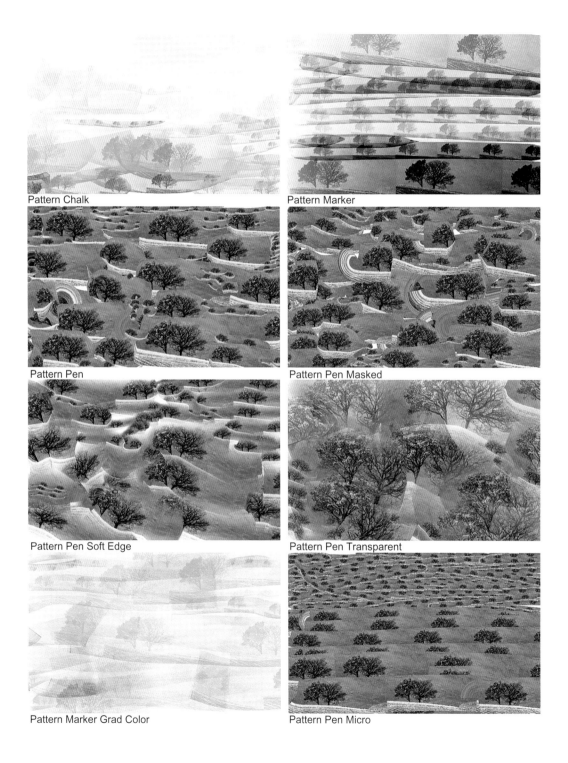

Pattern Chalk

Pattern Marker

Pattern Pen

Pattern Pen Masked

Pattern Pen Soft Edge

Pattern Pen Transparent

Pattern Marker Grad Color

Pattern Pen Micro

Pencils

Whether drawing traditionally or using these pencils in Painter it is likely to take quite a long time to finish a quality painting so you need to bear this in mind. Try using the pencils at a larger size to save time and you will find that the result will no longer look like a pencil drawing.

Although the examples on these pages are in monochrome, you can of course clone from a color original just as easily. The main differences between the pencils are described in their names; greasy pencils will pull the image round while the grainy pencils show the grain well. The old favourite 2B is the equivalent of the traditional pencil.

FIG 4.22 Owl.

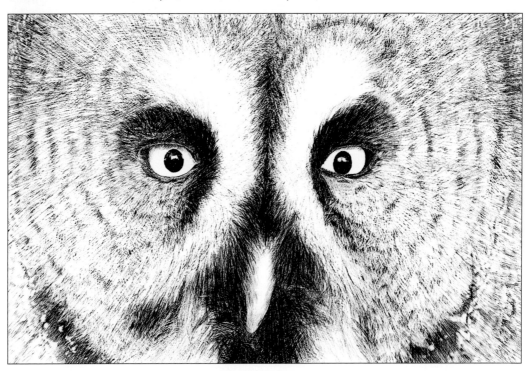

The first step is to turn this picture to monochrome, reduce the Saturation slider in the Underpainting palette to zero. Select the Sketching Pencil, size 3.0 opacity 40%. Use Basic Paper and the Clone Color option. Make a Quick Clone, turn the tracing paper on and clone in the picture. Start below the eye, painting in medium strokes. Turn the Tracing Paper off to get an indication of the textures that are showing and build up that area so that the section is fully cloned.

In the darker areas around the eye you can use crosshatching; this is a traditional technique where lines are drawn across each other to create a dense but not black area. When the eye and surrounding area is done, reduce the brush opacity to 20% and add some shading in the white of the eye. Continue with the rest of the picture.

Full step by step instructions for this picture are on the website.

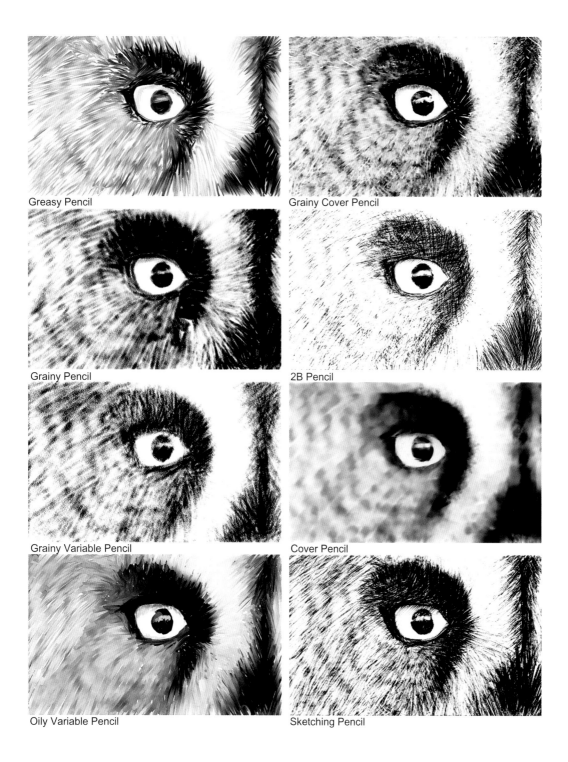

Greasy Pencil

Grainy Cover Pencil

Grainy Pencil

2B Pencil

Grainy Variable Pencil

Cover Pencil

Oily Variable Pencil

Sketching Pencil

Pens

The Pens brush category contains both the Pens and Calligraphy brushes. Neither category is a natural candidate for cloning, but several brushes can be used with some creative work.

The Nervous pen is very useful when cloning water, as the irregular brush stroke is very reminiscent of water ripples. The Barbed Wire pen has a strong fibrous texture and is very useful for creating backgrounds or overlays in montages; this is one pen that also works well at larger sizes. Several of the Calligraphy brushes can be used, the key is to start with large sizes and then to bring in detail with smaller sizes.

FIG 4.23 Olive grove.

Open 'Olive Grove' and make a Quick Clone.

Select the Nervous Pen, size 29 opacity 100%. Paint over the whole of the picture, but leave the edges white. Keep the texture light by moving the pen constantly. This pen is very useful when you want an interesting edge for a picture.

Create a new layer. Select the Dry Ink pen, size 31 opacity 25%. In the General panel change the Method to Cloning and the Subcategory to Grainy Hard Cover Cloning and the Grain to 12%. Paint the tree trunks to bring back some detail and then dab in other areas to allow more detail in the flowers and leaves. Reduce the opacity of the layer to around 75% so that the detail only just shows through.

Full step by step instructions for this picture are on the website.

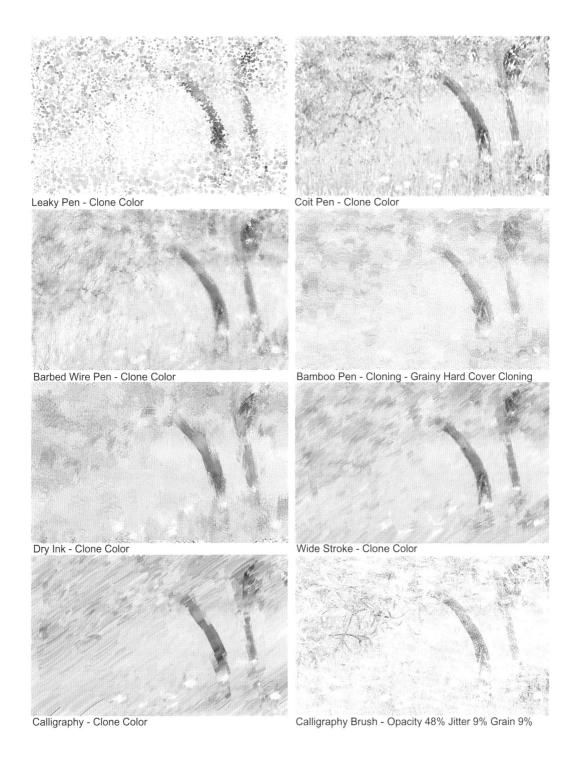

Leaky Pen - Clone Color

Coit Pen - Clone Color

Barbed Wire Pen - Clone Color

Bamboo Pen - Cloning - Grainy Hard Cover Cloning

Dry Ink - Clone Color

Wide Stroke - Clone Color

Calligraphy - Clone Color

Calligraphy Brush - Opacity 48% Jitter 9% Grain 9%

Photo

The Photo brushes are used for adjusting small areas of photographs.

The Burn and Dodge brushes are very useful for lightening or darkening areas, this adds local contrast. There are four brushes which diffuse to varying degrees: Diffuse Blur is the strongest and has a grainy finish; Fine Diffuser works in a similar way but more gently. Blur diffuses in a smooth manner while Scratch Remover can blend imperfections or be used as a small blender. Colorizer changes the color based on the current color in use, Saturation Add is self explanatory, as is Sharpen. Be careful with these last three brushes, as over-application can easily ruin a picture.

FIG 4.24 Motocross rider.

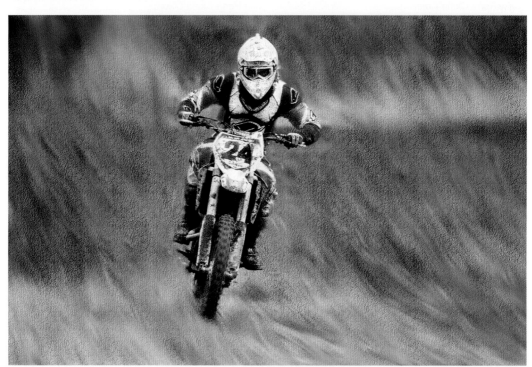

File>Clone. Select the Rough Charcoal Paper in the Paper panel. Select the Diffuse Blur brush, size 85 strength 49% and paint over all the background area. Select the Blur brush, size 42 strength 57%, paint over the blended areas to remove most but not all of the rough texture. Select the Scratch Remover, size 8.5 strength 75%. Use this brush to slightly diffuse the edges of the motorcycle and the rider. Select the Dodge brush, size 45 opacity 3%. Paint over the white areas of the clothing to brighten them. Select the Sharpen brush, size 21.5 strength 2%. Paint over the helmet and parts of the clothing. Select the Saturation Add brush, size 19.6 strength 65% and paint over the eyes and parts of the clothing.

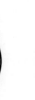

Full step by step instructions for this picture are on the website.

Add Grain

Blur

Burn

Colorizer

Diffuse Blur

Dodge

Saturation Add

Fine Diffuser

Real Watercolor

Real Watercolor is one of the new brush categories in Painter 12 and replicates real world watercolor painting to a much greater extent than the earlier Watercolor and Digital Watercolor categories. There are a wide variety of brushes in the category and I particularly like the Fractal brushes for the beautiful textures which they create. Many of the variants use the Build-up Subcategory and when cloning it often helps to change this to the Real Dry Cover category as this helps to stop the paint building so quickly. The other important control is the Pause Diffusion option on the Properties bar, try this turned off and on to see the difference, I usually prefer it turned on.

FIG 4.25 Parrot tulip.

Open 'Parrot tulip' and select the Dry on Dry Paper brush, size 20 opacity 50%, Grain 80%. Select the Clone Color option and the Pause Diffusion option on the Properties bar. In the General panel change the Subcategory to Real Wet Cover. Select Italian Watercolor paper in the Paper panel. Start painting from the top right, work quickly and make short strokes to fill the area you are painting. Keep the painting fairly loose, follow the lines of color in the flower and make the brush size smaller to paint the narrow lines.

Reduce the brush size to 10 or less for the rest of the picture. Once the paint has dried you cannot paint over it again without making the paint darker and leaving unsightly marks. Continue with the rest of the flower.

Full step by step instructions for this picture are on the website.

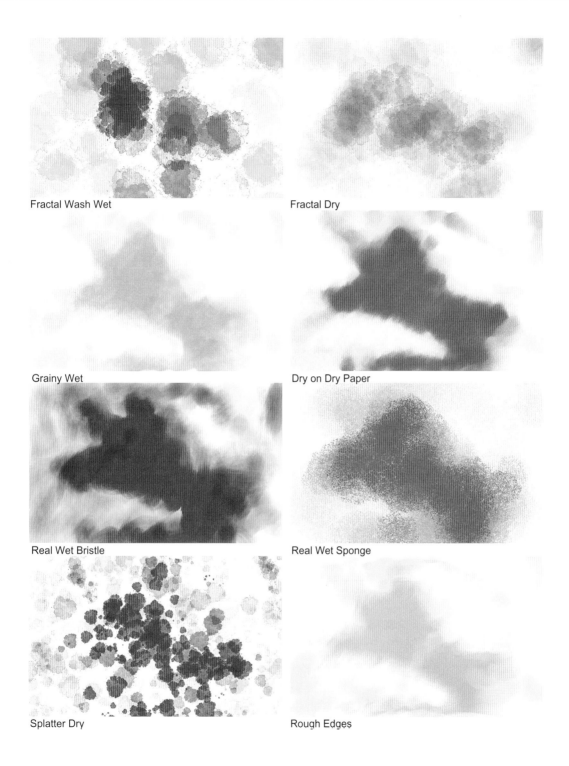

Fractal Wash Wet

Fractal Dry

Grainy Wet

Dry on Dry Paper

Real Wet Bristle

Real Wet Sponge

Splatter Dry

Rough Edges

Real Wet Oils

Real Wet Oils are new in Painter 12 and have the same free-flowing characteristics of real oils. They give a lovely soft texture, especially the wet varieties. They have their own control panel where you can control the paint consistency and movement, and the way the paint interacts with the canvas.

Unfortunately, I have had problems using these brushes for cloning, as after a short time my computers slow to a halt; this has made it difficult to use them. Hopefully they may be faster in later versions of Painter.

FIG 4.26 Magnolia petals.

Open 'Magnolia petals.' File>Clone and select the Real Wet Oil>Wet Oil brush, size 20 opacity 75%, Grain 25%. Click the Clone Color option in the Color panel. Paint over the petals; as you are cloning on the original picture you need to ensure that all areas are covered otherwise the photographic texture may be seen. Leave the center until all the other areas are done.

Reduce the brush size to 6 and paint the individual stamens.

Change the brush size to 20 and opacity to 10% and paint over the petals, blending any rough edges. Increase the brush size to 50 and blend the edges of the petals around the edge of the picture, the edges should be very soft and delicate with the center stamens and surrounding petals showing detail.

Full step by step instructions for this picture are on the website.

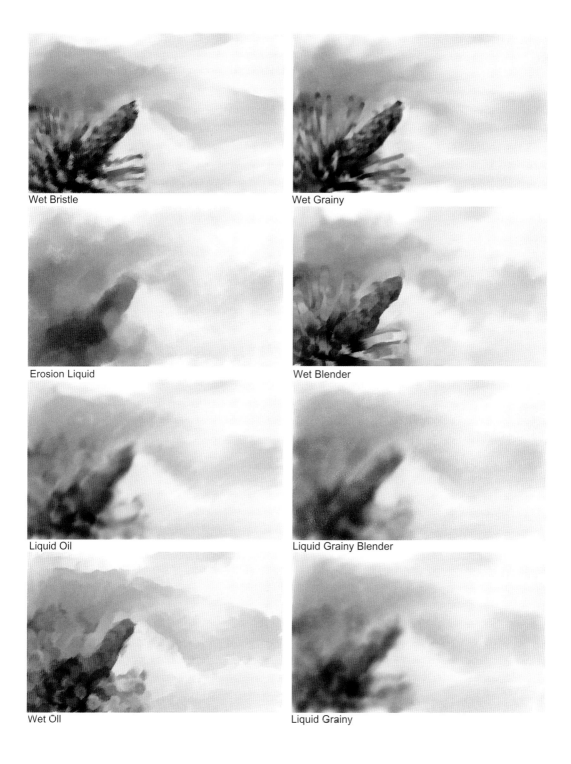

Wet Bristle

Wet Grainy

Erosion Liquid

Wet Blender

Liquid Oil

Liquid Grainy Blender

Wet Oil

Liquid Grainy

Smart Strokes

These brushes have been designed to work with the Auto-Painting system and most of the examples shown on these two pages have been used in that way. They can of course also be used as normal cloning brushes and they all work very well.

The range of variants covers many of the main categories and includes popular types such as Acrylics, Gouache, Chalk and Watercolor.

The Auto-Painting panel can be very useful for creating underpaintings; let the program do the work of creating the basic textures in the painting style you would like and then you can do the more interesting details by hand.

FIG 4.27 Frosted leaf.

Open 'Frosted leaf,' make a Quick Clone and select the Sponge Soft brush, size 100 opacity 100%. Paint over the whole of the picture, this will give a dense texture which will provide a beautiful base on which to clone details from the photograph. Change to the Soft Cloner brush, size 72 opacity 30% and lightly paint in some details, concentrate on the outside edge of the leaf and a few of the larger drops of water on the leaf. Use the Tracing Paper to see where to paint. Go over some other areas of the leaf, this time just dab the detail in by tapping the pen on the tablet or clicking the mouse button. This will give an attractive stippled finish which goes well with the sponge base painting.

Change the brush opacity to 100% and continue to dab within the leaf.

Full step by step instructions for this picture are on the website.

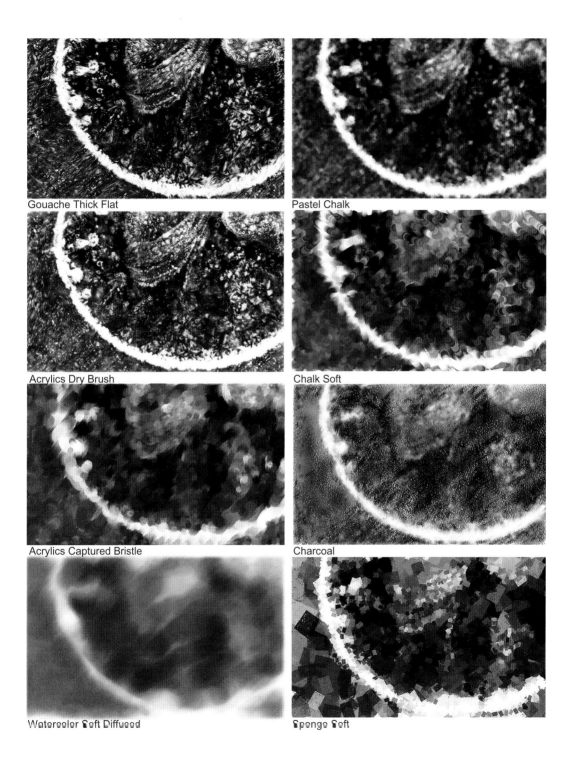

Gouache Thick Flat

Pastel Chalk

Acrylics Dry Brush

Chalk Soft

Acrylics Captured Bristle

Charcoal

Watercolor Soft Diffused

Sponge Soft

Sponges

In traditional painting sponges are often used to dab on wet paint and add a textured finish so they are not obvious candidates for use with photographs; however, they have a very beautiful painterly appearance and they can be used in several ways. The painting below has a very attractive finish and it was created solely with sponges. Other excellent uses are for preparing backgrounds and adding textures to montages which will help create layering effects. The Dense Sponge and the Square Sponge have hard edges but will still give reasonably fine detail if used with small brush sizes.

FIG 4.28 Cherry tree blossom.

The Sponge variant is a good brush for adding texture.

Open 'Cherry Tree Blossom.' Make a Quick Clone. Turn off the Tracing paper as you will not need it for this painting. Select the Sponges>Dense Sponge, size 60 opacity 82%, other settings on default. Click the Clone Color option in the Color panel.

Open the Auto-Painting panel and click the Smart Stroke Painting option.

Start the auto-painting by clicking on the Play button. Allow the auto-painting to continue for a few minutes until all the canvas is covered. Make a new layer. Change the brush size to 30 and run the auto-painting again. Make a new layer. Change the brush size to 15 and run the auto-painting again. You should now have three layers of painting at different brush sizes. These can now be blended using layer masks and layer opacities.

Full step by step instructions for this picture are on the website.

134

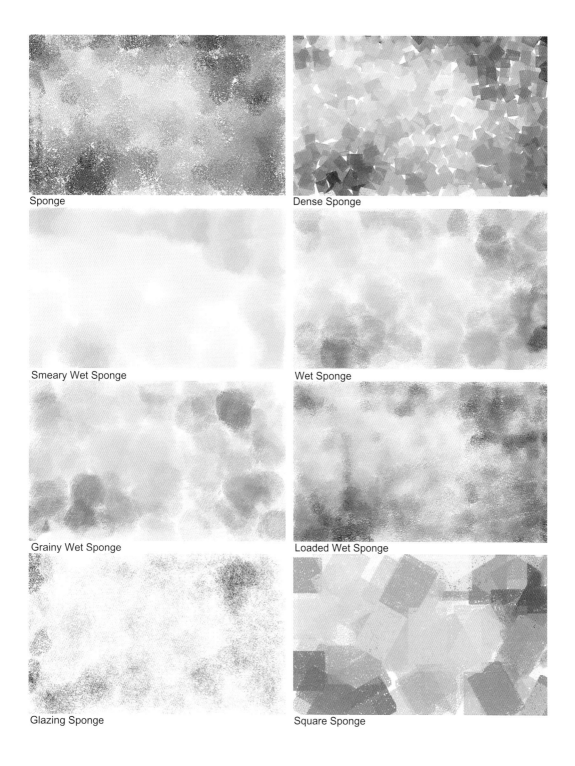

Sponge

Dense Sponge

Smeary Wet Sponge

Wet Sponge

Grainy Wet Sponge

Loaded Wet Sponge

Glazing Sponge

Square Sponge

Sumi-e

Sumi-e is an unusual and distinctive brush which uses the rake dab in most of its variants. The Digital Sumi-e and the Tapered Digital Sumi-e brushes both use a very thin rake stroke to gradually build up the picture. This can take a long time so it is often better to use Auto-Painting to get the bulk of the picture painted and then finish it off by hand.

The Real Sumi-e Dry brush has an excellent texture and is very easy to use. Quite a few of the brushes use the Build-up method which make cloning from photographs very difficult as the brush strokes build very rapidly to black.

FIG 4.29 Birmingham city.

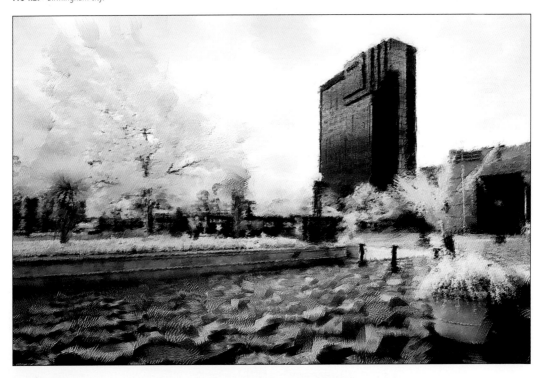

Make a Quick Clone and select the Real Sumi-e Dry Brush, size 123 opacity 77%. Click the Clone Color option. Create a new layer. Open the Auto-Painting panel; leave the Smart Stroke option unticked and choose Zig Zag in the Stroke drop down menu. Start the clone and allow the auto-painting to fill the picture. Fill in any white gaps by painting over them; this should give you a roughly painted picture. Create two new layers and make two more auto-painting versions using brush sizes 61.4 and 30.6. You will now have three versions of the clone, in three different levels of detail. They can now be blended together using layer masks. Create a new layer and clone directly onto this layer by hand to finish the picture.

Full step by step instructions for this picture are on the website.

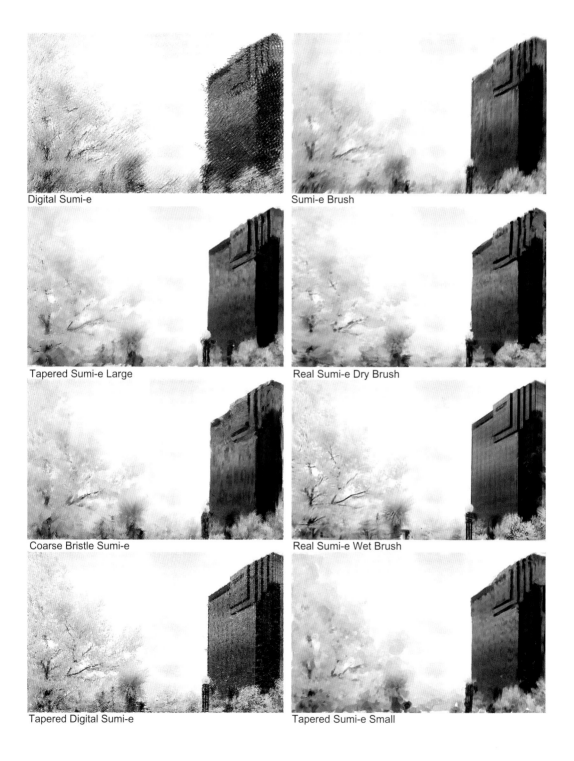

Digital Sumi-e

Sumi-e Brush

Tapered Sumi-e Large

Real Sumi-e Dry Brush

Coarse Bristle Sumi-e

Real Sumi-e Wet Brush

Tapered Digital Sumi-e

Tapered Sumi-e Small

Tinting

The Tinting category is a strange mix of brushes, blenders and erasers. As their name indicates, the brush variants are very suitable for hand-tinting, having low opacities in most cases. Even at these low opacities I still find them too strong for delicate work and have developed a procedure of painting on a layer and immediately reducing the layer opacity to around 25% and then adjusting it as necessary.

In addition to the brushes there are several very useful blenders; the two diffusers are particularly good for softening paint into the canvas, they can of course be used with many other brushes.

FIG 4.30 Cottage in the wood.

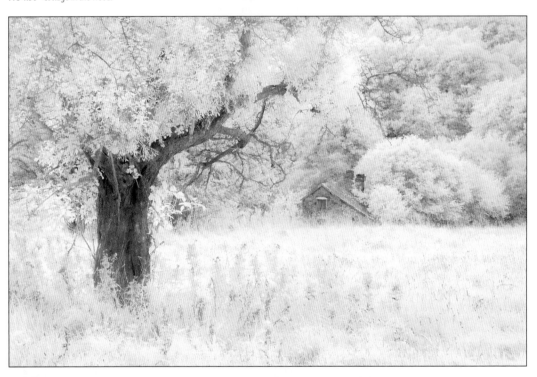

In this step by step the procedure is to paint every element of the picture on separate layers so that the layer opacities can be adjusted at any time. The intended effect is a very soft, gentle coloring and this is achieved by keeping the brush opacity low, reducing the layer opacity and selecting delicate colors from the Color panel. Open 'Cottage in the wood.' Select the Tinting>Hard Grainy Round brush, size 24 opacity 10%. Select the French Watercolor Paper from the Paper panel. Make a new layer; change the Layer Composite Method to Colorize and the layer opacity to 25%. Choose a warm brown color for the grass and paint the lower part of the picture. Continue to make new layers with the opacity and composite methods as above.

Full step by step instructions for this picture are on the website.

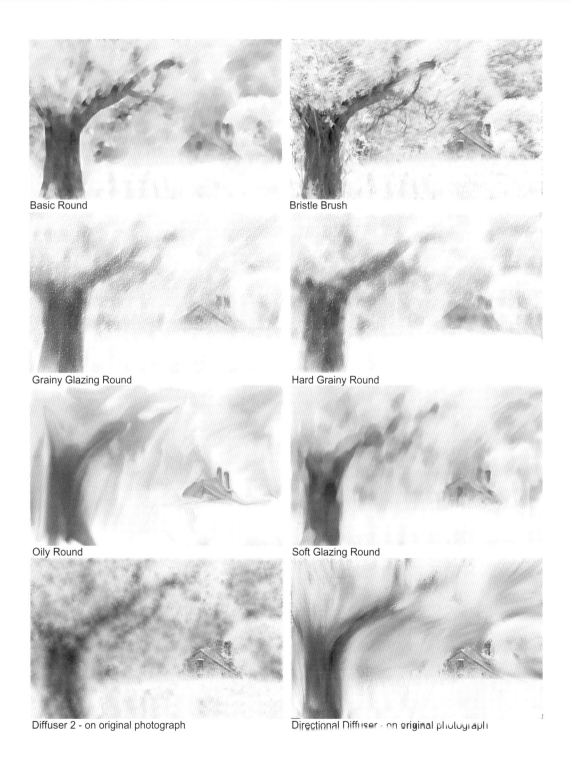

Basic Round

Bristle Brush

Grainy Glazing Round

Hard Grainy Round

Oily Round

Soft Glazing Round

Diffuser 2 - on original photograph

Directional Diffuser - on original photograph

Watercolor

Watercolor is one of the most popular painting styles for artists and this brush category has some beautiful brushes for painting; unfortunately most of them are not very satisfactory for use with photographs. The main problem when cloning is that the brush strokes build to black very quickly at the default settings. One way to avoid this happening is to reduce the opacities right down to around 5%. All the examples shown on the opposite page use between 5% and 10% opacity. Another way to avoid the build-up of color is to paint on multiple layers, this allows the layer opacity to be reduced at any time, see the example below.

FIG 4.31 Clematis.

Open 'Clematis' and make a Quick Clone. Select the French Watercolor paper and the Soft Bristle brush, size 41 opacity 11%. Click the Clone Color option in the Color panel. By using the Tracing Paper as a guide, paint the picture making sure that your brush strokes follow the lines in the flower petals. Paint very lightly and don't overwork any area or it will darken too much. You will notice that this brush works very slowly, even on a modern computer. When you complete an area, create a new Watercolor layer by clicking and holding the new layer icon in the Layers panel and selecting New Watercolor Layer. Continue to paint over the picture on different layers to build up the density very gradually; this may take a long time.

Full step by step instructions for this picture are on the website.

140

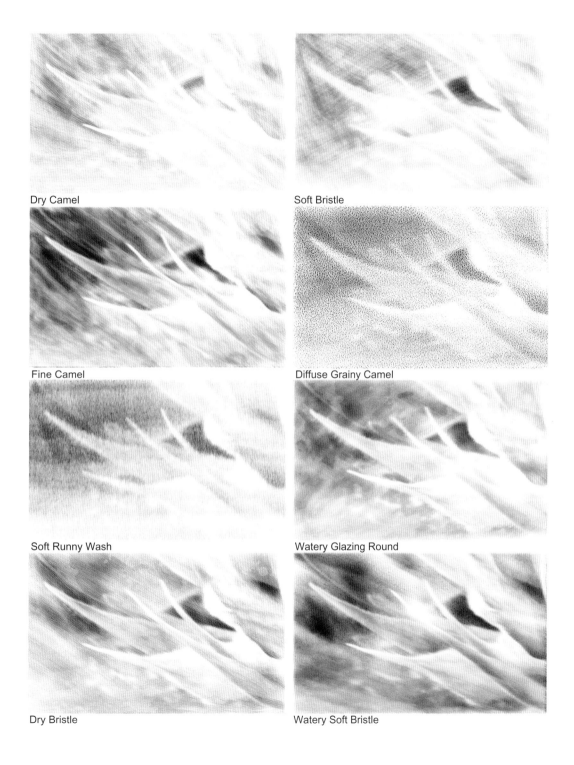

Dry Camel

Soft Bristle

Fine Camel

Diffuse Grainy Camel

Soft Runny Wash

Watery Glazing Round

Dry Bristle

Watery Soft Bristle

Extra Brushes

Painter 12 includes an extra range of brushes as Extra Content included on the program DVD or available to download from the Corel website. Details on how to download and install these brushes are in the 'Customizing Brushes' chapter.

Although I haven't counted them, there are certainly a lot of brushes and there are quite a lot of interesting ones. On the page opposite I have included examples from eight different brush categories. The Fun brushes and Nature brushes are new and worth exploring, most work as cloners. The two examples at the bottom of the page are both used as blenders.

FIG 4.32 Monet's house.

Open 'Monet's house' and make a Quick Clone. Load the String brush category and select the Cool Angled Cloner, size 160 opacity 100%. Click the Clone Color option.

Create a new layer, open the Auto-Painting panel and run the Auto-Painting with Pressure Modulate in the Stroke box. Make another new layer, change the brush size to 80 and run the Auto-Painting again for a few seconds. Repeat again using brush sizes 40 and 20. This will give a mixture of brush strokes. Change the Layer Composite Method of the top layer to Lighten. Use Correct Colors to add some extra contrast and brightness.

Full step by step instructions for this picture are on the website.

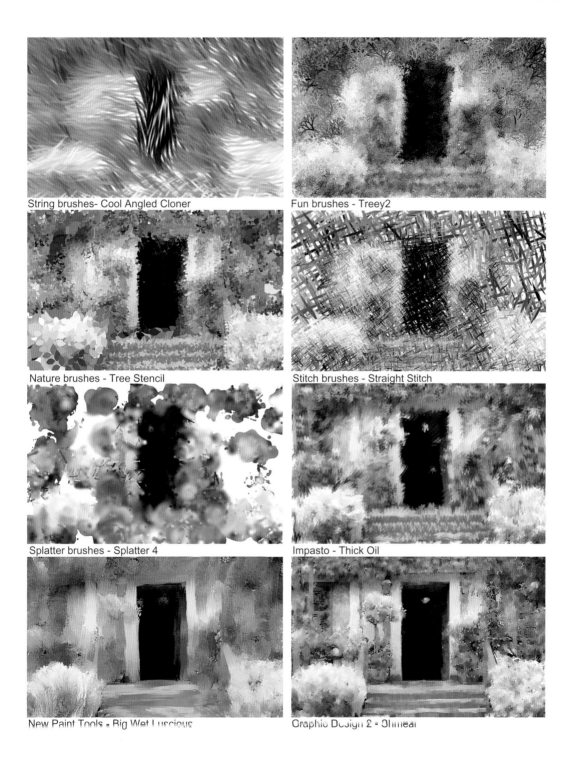

String brushes- Cool Angled Cloner

Fun brushes - Treey2

Nature brushes - Tree Stencil

Stitch brushes - Straight Stitch

Splatter brushes - Splatter 4

Impasto - Thick Oil

New Paint Tools - Big Wet Luscious

Graphic Design 2 - Shmear

Customizing Brushes

The 'Choosing Brushes' chapter looked at the wide range of ready-made brushes available in Painter 12, but even with all these varieties it is still often necessary to customize them to get exactly the brush strokes required.

It is worth remembering that often the only difference between one brush and another is a few settings in the Brush control panels.

The best way to customize a brush is to find one of the standard brushes nearest to the one you want and change some of the options to fine-tune the brush. You can then save the new variant for future use.

In this chapter some of the more useful Brush control panels are explained with examples to illustrate the effect when changes are made. Not all panels are available for all brushes; several, for example Watercolor and Artists Oils, can only be used with those categories.

Painter 12 for Photographers.

FIG 5.2 The Brush control panels and right, the Brush Calibration panel.

The Brush Control Panels

There are 26 brush control panels and the full set is shown in Figure 5.2. These are shown on screen as a set via Window>Brush Control Panels or the keyboard shortcut Ctrl/Cmd+B.

Generally you only need a few of them at any one time. Which you keep on screen depends upon what you are working on.

Brush Calibration Panel

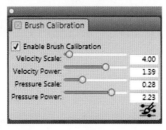

The Brush Calibration panel lets you calibrate individual brush variants to match your stroke strength in the same way as Brush Tracking does for all the brushes. This setting will override the one set in the Preferences dialog.

FIG 5.3 The full list of Dab types and right, the General panel.

The General Panel

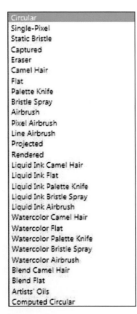

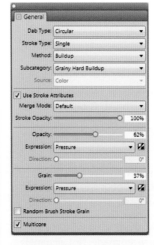

The General panel is one of the most important control panels as it holds a lot of controls which apply to most brushes, therefore it is worth keeping on screen at all times.

FIG 5.4 The new painting merge modes:
Top row:
Original 'Mannequin' picture, Default, Gel.
Colorize, Reverse-out, Shadow Map, Magic Combine.
Pseudocolor, Normal, Dissolve and Multiply.
Bottom row:
Screen, Overlay, Soft Light, Hard Light.
Darken, Lighten, Difference, Hue.
Saturation, Color, Luminance and GelCover.

General Panel: Stroke Attributes

This is a new addition to the General panel in Painter 12, and an important one as it allows many brushes to use the merge modes which were previously only available for a complete layer. These are similar to the painting modes for brushes in Photoshop. Tick the Use Stroke Attributes option and a drop down list shows the merge modes. They are especially useful for painting lighter or darker brush strokes on a painting without overpainting other tones. The examples in Figure 5.4 show what happens when painting a blue color using the different merge modes, the result is not always easy to predict.

General Panel: Dab Types

The Dab is the mark that the brush makes when a single mark is made using the brush completely vertical. Figure 5.3 shows the long list of dab types, those grayed out are not available for the chosen brush.

Making alterations in this section will make a fundamental change to the brush, so do try out some of these types yourself. Don't worry if you mess up the brush settings as you can easily revert the brush back to the default setting by clicking the brush icon on the left in the Properties bar when the brush is active. The chief dab types are illustrated on the following pages.

General Panel: Dab Types 1

1. Circular dab types have a very smooth finish, and despite their name the brushes are often long and narrow. Soft clones use circular dab types so this is a good option if you want a smooth, clear picture.

2. Static Bristle brushes are made up of individual bristles and therefore the brush lines are usually visible. This is the dab type to use if you want to emphasize the brush strokes.

3. Captured means that the shape has been made from a design or image rather than using individual bristles. When you make your own dab type this is called Captured. The dab illustrated comes from a Chalk variant. How to create your own captured dab is covered later in this chapter.

4. Camel Hair uses what are called Rendered dabs, which means that the brush is made up of individual bristles all computed separately. The brushes are often slow to operate, especially when smooth strokes are chosen. The Feature Slider in the Size panel controls the spread of the bristles.

5. Flat dab types also use Rendered dabs like the Camel Hair type.

6. Palette Knife has an elongated shape and can be used to move imagery around directly on a picture. When using this dab for cloning, the image will appear with the very distinctive knife-like shape.

7. Airbrush sprays paint in the direction that the stylus is pointed, just like a real airbrush. This dab has a smooth spray.

8. Pixel Airbrush also sprays in the direction that the stylus is pointed, but the texture of the spray is rougher than the Airbrush.

9. Line Airbrush sprays imagery and also severely distorts it. The Furry Clone uses this dab type.

10. Rendered dab is rather like the Palette Knife in shape; it is difficult to clone with this brush as the image is very distorted.

11. Artists Oils is specifically for the Artists Oils brushes and works like real world oils. These brushes are now included in the Oils category.

12. Projected takes the source image and from it makes a brush stroke.

FIG 5.5 Dab types (Opposite page).

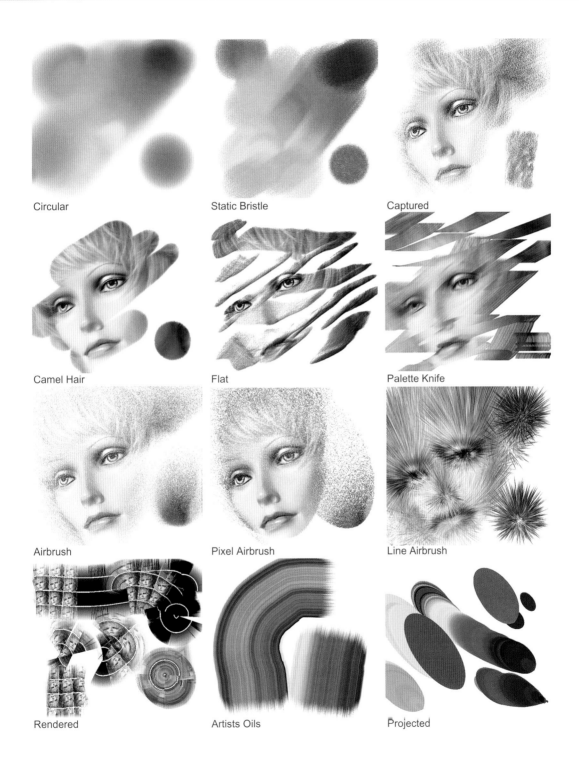

Circular

Static Bristle

Captured

Camel Hair

Flat

Palette Knife

Airbrush

Pixel Airbrush

Line Airbrush

Rendered

Artists Oils

Projected

General Panel: Dab Types 2

1. Watercolor Camel Hair paints in the Wet method and diffuses the image, blending it into the paper.

2. Watercolor Flat also diffuses the brush strokes, but being a flat brush uses a broad or narrow brush stroke depending on the angle of the pen.

3. Watercolor Palette Knife diffuses less than the other types and has the characteristic bladed knife style.

4. Watercolor Bristle Spray creates spray patterns which then blend into the paper. This is a good dab for creating soft light clones. As with all Watercolor brushes, use at a low opacity.

5. Watercolor Airbrush sprays out paint in an even way and creates a soft finish if used at a low opacity.

6. Blend Camel Hair is the dab which is used in the RealBristle brushes, it gives a most attractive brush texture and when applied to other brush types will transfer the very smooth texture and appearance.

7. Bristle Spray will spray the paint in a distinctive spray; the Nervous Pen from the Pens brush category uses this effect which is very useful for creating a textured background.

8. Liquid Ink Airbrush, the Liquid Ink dabs resemble free-flowing fluid ink and this variety sprays out the ink in an airbrush style.

9. Liquid Ink Bristle Spray sprays out the ink in a pattern. There are several resist brushes in this category which are paired with this and other variants. Painting with these resist variants before the main brush will stop the ink from painting in the areas painted with the resist brush.

10. Liquid Ink Camel Hair creates a very smooth even color across the picture.

11. Liquid Ink Flat is also smooth and clear, but due to the flat shape of the brush it paints with a narrow or broad side.

12. Liquid Ink Palette Knife moves the image around like a traditional panel knife.

FIG 5.6 Dab types (Opposite page).

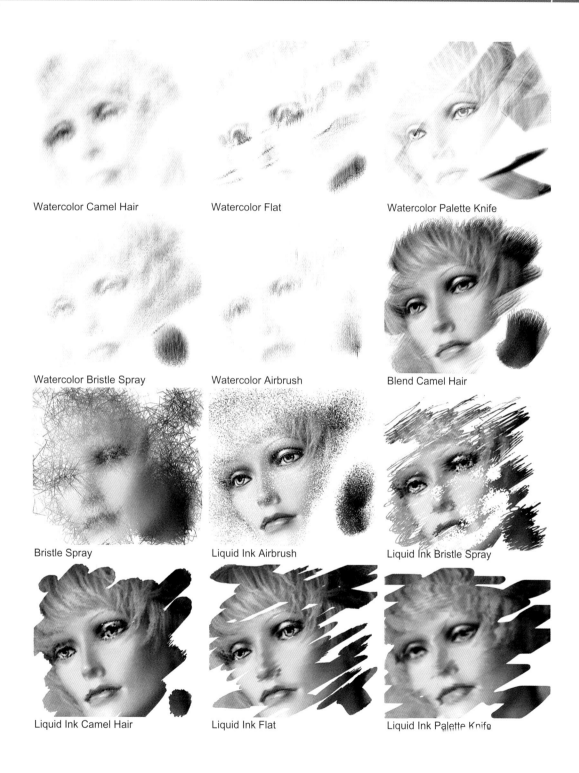

Watercolor Camel Hair

Watercolor Flat

Watercolor Palette Knife

Watercolor Bristle Spray

Watercolor Airbrush

Blend Camel Hair

Bristle Spray

Liquid Ink Airbrush

Liquid Ink Bristle Spray

Liquid Ink Camel Hair

Liquid Ink Flat

Liquid Ink Palette Knife

General Panel: Method

The Method controls how the paint is laid on the paper.

Cover will cover anything previously painted but will not become darker than the existing color. Build-up will get darker as more brush strokes are added, eventually going to black. Drip distorts the picture, while Wet is a watercolor method which diffuses the brush strokes.

There are two ways of making brushes into cloners, one is by using the option in the General panel if available; the other is by clicking the Clone Color icon in the Color panel. The option in the General panel will generally reproduce the original picture more accurately than the Clone Color option, while the Clone Color creates a more painterly impression.

The brush used for the examples shown was the Chalk and Crayons>Dull Grainy Chalk brush, the results would be different according to which brush is chosen and also which Subcategory, but the general effect will be similar.

FIG 5.7 The Method significantly changes the look of the brush.

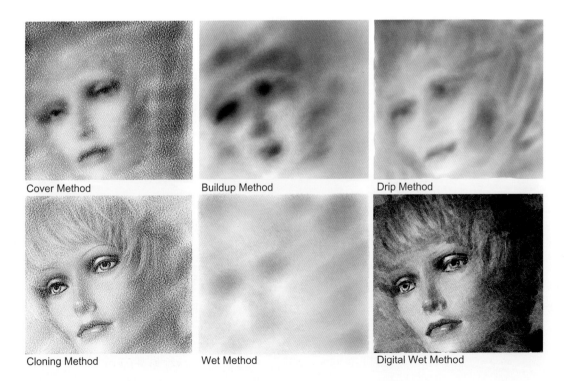

Cover Method

Buildup Method

Drip Method

Cloning Method

Wet Method

Digital Wet Method

General Panel: Subcategory

The Subcategory refines the chosen Method, and each Method has its own set of variables. In the case of the Cloning Method there are five choices, the two that are used regularly are Soft Cover Cloning, which has a smooth even finish with soft edges, and Grainy Hard Cover Cloning, which has a rough finish that shows paper grain.

FIG 5.8 The Subcateory refines the Method.

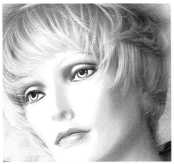

Soft Cover Cloning

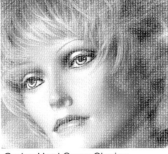

Grainy Hard Cover Cloning

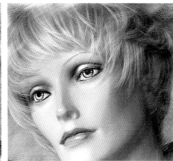

Grainy Soft Cover Cloning

General Panel: Grain

This slider controls the amount of grain that is revealed when brush strokes are applied to the paper. The amount that is needed depends on the combination of brush and paper being used. Generally the control needs to be set at a very low level, sometimes as low as 1 or 2. It seems strange to be reducing the slider control to increase the amount of grain, but the slider really controls how much paint goes into the grain, so the higher the setting the less grain will be visible. Many of the more recent 'Real' brushes use the slider in the opposite way with the higher the setting, the more grain being shown, so you will often have to experiment with the settings.

FIG 5.9 The Grain slider controls the amount of paper grain that is shown in the picture.

Grain set at 3%

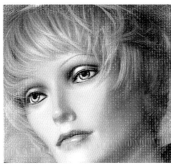

Grain set at 10%

Grain set at 20%

Spacing Panel

Brush strokes usually appear to be continuous, but are really a series of individual brush dabs spaced very closely so that they overlap. This panel adjusts the spacing between the dabs and Figure 5.10 shows the Acrylic Captured Bristle brush with spacing at 12% (the default setting), 100% and 200%.

The Min Spacing slider lets you control the minimum amount of space between the dabs; the difference is mainly noticeable when the spacing slider is set low.

FIG 5.10 The Spacing panel adjusts the space between the brush dabs.

The default Spacing of 12%

Spacing set at 100%

Spacing set at 200%

Angle Panel

In the Angle panel the shape and angle of many brushes can be changed.

The Squeeze slider flattens the brush shape and will change a round brush to an oval or very narrow shape, moving the Angle slider will alter the angle at which the brush paints.

Not all brushes can be changed in this way, for the example shown I used the Charcoal and Conte>Square Conte brush.

FIG 5.11 You can change the shape of the brush in the Angle panel.

Squeeze 80% Angle 0

Squeeze 50% Angle 50

Squeeze 4% Angle 59

Well Panel

The sliders in this section control how much the brush smears the existing artwork and how clear the detail is from the clone. The two sliders that control the level of diffusion are Resaturation and Bleed and they work together. Resaturation controls the amount of paint that is being replenished, and in the case of a clone, this means the amount of detail from the clone source. Bleed controls how much the picture is being smeared. The default settings for the Wet Soft Acrylic brush are Resaturation 73% and Bleed 20% and in the examples shown in Figure 5.12 you can see the result of changing the values.

FIG 5.12 Resaturation and Bleed affect the clarity of a cloned picture.

Resaturation 20% Bleed 73% Resaturation 73% Bleed 20% Resaturation 50% Bleed 50%

Jitter Panel

The Jitter panel contains the Jitter slider which is often on the Properties bar for easy access. Increasing the amount of the jitter breaks up the image into what looks like cotton wool in some brushes and rough texturing in others. In the examples shown the Jitter slider was increased while using the Thick Acrylic brush and the Square Chalk.

FIG 5.13 The Jitter panel.

Thick Acrylic - Jitter at 0 Thick Acrylic - Jitter at 2.86 Square Chalk - Jitter at 2.62

155

Creating a Captured Dab

By creating your own captured dab you can further customize favorite brushes. The dab can be made from a specially designed pattern as shown below or could be created from a photograph. Before you start this you need to be careful that you do not replace the captured variant for the default brush you are using. In theory you can click on Replace Default Variant in the Brush selector options menu and it should do what it says; however, there are some brushes where this does not work and the captured dab stubbornly refuses to change. A simple way of avoiding this is included in Step 6.

FIG 5.14 Creating a captured dab.

FIG 5.15 The Brush Selector with panel options menu highlighted.

FIG 5.16 The Brush Selector panel options menu.

1. File>New, to make a new empty document, 500 × 500 pixels at 200 ppi.
2. Choose a brush to make the dab, use the Pens>Scratchboard Tool, size 3.5 opacity 100%. Select black in the Color panel.
3. Make some distinctive marks on the paper as in Figure 5.14; this must be on the canvas and not on a layer.
4. Select>Select All.
5. Choose an existing brush variant on which you want to base the new brush dab, for this example use Acrylics>Real Dry Flat. When you choose the brush the characteristics of the original brush will be retained and only the brush dab will be changed.
6. In the Brush Selector panel options menu select Save Variant and give it a new name. Select this brush to use for your trial dab captures. This will avoid the issue of losing your default setting.
7. Click the Brush Selector options menu icon to access the panel menu and select Capture Dab; this will fix this design as the new dab. Close down the file you have just created.
8. Open 'Rag Dolls.'
9. File>Quick Clone.
10. Click the Clone Color option in the Color panel.
11. Paint the picture starting with brush size 244 opacity 100%. Use a dabbing motion rather than a continuous brush stroke and you will see the very distinctive brush dab which you have created (Figure 5.17).
12. Open the General panel (Window>Brush Control Panels>General) and change the Method to Cloning and the Subcategory to Grainy Hard

Cover Cloning. Reduce the brush size to 90 and paint in the two dolls. Reduce the size to 30 and clean up any marks on the faces.

13. To keep the variant for future use you can either keep the name you gave it or save it again using a new name.

FIG 5.17 Using the captured dab.

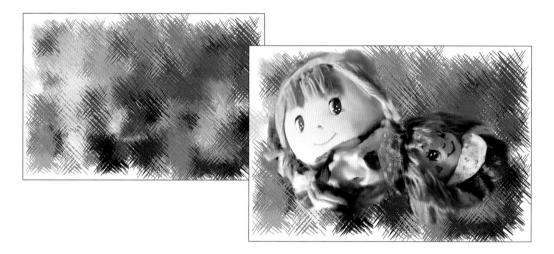

Creating Brush Dabs from a Photograph

1. Open 'Mannequin.'
2. Select the Cloners>Soft Cloner brush size 90 opacity 100%.
3. Save Variant with a new name as previously. Select the new brush and in the Mannequin photograph make a square selection of the eye, then capture the dab as before.
4. Make a Quick Clone, select the new brush and clone the picture using a dabbing motion around the edge to see the pattern.

I have found problems with capturing dabs in Painter 12; if you find that the option is grayed out, or just does not work, restart Painter and generally that will solve the problem.

FIG 5.18 A brush dab captured from a photograph and the cloned picture made with the captured dab.

Saving Brush Variants

Customizing a brush for a particular use can take some time, so it is sensible to save it for future use; Painter allows you to save brushes and also to make your own brush category.

The process is very easy, when you have customized the brush and are ready to save it, open the Brush Selector panel options menu and click on Save Variant. Figure 5.19 shows the dialog box.

FIG 5.19 Save variant dialog box.

Give it a different name from the original and click OK. The new variant will be saved in the same brush category as the original. In order to identify brushes that you have customized and saved it is a good idea to prefix them with your initials, so 'Square Chalk' might become 'MA Square Chalk – star', for example.

If you want to delete the variant, select the same brush and in the panel options menu, choose Delete Variant. Painter will ask you to confirm that you really want to delete the brush, if so click OK.

It is a good idea to return the original brush to its default settings when you have finished, otherwise it will retain the customizations you have made and may lead to confusion later.

Creating a New Brush Category

You can make a new brush category for your own saved brushes, this helps to organize them and keeps them all in one place.

To make a new brush category and add brushes to it follow the next set of instructions.

1. The first step is to create an icon which will be used for the brush category. This can be an image or text, whatever you will recognize. For this example it will be an image with a single letter.
2. Make a new document 500 × 500 pixels and using the type tool type a single letter in capitals as in Figure 5.20. Paint color on the canvas layer (which is underneath the text layer) then Drop all the layers.
3. Make a square selection of the area with the Rectangular Selection tool, hold down the shift key to keep it square.

FIG 5.20 Brush category icon.

4. Open the Brush Selector panel menu and click on Capture Brush Category. A dialog box will appear and here you can type in a name for the category, click OK and the new category will appear in the brush category list (Figure 5.21).

FIG 5.21 The new brush category in the Brush Selector.

5. To add a brush variant to your new category, open an existing brush in any category, make the changes to the brush variant and save the brush under a different name.
6. To move it to your own brush category, go to the panel options menu again and select Copy Variant. Figure 5.22 shows the dialog box which appears, select your brush category from the drop down list and click OK.

FIG 5.22 Copying a variant to your newly created brush category.

7. In the Brush Selector panel you can drag and drop brush categories to new positions in the list, this is useful to move the categories you use constantly to the top.

Another advantage in saving all your customized brushes in a new category is that you can save a copy in case you have to reinstall the program.

Installing Extra Brush Libraries

When you install Painter 12 it comes with the Painter 12 brush library as default; however, there are 20 additional brush libraries available. The extra content is available on the DVD when you install Painter from a boxed version, from the auto-run screen you can elect to install the extra content which will allow you to set the installation location. If you have downloaded the program the same content is available online at corel.com. The extra content includes many brushes which were in earlier versions of Painter and have now been deleted or replaced, as well as several completely new libraries.

To download the libraries go to the Corel.com website, find the Painter 12 page and go to the Resouces tab. Under Learning Resources you will see Extra Content, click this and follow the instructions to download and install the contents.

On Windows the file will run an installation process which puts the libraries into your Program files folder; however it is important to note that (strangely) it does not put the libraries into the folder where they need to be! You will therefore need to copy the files as shown below. The file structure shown here applies to Windows 7, other operating systems will vary.

1. After running the installation process there will be a new folder called Extra Content created under System C>Program Files>Corel>Painter12, as highlighted in Figure 5.23.

FIG 5.23 After running the installation process.

FIG 5.24 Left: the contents of the Extra Content folder.
Right: The contents of the Brushes folder.

2. Open this folder and you will see the extra content which you have downloaded. The folder contains content for many different areas of Painter, as you can see on the left in Figure 5.24.

3. Open the Brushes folder and you will see a list of all the extra brush libraries supplied, as shown on the right in Figure 5.24.
4. Copy all these folders, go to System C>Program Files>Corel> Painter12>Brushes and paste them into that folder. The folder will already have a folder called 'Painter Brushes' and this is the default brush library folder for Painter 12.

FIG 5.25 The panel options menu in the Brush Selector and the two drop down menus.

5. You will need to restart Painter, then open the Brush Selector, click on the panel options menu icon and select Brush Library. A drop down list of brush libraries will be shown, select the one you require from the list shown in Figure 5.25.
6. When a new library is selected it will replace the current library, to return to the default, select the Painter Brushes library in the menu.
7. Changing libraries is not a quick operation and a quicker way to access the extra libraries is to create a custom palette (see the Painter Basics chapter for details on creating custom palettes). By adding a single paper from each library to a custom palette it is just a matter of clicking the icon to swop quickly from one library to another.
8. Figure 5.26 shows a custom palette created for this purpose. The names which appear when the cursor is held over an icon can be changed to the name of the library by right-clicking the relevant icon. Remember to include a brush from the default Paper Brushes library.

FIG 5.26 A custom palette created to allow easy access to the brush libraries.

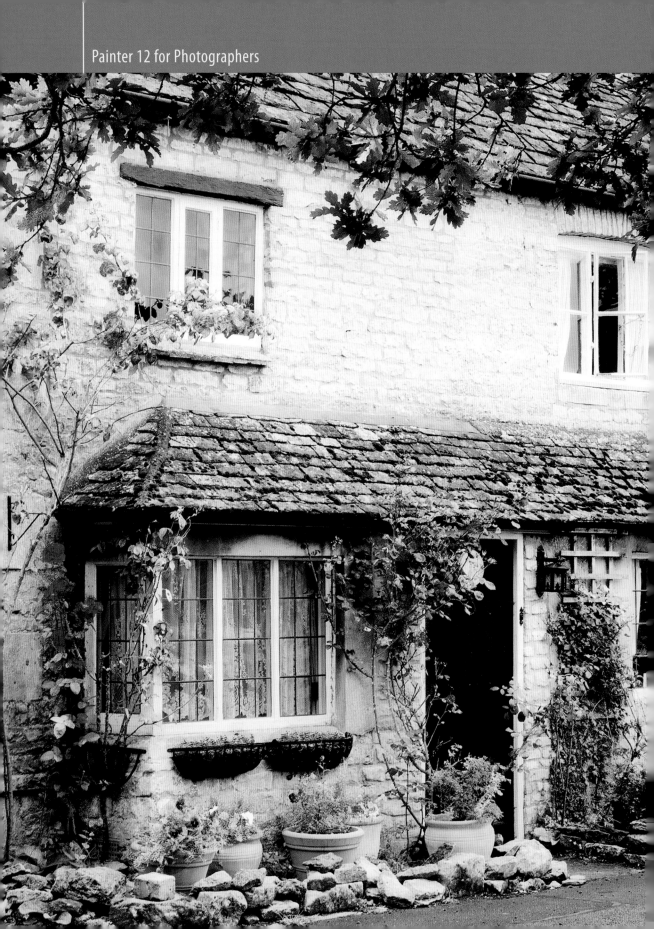

Using Color

Photographers who use Painter primarily take the color from the original photograph, however, there are times when we need to add or adjust the colors and this chapter addresses those occasions.

The chapter starts by describing the various panels in Painter from which color is available; this includes the Mixer and Color Sets as well as the frequently used Color panel.

It is also often necessary to adjust the tonality of the picture, this is an important part of the final stages of finishing a picture, but it is also frequently used to prepare the photograph prior to cloning. The controls look complicated initially so there is plenty of guidance in this chapter on how best to use them.

There are also occasions when a picture needs to lose the original color and have a tone applied and there are several ways in which this can be done.

Hand tinting has been popular since the early days of photography and I have included a tutorial on how this effect can be achieved.

Painter 12 for Photographers.
© 2012 Martin Addison. Published by Elsevier Ltd. All rights reserved.

The Color Panel

Open 'Roses' picture to try out the examples in this chapter.

The Color panel is shown in Figure 6.2, if this panel is not visible on the screen go to Window>Color Panels>Color. The Temporal Colors palette is a floating palette which appears when you use the keyboard shortcut Ctrl/Cmd+ Alt/Opt+1, pick the color and it disappears when you click on the canvas.

The Color panel is where colors are selected, click in the outer ring to select the hue and then in the inner triangle to choose the saturation and value. Within the color triangle the pure colors are on the right-hand side, and as the cursor moves to the left the colors are mixed with either black (down) or white (up). The Color panel is resizable which makes it easier to select precise colors.

FIG 6.2 The Color panel on the left and the Temporal Colors Palette on the right.

 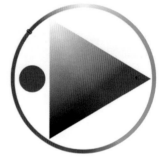

The three sliders below the color wheel show the HSV (hue, saturation and value) values of the color chosen, this information is very useful in cases where you need to use the same color again. Go to the Toolbox and make the eyedropper tool active, then click in a picture and the exact color breakdown will show in both the color wheel and in the sliders. This is often used when you need to enhance a color in your picture, click to identify the color you need and then move the color wheel cursor to a stronger color and paint into your picture.

The display shows the HSV values by default but this can be changed, click on the panel options menu (small icon top right in the panel) and select the RGB option.

The two small color circles on the left show the Main and Additional colors. The one in front is the Main color and is the one that is used for painting. The circle behind is the Additional color and is used for some special brushes that paint with two colors. It is *not* the same as the background color in Photoshop.

The rubber stamp icon is the Clone Color option, which makes the brush pick the color from the clone source instead of the Color panel. When the Clone Color is selected the colors in the panel are muted.

The Mixer

The Mixer works like an artist's palette where paints can be mixed together to blend colors. Figure 6.3 shows the Mixer panel, which is resizable to make it easier to select colors.

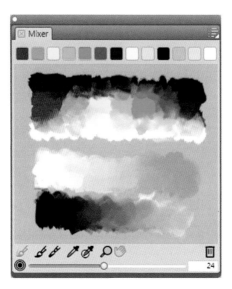

FIG 6.3 The Mixer panel.

FIG 6.4 Painting with multiple colors.

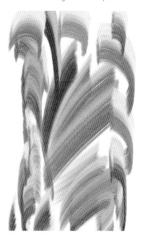

Click on the Apply Color icon (second from left) and select a color from the color swatches at the top of the panel, or use the Eyedropper in the Toolbox and click in the picture currently open. Paint some brush strokes into the panel, then select another color and paint some more, the size of the brush that adds the color can be changed by moving the slider. The paint will mix together as it is added to the palette. When you have added several colors click the Mix Color icon (third from left) and mix the colors together.

When you are ready to paint, choose a brush, then click the Sample Color icon (fourth from left) in the Mixer panel and then click in the mixer to select the color you need and paint into your picture. The Sample Multiple Colors icon is used for brushes which can pick up more than one color at a time. Figure 6.4 shows the Oils>Real Fan Short brush painting with colors mixed in the Mixer panel.

FIG 6.5 The Mixer panel menu.

The Dirty Brush Mode icon replicates real world painting and when this is selected any paint remaining on the brush from the previous stroke will be mixed with the new color.

The Zoom and Pan icons will enlarge and move the mixer display. Click on the Trash can to clear the panel display.

Figure 6.5 shows the panel menu which has controls to load and save mixer colors and also the option to create a Color Set from the mixer panel.

Add Swatch to Color Set...
New Color Set from Mixer Pad

Load Mixer Colors...
Save Mixer Colors...
Reset Mixer Colors

✓ Dirty Brush Mode

Open Mixer Pad...
Save Mixer Pad...
Clear Mixer Pad

Change Mixer Background...
Restore Default Mixer

Color Sets

Color sets are another way of picking colors and the control panel is displayed via Window>Color Panels>Color Sets. Figure 6.6 shows the default Color Set Libraries panel.

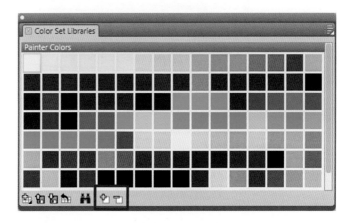

FIG 6.7 The Color Set Libraries panel menu.

It can be an advantage to choose a color from the Color Set Libraries panel, as specific color shades may be more readily identifiable from the individual squares rather than from a continuous color range. To select a color, click on the square and the brush will paint with that color.

The panel options menu shown in Figure 6.7 contains options for customizing the display. The first group of options is for creating new color sets from a variety of sources.

New Color Set is used to individually pick a range of colors and store them for future use. This could be useful if you are designing a layout or color scheme and want to keep all the colors used together. Click the New Color option in the menu to make an empty set and give it a name, you will see it appear at the bottom of the panel. Use the eyedropper to click on a color in the active image and then click the icon with the plus (+) symbol, highlighted in Figure 6.6. The icon with the minus (−) symbol removes the selected color.

New Color Set from Image creates a Color Set from the image currently active on the desktop. You could use this to restrict the number of colors in a new image to those of an existing one. The New Color Set from Layer and New Color Set from Selection work in the same way, but take the colors from the active layer or the active selection. New Color Set from Mixer Pad takes the colors from the Mixer.

The default color set is only one of many sets available and clicking the Import Color Set icon will add the new set at the bottom of the list. The extra color sets are loaded with the Painter program and when the open box appears it will normally take you straight to the relevant folder from where you can choose the new color set. If this does not happen you will need to navigate to the Corel Painter program files and go to the Support>Color Sets folder. The default set is called Painter Colors. There is a large selection to choose from, about 50 in all, and Figure 6.8 shows the Color Set Libraries panel after importing several sets. The Color Set Libraries option menu will allow you to show or hide any of the sets which you have imported.

Export Color Set will export sets that you have created and Remove Color Set will remove the set when you deselect the name in the drop down menu.

In the Color Set Library View you can change the Swatch Size; I find it useful to enlarge them as the colors can be seen more easily.

FIG 6.8 Some additional Color Sets loaded into Painter.

Brightness and Contrast

Effects>Tonal Control>Brightness and Contrast

There are many ways in which tone and color can be adjusted in Painter and they all work in different ways so it is worth getting to know which control is better for which task. Most of the controls are available from the Effects menu.

FIG 6.9 The original photograph prior to making any adjustments.

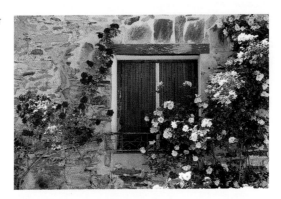

Brightness and Contrast is a very simple control, just two sliders, its main use is to increase contrast. In most cases the process of cloning reduces the contrast and vibrancy so moving the contrast slider (the top one) to the right will give the finished picture more impact. I would caution against using the brightness slider for anything other than very small adjustments as this affects all the tones and it is easy to lose detail in the highlights or shadow areas. If you need to brighten your picture use the Correct Color controls which are rather gentler.

Figure 6.10 shows the Brightness and Contrast dialog box and the picture to the right of the box shows the result of changing the sliders.

FIG 6.10
The Brightness and Contrast dialog box with the settings applied to the picture.

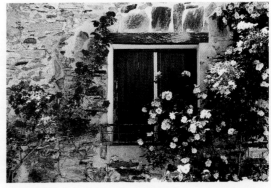

Equalize

Effects>Tonal Control>Equalize

Equalize is a very useful control where you can adjust both the black and white points to improve contrast and also the mid-tones.

The black shape in the display is the histogram and this shows the distribution of tones in the picture, with the darkest tones on the left and the lightest on the right. The illustration shown in Figure 6.11 shows that the tones are predominantly in the middle, the gap at the left indicates that there are no pure blacks, while the spike on the right indicates that there are some pure white areas, they would be the white roses.

The black and white point indicators are the small markers under the histogram and before the picture is adjusted they would be at each end, the left at 100% and the right at 0%; however, when the dialog box opens Painter will have automatically set the black and white points to maximum contrast and spread the remaining tones across the dynamic range. In Figure 6.11 they are set to 88.23% and 2.3% respectively, your picture will have changed too, reflecting the suggested settings. Very often the suggested settings are not those that are required, so move the two markers until the picture has the contrast you need.

When you have set the black and white points you may find that the overall picture is too dark or too light, so the Brightness slider below is there to make adjustments to the mid-tones which affect the overall look of the picture.

When you accept the adjustment the tones are redistributed and if you open the Equalize dialog again the histogram will be very different, as you can see when you compare the displays in Figures 6.11 and 6.12.

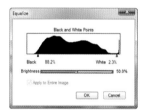

FIG 6.11 The Equalize dialog box showing the distribution of tones in the original picture.

FIG 6.12 The Equalize dialog box after making the suggested adjustments and (left) the adjusted picture.

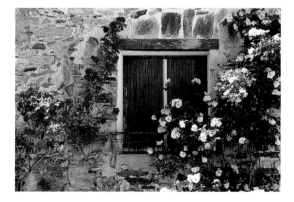

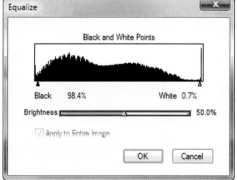

169

Adjust Colors

Effects>Tonal Control>Adjust Colors

This tool is similar to the Hue and Saturation controls in Photoshop. The Hue slider will shift all the colors in the picture around the color wheel; this is useful as a quick tool for warming or cooling a picture when a small change is all that is needed. It is useful for graphic effects, but when accurate color changes are required it is usually better to use the Correct Colors adjustments.

FIG 6.13 Adjust Colors is useful for creating delicate colors as well as for strengthening color.

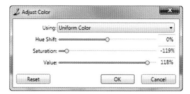

The Saturation slider is extremely useful and should be used when the colors need boosting, either before cloning or when finishing a picture. It can also be used to reduce color saturation when you need delicate colors, and to remove all the color to make a monochrome picture.

The Value slider affects the overall brightness.

There is a further option in this dialog box and that is the choice of the source on which of the color adjustment is calculated. The four options are Uniform Color, Image Luminance, Original Luminance and Paper. These are the same options for applying paper textures and are described in more detail in the Paper Textures chapter. Figure 6.14 shows the different results when either Uniform Color or Image Luminance is selected.

FIG 6.14 Left: Adjustment using Uniform Color.
Right: The same adjustment using Image Luminance.

Match Palette

Effects>Tonal Control>Match Palette

The Match Palette lets you take the colors from one image and apply them to another picture. This can be useful if you want to create a set of pictures which all require the same tonal range.

In the example the original picture is 'Rust Textures' and the colors have been taken from the 'Flower' picture. Both images are on the website for you to use with this demonstration.

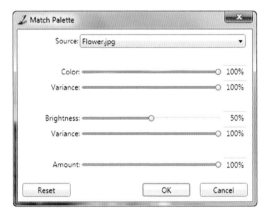

FIG 6.15 The Match palette takes the color from one image and applies it to another.

The Color slider controls the amount of color transferred. Brightness controls the way the colors are matched, higher settings mean more contrast.

The two Variance sliders, one for Color and the other for Brightness, control the amount of variance from the original image; the higher the value, the wider the range of colors or brightness compared to the source.

When you have found the required settings you can adjust the overall amount of the effect with the Amount slider.

FIG 6.16 Using the Match panel the colors of the flower picture have been applied to the rust picture. Note that only the colors of the flower picture have been applied and not the shapes.

Correct Colors 1

Effects>Tonal Control>Correct Colors

This is a very powerful tool for changing both tone and color. In Photoshop it is known as Curves, although in Painter it works slightly differently. If you have never used Curves before it can be a little non-intuitive but it is worth making the effort to understand how it works.

FIG 6.17 Color Correction dialog box showing an S curve to increase contrast and the result when applied to the picture.

When you open the dialog box there is no curve, just a diagonal line. This line represents all the tones in your picture, the top right corner being the lightest tones and the bottom left the darkest tones, the middle point being mid-gray.

When the curve moves up and to the left the tones in that area are made lighter, down and to the right the tones are darker.

FIG 6.18 Color Correction dialog box showing an inverted S curve to decrease contrast and the result when applied to the picture.

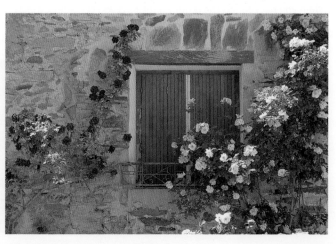

When the dialog box opens the default option in the drop down menu is Contrast and Brightness and moving the Contrast slider to the right will produce a gentle S-shaped curve in the display, this increases the contrast as can be seen in Figure 6.17.

Moving the slider to the left produces a reverse S curve which decreases the contrast; this can be seen in Figure 6.18.

FIG 6.19 Adjusting the Brightness slider affects mainly the mid-tones.

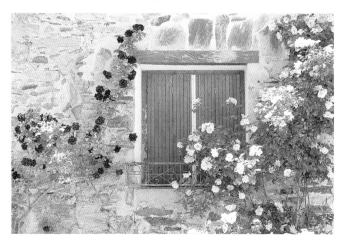

The Brightness slider controls the mid-tones and when it is moved the center point moves to the right or left and the overall brightness increases or decreases. The brightest and darkest tones are changed the least, this is shown in Figure 6.19.

To manipulate the curve directly you need to change to the next option in the dialog box, which is Curve. Here you can move parts of the curve without creating an S curve. In the example shown in Figure 6.20 the curve has been pulled down to the bottom which results in only the dark tones being affected and very little change in the lighter areas. This is used when you need to lighten or darken just one part of the tonal range.

FIG 6.20 Pulling down the curve manually to darken just the darker areas.

Correct Colors 2

Effects>Tonal Control>Correct Colors

There are four colored boxes below the curve and they represent the three color channels plus the Master icon. When the Master icon is active all the colors in the picture will change, but when only one color channel is active then only that color will be altered. This allows the separate red, green and blue channels to be adjusted.

FIG 6.21 Increasing the brightness of the red channel will add red to the picture.

Try this out by selecting Brightness and Contrast in the options box, click in the red box and move the Brightness slider to the right, Figure 6.21 shows the result. As you can see the picture now has a red color cast.

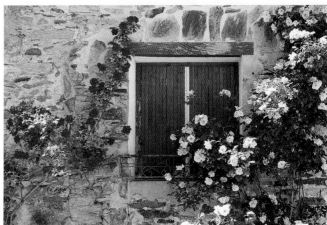

There are two further options in this dialog box.

Advanced allows you to enter values into the various boxes to adjust the tones very precisely.

FIG 6.22 The Freehand option produces wild colors.

Freehand is where you can go wild with psychedelic colors! The result of drawing vertical lines in the curves box is shown in Figure 6.22.

Adjust Selected Colors

Effects>Tonal Control>Adjust Selected Colors

The Adjust Selected Colors dialog box has the same controls (hue, saturation and value) as the Adjust Colors tool already discussed, with the addition of extra sliders to restrict the adjustment to specific colors.

The procedure is to open the dialog box and then click in the main picture to set the color to be changed. Make the adjustment required using the Hue Shift, Saturation and Value sliders (the bottom three sliders) and then use the additional sliders to further control the result.

FIG 6.23 The Adjust Selected Color dialog box and picture after increasing the saturation of the red.

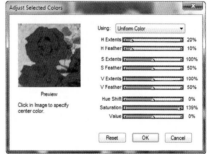

Each of the three controls has two sliders, Extents and Feather. The Extents slider defines how far from the exact color selected the adjustment will be applied; the higher the number, the more colors will be affected. The Feather slider softens the edges of the adjustment; the higher the number the softer the edge is. If you are changing a color with a clearly defined edge the slider should be kept low and *vice versa*.

The Adjust Selected Colors tool is a very precise way to adjust colors, but it does suffer from the huge disadvantage that you can only see the planned adjustment in the tiny preview window and it is very difficult to assess what you are doing, which makes it difficult to use. You can pan around within the window which helps a little.

FIG 6.24 The Adjust Selected Color dialog box and picture after decreasing the saturation and increasing the value (brightness) of the red.

Negative

Effects>Tonal Control>Negative

Negative changes the colors in a picture to negative which can be useful when creating special effects. There are no options or controls, it just does it.

FIG 6.25 The Negative command turns the colors to negative, in this case inside an active selection.

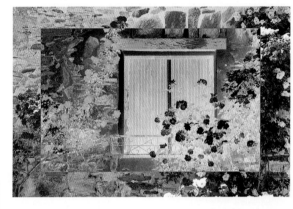

FIG 6.26 The Posterize dialog box.

Posterize

Effects>Tonal Control>Posterize

The Posterize command splits the colors from the original picture into separate levels of tone as determined by the number entered in the dialog box.

The examples shown in Figure 6.27 have been split into, from left to right, two, six and twelve posterizations.

FIG 6.27 Posterize splits the tones into a specified number of levels.

Posterize Using Color Set

Effects>Tonal Control>Posterize Using Color Set

Like the Posterize effect, this splits the picture into separate tones, but in this case takes the colors from the current Color Set instead of the original picture, which makes it a valuable tool for creating new color schemes.

To try out this effect open the 'Flower' picture and go to Effects>Tonal Control>Posterize Using Color Set; there is no dialog box, the effect is purely based on the Color Set currently active. The number of posterized tones will depend upon the number of colors in the Color Set.

If you have not previously loaded any Color Sets your first result will be based on the default Color Set. Open the Color Sets panel options menu and import some additional Color Sets, repeat the process and see the difference, the instructions for loading Color Sets are given earlier in this chapter.

FIG 6.28 Posterize using Color Sets, these examples are from a selection of Color Sets.
Top row L to R:
A. Rich Oils
B. Black Walnut
C. Flesh Tones
Bottom row L to R:
D. Jacaranda
E. Vivid Spring
F. Artist Oils

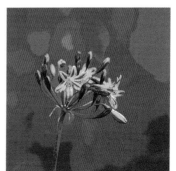

FIG 6.29 Original photograph.

Toning

Effects>Tonal Control>Adjust Color

There are several ways of toning photographs in Painter and one of the easiest and most flexible is to create a new layer and add color. This has the advantage of being able to sit on top of any number of layers.

1. Open 'Olive Grove.'

FIG 6.30 Changed to monochrome.

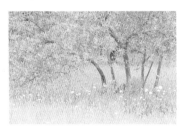

FIG 6.31 Color panel.

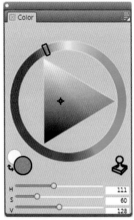

2. Effects>Tonal Control>Adjust Color, use Uniform Color and move the Saturation slider to −138% to produce a monochrome version.
3. Create a new layer.
4. Select the color you plan to use in the Color panel.
5. Edit>Fill>Fill with Current Color.
6. Change the Layer Composite Method to Colorize.
7. To change the color, select the new color and Edit>Fill again.
8. To reduce the density of the color you can reduce the layer opacity.
9. Change the Layer Composite Method to Screen, Overlay or Soft Light to get slightly different results.

FIG 6.32 Toned version.

FIG 6.33 Layers panel.

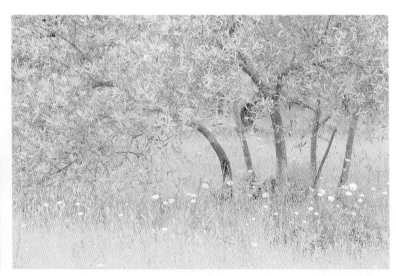

Dye Concentration

Effects>Surface Control>Dye Concentration

This is a useful and easy way to make pictures darker or lighter. There are two sliders and one set of options.

The best way to use Dye Concentration is to create a copy of the canvas and apply the effect to the layer; you can then adjust the layer opacity to reduce the amount very easily. You can also change the Layer Composite Method to get different results.

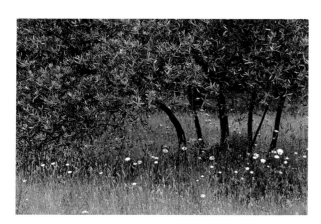

FIG 6.34 Dye Concentration with the Maximum slider at 500% and the Minimum at 800%.

The box at the top of the control panel gives the option to apply the effect based on four different sources. Uniform Color and Image Luminance are usually the most useful and they give slightly different results.

The Maximum slider controls the amount, more than 100% will make the picture darker; less than 100% will make it lighter. The Minimum slider controls the contrast.

FIG 6.35 Dye Concentration with the Maximum slider at 21% and the Minimum at 250%.

Hand Coloring: Cosy Cottage

This demonstration of hand coloring uses many layers on which to add color and this allows considerable flexibility in being able to adjust the opacity at a later stage. The way the color is displayed will vary depending upon the Layer Composite Method. The most frequently used methods are Default, Colorize and Color. The best way to see the differences is to paint color on a layer and then to change the Composite Method. Default or Normal will cover the underlying layers. Colorize will be semi-transparent while Color is somewhere between Normal and Colorize. Other Composite Methods can be used where appropriate and the quickest way to review these is to make a change to the method and then use the up and down arrow keys to cycle through the different modes.

1. Open 'Cosy Cottage.'

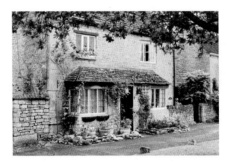

FIG 6.36 Original monochrome photograph.

2. File>Clone, File>Save As, give it a new name.
3. Select>All, then click in the picture with the Layer Adjuster tool to lift the canvas to a new layer, leaving the canvas white.
4. Create a new layer on the top of the layer stack and change it to Colorize Layer Composite Method.
5. Select an orange in the Color panel; try R253 G149 B3 on the RGB readout. Edit>Fill>Fill with Current Color; reduce the layer opacity to 15% to add a sepia type toning (Figure 6.38).
6. Create a new layer in Colorize method.
7. Select the Tinting>Basic Round brush, size 110 opacity 13%. Select a light orange/brown color (R237 G210 B165) and paint over all the stonework; this will add a warmer tone to those areas painted. Reduce the layer opacity to 40%.
8. Open the Mixer (Window>Color Panels>Mixer) and drag it out into the workspace. Drag the corner to make it larger and click the Waste bin to clear the Mixer display. The Mixer makes it easy to select a range of colors and mix them together.

FIG 6.37 The Color panel at Step 5.

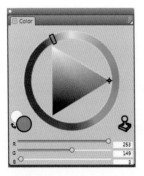

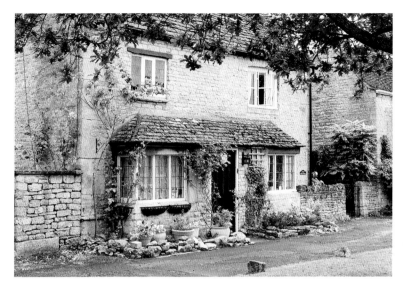

FIG 6.38 The picture at Step 5 after toning.

FIG 6.39 The Mixer at Step 9.

9. Click the Apply Color icon (second from the left), click a yellow color swatch from the selection at the top of the palette and paint into the Mixer area, this will add the color to the palette. Continue to select more colors, either from the swatches or from the main Color panel. Include mainly yellows, oranges and reds plus some greens. Figure 6.39 shows the Mixer at this point.

10. Now that you have a selection of colors in the Mixer the next step is to mix them to get a wider range of colors to choose from. Click the Mix Color icon (third from the left) and mix some of the colors. Figure 6.40 shows the Mixer after mixing the colors.

FIG 6.40 The Mixer at Step 10.

FIG 6.41 The picture at Step 13.

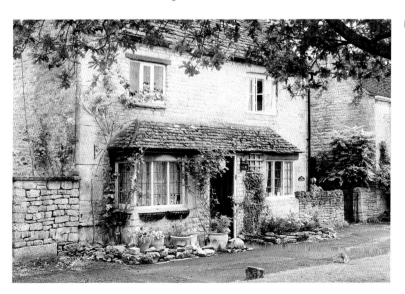

11. Click the Sample Color icon in the Mixer palette (fourth icon from the left) and you are ready to paint by clicking in the Mixer color display to select the color you need.

12. Select the Sponges>Sponge, size 50 opacity 50%. The sponge brush gives a textured finish which will suit the stonework. Paint the front of the house and the walls; paint some areas more than others to get a variation in the color of the stone.

FIG 6.42 The picture at Step 17 after painting the foliage.

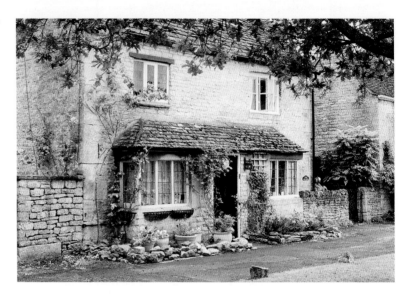

13. Create a new layer on the top of the layer stack and change it to Hard Light Composite Method. Paint the house with more warm tones and then reduce the layer opacity to 70%.

FIG 6.43 The layer panel at Step 18.

14. The windows would look better without the toning, so create a new layer and select the Cloners>Soft Cloner, size 50 opacity 10%. Clone in from the original mono picture; reduce the layer opacity to about 60% so that the white does not stand out too much.

15. Create a new layer in Colorize mode and select the Sponges>Sponge, size 6 opacity 50%. Select some green colors and paint the leaves of the plants on the walls and in front of the cottage.

16. Create a new layer in Colorize mode and using the same brush paint the larger shrub on the far right. Also paint the grass in the foreground, using a lighter green.

17. Create a new layer in Colorize mode and paint the tree at the top, Figure 6.42 shows this stage.

18. Create a new layer in Colorize mode and paint the flowers. Use the Acrylics>Glazing Acrylic, size 19 opacity 100%. Choose bright colors to add some strong focal points. Reduce the brush size down to about 9 to use on smaller flowers. You can also paint some flowers in the empty window boxes if you wish.

19. Save the picture, then File>Clone to create a new flattened copy on which to base the final steps.

20. Select>All, then click in the picture with the Layer Adjuster tool to lift the canvas to a new layer, leaving the canvas white.

21. Right-click to duplicate the layer.

22. Click on the Canvas and create a new empty layer between the two layers. Make it the active layer.

23. Before you do the next step, ensure that the original mono image is not still open on your desktop. The default settings will have closed it, but if you changed the defaults, then you need to close it now.

24. In the Clone Source panel, click on the Open Source Image icon and then Open Source; select the original monochrome picture 'Cosy Cottage.'

25. Edit>Fill>Fill with Clone Source; this will place a copy of the mono layer between the two color layers.

26. With the top color layer active, go to Effects>Focus>Soften and choose Gaussian with the amount 40%. Change the Layer Composite Method to Colorize, this will clean up the colors; however the bright colors of the flowers have disappeared.

27. Hold down the shift key and click on the two top layers to select them both, then Ctrl/Cmd+E to merge the layers.

28. Highlight the top layer and create a layer mask (icon at the bottom of the layers panel), select the Tinting>Basic Round, size 21 opacity 100%. Select black in the Color panel then click on the layer mask to make it active and paint in the mask to reveal the full color of the flowers.

FIG 6.44 The layer panel at Step 26.

FIG 6.45 The layer panel at Step 28.

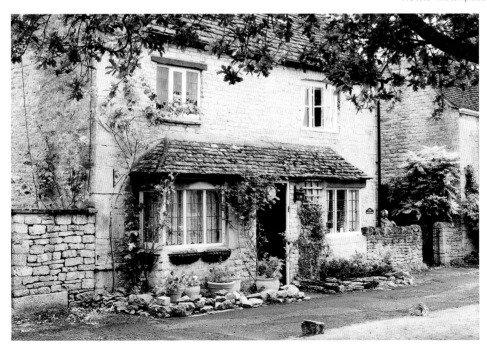

FIG 6.46 The completed picture.

Paper Textures

When painting traditionally the choice of paper is critical to the success of the painting, and when using Painter the choice of the right texture is just as important. The huge range of paper textures is one of the reasons that Painter is so attractive to photographers.

In this chapter you will explore the library of paper textures that come as the default set, altering the size of the texture and also the contrast and brightness, all of which will change the appearance of the finished picture.

In addition to the default paper library there are many more papers available on the Painter 12 program DVD, or to download from the Corel.com website. You can also make your own paper and this is explained later in the chapter.

Paper textures can be applied after the picture is finished based on both the paper texture and also the image itself, and in many cases this is the best way to get an overall texture such as a canvas effect.

The Paper Panels

When printing on a textured surface in the traditional manner the surface texture can be clearly seen, Painter replicates this by printing a pattern on the paper which resembles this texture. The result is obviously not the same, but it can be very effective when viewed at the right distance. Not all brushes show the paper texture clearly, the best ones to do so are the hard media, such as chalk, charcoal and conte.

There are two panels which control the paper selection, the Paper Libraries panel where the papers are displayed and the Papers panel where the characteristics of the selected paper can be adjusted.

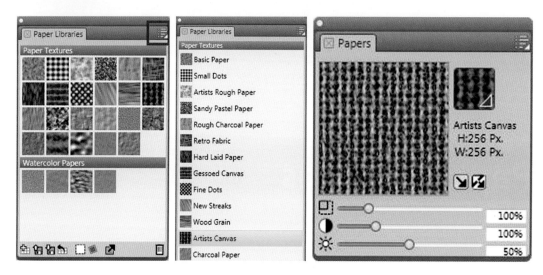

FIG 7.2

Left: The Paper Libraries panel showing the currently loaded paper libraries.
For quick switching between paper textures you can access the paper library from the flyout on the papers controls panel as well as from the library panel.
Center: The List view is an alternative way of display. The view can be changed in the panel options menu.
Right: The Papers panel. The three sliders control the scale, contrast and brightness of the selected paper.

The examples in this chapter are designed to work on the photograph provided, when you use your own picture you may need to adjust the brush size, opacity and grain settings as these are all dependent on the size and density of the photograph being cloned. The key control for using paper textures is the Grain slider. Basically the lower the setting, the more the grain is visible. The slider is usually on the Properties bar, but if it is not shown it can be found in the General panel (Window>Brush Control Panels>General).

1. Open 'Poppy.'
2. Select the Chalk>Square Chalk brush, size 80 opacity 100%, grain 9%.
3. In the General panel change the Method to Cloning and the Subcategory to Grainy Hard Cover Cloning. This will make a brush which shows the paper texture clearly.
4. Make a Quick Clone.
5. Try out several of the paper textures on this picture; you will soon appreciate the difference between them.

Paper Panel Controls

The Paper Scale control (top slider in the Papers panel) controls the size of the texture on the paper. This is particularly useful when different file sizes are used. Generally speaking, the larger the file size, the larger the paper scale needs to be to show a significant effect.

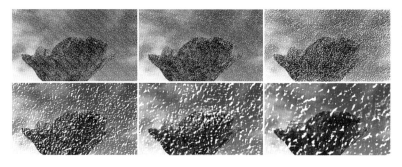

FIG 7.3 The Paper Scale slider at 25%, 50%, 100%, 200%, 300% and 400%.

The Paper Contrast control (center slider in the Papers panel) increases or decreases the contrast; the higher the setting, the more pronounced the texture appears.

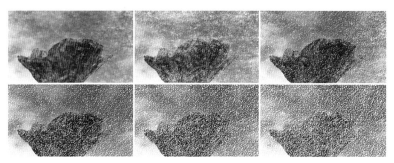

FIG 7.4 The Paper Contrast slider at 0%, 25%, 50%, 100%, 200% and 400%.

The Paper Brightness slider controls the brightness of the paper texture. The brightness is effectively the depth of the paper grain; the shallower the grain the less texture is visible. In common with the other two controls, as the brightness level is raised the texture becomes more pronounced.

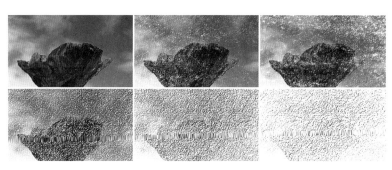

FIG 7.5 The Paper Brightness slider at 0%, 15%, 25%, 50%, 75% and 100%.

Using Extra Paper Libraries

Painter 12 has two paper libraries loaded at installation: the default Painter 12, plus a new Watercolor papers library. You can install more libraries from the program DVD or download more libraries from the Corel website.

FIG 7.6 Loading additional paper libraries, the Panel options menu is highlighted and the list of paper libraries is on the right.

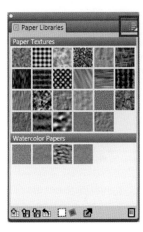

FIG 7.7 The options in the panel options menu.

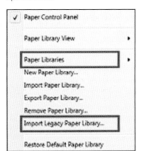

To download the libraries go to the Corel.com website, find the Painter 12 page and go to the Resouces tab. Under Learning Resources you will see Extra Content, click this and follow the instructions to download and install the contents. On Windows the file will run an installation process which puts the libraries into your Program files folder. Mac users will need to move the files manually.

1. After running the installation process there will be a new folder called Extra Content created under System C>Program Files>Corel>Painter12.
2. Open this folder and you will see the extra content which you have downloaded. The folder contains content for many different areas of Painter, including Papers.
3. Restart Painter.

FIG 7.8 The list of papers loaded into Painter with ticks against the ones displayed.

4. Open the panel options menu in the Paper Libraries panel and select Import Legacy Paper Library (Figure 7.7). Select the library you want and click Open.
5. Once the extra library has been loaded the new thumbnails will show below the existing paper libraries in the Paper Libraries panel.
6. Which papers you choose to have showing can be specified using the panel options menu, select Paper Libraries and the list of the libraries loaded will show, with ticks alongside those already displayed (Figure 7.8).

Creating Your Own Paper Texture

In addition to the many paper textures supplied with Painter, paper textures can also be created from a pattern or a photograph of your own.

1. In the Paper Libraries panel click the New Paper Library icon at the bottom of the panel, give it a name.
2. Open 'Cracked paint.' Though not necessary, it can be helpful to convert the image to grayscale before capturing so you can more easily assess the quality of the paper texture. (Effects>Tonal Control>Adjust Colors>move Saturation slider to the left.)
3. Select>All, or use the Rectangular Selection tool and select a part of the image.
4. Select Capture Paper in the Papers panel options menu (Figure 7.10), type in a name for the paper in the dialog box that appears and click OK. Close the image.
5. Your new paper texture will appear in your newly created Paper library, click the paper name to make it ready for use.
6. Select Invert Paper in the Papers panel options menu.
7. Open 'Poppy.' File>Quick Clone.
8. Select the Chalk & Crayons>Square Chalk brush, size 248 opacity 100%. In the General panel change the Grain to 12%, Method to Cloning and the Subcategory to Grainy Hard Cover Cloning.
9. Clone the picture and you will clearly see the overlaid pattern.

You need to be aware that when you use paper textures, and particularly when you make your own textures, you need to be careful with repeating patterns as at smaller sizes the papers will repeat and this may produce hard lines of tiles. Try doing this exercise again, but this time, change the paper size to 25% – you will see the unsightly lines which this produces. These tiling effects can be reduced if the photograph from which you make the pattern has a very even texture.

FIG 7.9 Cracked paint photograph used as the source for the paper texture.

FIG 7.10 The Capture Paper command in the Papers panel options menu.

FIG 7.11 The paper texture applied to the Poppy picture.

Applying Texture on a Completed Picture

Having seen how paper textures can be applied as part of the brush strokes when painting, you can now move on to applying the same textures, but this time on top of a painting and usually at the end. The textures that you can apply are not confined to paper textures; they can also be based on the luminance of the picture and the luminance of the source image when you are cloning.

FIG 7.12 Apply Surface Texture dialog box.

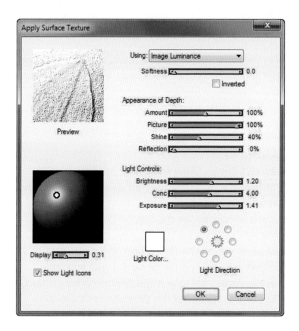

The choice of whether or not to apply texture to a finished picture can be a difficult one, as the result is not easily previewed on screen, it is only really apparent when you print the image. I would recommend that you save a copy of the file and apply the texture to a duplicate version.

An alternative method is to make a copy of the canvas and apply the texture to that layer; this allows you to reduce the opacity and thereby lessen the effect. Experience will help you decide on the settings but it is always difficult to tell on screen so a test print is often required.

Another way of making textures crisper in a print is by applying sharpening to the picture. In Painter this can be done in the Effects menu. Effects>Focus>Sharpen.

Applying a Paper Texture

The most important options in the Apply Surface Texture dialog box are the choices in the Using box and the Amount. On the following page are examples of the four different choices: Paper, based on the current selected paper; Image Luminance, based on the content of the picture; Original Luminance, based on the clone source and 3D Brush Stroke, based on the differences between the picture and the clone source.

Where you set the Amount slider has a crucial impact on the result, as this controls the strength of the applied texture. The default is 100% and I generally find this too strong, try 50% as a starter for most photographs. It is often difficult to assess the amount needed as the preview window is small, so you may need to make several attempts to get the right setting. If the texture is too strong you can use Edit>Fade to reduce the strength. This option to fade an action is really useful as it applies not only to this effect, but also to many actions throughout Painter including individual brush strokes.

1. Open 'Sunflower.'
2. Select the Italian Watercolor Paper in the Papers panel.
3. Open the Effects>Surface Control>Apply Surface Texture dialog box.
4. Ensure that Paper is selected in the Using box.
5. Use the default settings as shown in Figure 7.12 and click OK; this will apply the texture to this picture.
6. One important point to remember is that texture is file size dependent, this is a small file and the texture is very prominent, indeed it is far too strong for the picture, however had the file been a lot larger then the effect would be quite subtle. Undo the texture before trying the next steps.
7. Open the dialog box and while it is open go to the Papers panel and change the paper. The ability to change papers with the dialog box open is very useful, the preview will update immediately so you can assess the likely result.

FIG 7.13 The Amount slider at 25%, 100% and 200%, from left to right.

Texture Source Options

Paper uses the current paper, in this case the Italian Watercolor paper. The paper option applies the texture across the whole picture, not only where it has been painted. This is the big difference between adding the texture at the end rather than applying it as you paint.

Image Luminance bases the texture on the luminance or brightness of the image itself. In effect, this means that you are putting an embossing effect directly upon the picture. The effect is used to add depth and texture to a picture. This is a very effective way to add more emphasis to brush strokes.

FIG 7.14 Two options in the Using dialog box, on the left Paper and on the right Image Luminance.

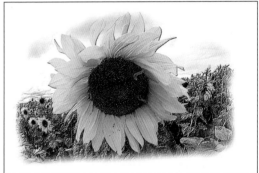

Original Luminance uses the original picture as the source of the texture and applies it to the clone copy. You must have an active clone source before the texture can be applied. The original and clone need not be the same picture as the texture can be taken from any image shown in the Clone Source panel.

3D Brush Strokes compares the original picture with the clone and bases the texture on the difference between the two. This is a little difficult to imagine but it gives a very 3D effect to the brush strokes, particularly when a rough brush and textured paper have been used.

FIG 7.15 Two options in the Using dialog box, on the left Original Luminance and on the right 3D Brush Strokes.

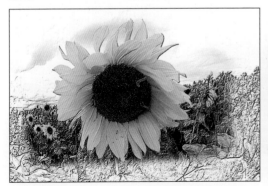
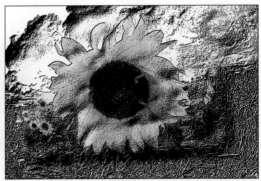

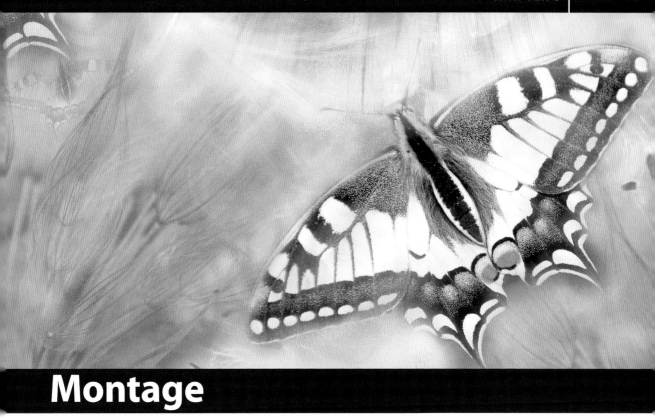

Montage

Montage is a long established technique and originally consisted of cutting documents and photographs and pasting them into a collage. Times have changed and there are now other ways to achieve a similar effect digitally.

The first montage is made up of several photographs put together to create an imaginative interpretation which includes a butterfly and a supporting cast of other images. This uses the Clone Source panel which is new in Painter 12.

The second tutorial shows how to assemble a collage built around a young girl and the miniature horses she works with. By adding several images it shows a wider appreciation of the person than a single portrait.

The final part is a step by step example of a family history montage which involves collating and assembling images on many different layers and blending them together with various composite methods.

Painter 12 for Photographers.
© 2012 Martin Addison. Published by Elsevier Ltd. All rights reserved.

Butterfly Montage

This tutorial is a creative montage with the focus being on a butterfly. Many techniques can be used in creating montages and this one uses the new Clone Source panel to swop between several clone sources to build the necessary textures and image overlays. Before you start, download the folder called Butterfly Montage from the website, this contains all the source images.

FIG 8.2 Original photographs 'Montage 1' and 'Montage 2.'

FIG 8.3 The Clone Source panel with the Open Source Image icon highlighted.

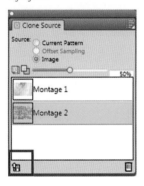

1. Open 'Montage 1.'
2. File>Clone, this photograph will act as a base into which you will clone other images.
3. File>Save as 'Butterfly montage,' save as a RIFF file as this will save the clone sources within the document. Make sure you save at regular intervals in case of any problems.
4. Create a new layer.
5. Open the Clone Source panel (if not already open Window>Clone Source Panel) and click the Open Source Image icon highlighted in Figure 8.3.
6. Select Open Source and select the Montage 2 photograph. The new source image will appear in the list and will be highlighted as the active source. You can swop sources easily by clicking on the one you want to clone from. Save the picture.
7. Select the Cloners>Soft Cloner, size 168 opacity 10% and lightly clone into the image, just enough to see it, don't clone all over (see Figure 8.4).

FIG 8.4 The montage at Step 7.

8. The leaves are an attractive texture, but the green does not suit, so with Layer 1 active, go to Effects>Tonal Control>Adjust Colors and reduce the saturation slider to −138% to make the layer monochrome.

9. In the Clone Source panel click Open Source Image and select the Montage 3 photograph as previously.

10. Turn on the Tracing Paper to see where the butterfly is in the picture, in this case it is in the wrong place, so you will need to move it before cloning and this is how you can do this.

11. Activate the Montage 3 layer in the Clone Source panel and click the Delete Source Image icon to remove this clone source.

12. Open the Montage 3 in Painter, your current montage document can remain open.

13. Select>All, activate the Layer Adjuster tool and click in the picture to lift the image to a layer so that it can be moved.

14. Edit>Transform>Rotate, enter −45 degrees in the dialog box and press Enter to accept. Use the Layer Adjuster tool to move the butterfly into the lower right corner as in Figure 8.5.

FIG 8.5 Montage 3 source image after moving in Step 14.

15. Return to the main image, leaving the recently opened photograph still active on the screen. Ctrl+Tab usually swops between the open documents on screen.

16. In the Clone Source Panel, click Open Source Image again, but this time the image in which you moved the butterfly is listed in the dialog box – all open documents will be listed here, select Montage 3 and it will be added to the Clone Source panel. Save your Butterfly Montage picture and then swop back to the Montage 3 image and close it down without saving. You no longer need this because the image is saved within the RIFF file.

17. Turn on the Tracing Paper and you will see the butterfly in the correct place. Create a new layer.

18. Select the brush Cloner>Soft Cloner, size 168 opacity 10% and clone the butterfly, try not to clone in the background. If you get the background in, particularly the bright pink of the flower, use the Eraser tool, size 33 opacity 30% to erase it. Figure 8.6 shows the picture at this stage.

FIG 8.6 Butterfly montage at Step 18.

19. In the Clone Source panel open Montage 4 and check the position with the Tracing Paper. Once again it is in the wrong place, the seedhead needs to come in from the bottom left corner, so repeat the process as you did last time by deleting the Clone Source reference, open the file, lift the image to a layer, move it to the left and down a bit as in Figure 8.7,

FIG 8.7 Montage 4 source image after moving in Step 19.

then swop back to the Montage file and select the file name in the Clone Source panel. Check the position is OK with the Tracing Paper then save your Montage file and close down the one you have changed.

FIG 8.8 Butterfly montage at Step 20.

FIG 8.9 Butterfly montage at Step 23.

20. Create a new layer and use the Cloners>Soft Cloner brush again, brushing up and outwards from the bottom corner. Figure 8.8 shows the picture at this point. Save the file.
21. The next step is to bring in another picture at the top, add it to the Clone Source panel, once again this is not in the right place, so delete it from the

FIG 8.10 Montage 5 source image after moving in Step 21.

panel, open the picture, move the picture upwards, return to your main document and select it in the Clone Source panel from the list of open files.

FIG 8.11 Butterfly montage at Step 23.

FIG 8.12 The Clone Source panel.

22. Check it is OK using the Tracing Paper, save your montage again and then close down the altered source file.

23. Create a new layer; clone the picture, with brush strokes coming from the top. Reduce the opacity of the layer to about 65% to keep it delicate.

24. Activate Layer 3 (the butterfly layer), right-click and select Duplicate Layer and move it to the top of the layer stack.

25. Move it to the top left corner using the Layer Adjuster tool; just allow the tail of the butterfly to show. Reduce the layer opacity to about 55%.

26. Duplicate Layer 4 (the seedhead bottom left), Edit>Flip Horizontal and move down just to fill the lower right corner. Reduce the layer opacity to about 75%.

27. Move Layer 5 (the seedhead at the top) to the right to balance better.

28. Add Montage 6 as another clone source, create a new layer and clone in some of the textures in the center, keep it light and reduce the layer opacity to around 50%.

29. Copy the butterfly layer again, Edit>Transform>Scale, make it quite small and move the layer down the layer stack. Reduce the layer opacity to make it indistinct and place it in a suitable position.

30. Finally play with the layers, move their position, change the layer opacities to alter the balance. In an alternative version below, the layers were rearranged and the tones made much darker to create a very moody interpretation.

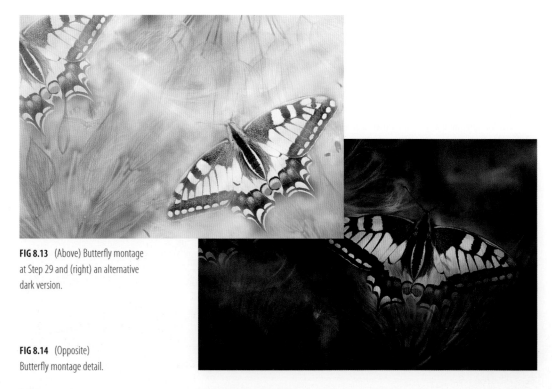

FIG 8.13 (Above) Butterfly montage at Step 29 and (right) an alternative dark version.

FIG 8.14 (Opposite) Butterfly montage detail.

Lucy and her Horses

This montage uses the Chalk and blender brushes to create a composite picture of Lucy and some of the horses she works with. The first step is to create a textured background; this is followed by the images being roughly cloned into the document to get the approximate positions and colors in place. The clone sources are brought in with more detail and the whole picture is blended to harmonize the colors and textures.

Unlike the previous tutorial where you had to move, rotate and reposition the images, in this case the source images have already been resized and placed into position. If you have a clear plan of the layout before you start this is generally the best way to create a composite such as this one.

Download the folder called Lucy Montage from the website; this contains all the source images.

1. File>New. Size 5000 × 3400 pixels 300 dpi. This will print easily up to A3. Name your picture 'Lucy Montage' and save as a RIFF file as this will retain all the clone source images, make sure you save regularly as the more complex the picture, the more important it is that you do not lose it all!
2. Select a color in the Color panel, a dark brown, I suggest setting R66 G40 B4 in the sliders.
3. Edit>Fill>Fill with current Color.
4. Select the Artists Rough paper in the Papers panel.
5. Select the Artists>Sargent brush, size 155 opacity 22%. Uncheck the Clone Color option if it is selected.
6. Open the Color Variability panel (Window>Brush Control Panels) and choose RGB in the drop down menu and set all the sliders at 20%, this adds some color variability to the brush.
7. Select colors in the brown–red range at various densities and paint in the document, the brush strokes will mix with the background and provide an interesting background. Figure 8.15 shows the document at this stage.

FIG 8.15 The background at Steps 7, 8 and 9.

8. Select the Blenders>Grainy Blender, size 155 opacity 100% and blend the picture, just enough to remove the hard edges but not to smooth it too much. The center image in Figure 8.15 shows this.

9. Select the Chalk and Crayons>Square Chalk, size 150 opacity 100%, Grain 30%, Resaturation 0% and Bleed 100%. These settings will change the brush from painting to blending. Blend selectively over the picture, this will leave some stronger brush marks.

10. Change the Grain slider to 12% and selectively blend the brush marks to create a mottled background, as in the picture on the right in Figure 8.15.

11. In the Clone Source panel (Window>Clone Source panel) click the Open Source Image icon, select Open Source and open 'Source 1.' Turn the Tracing Paper on to check it is showing.

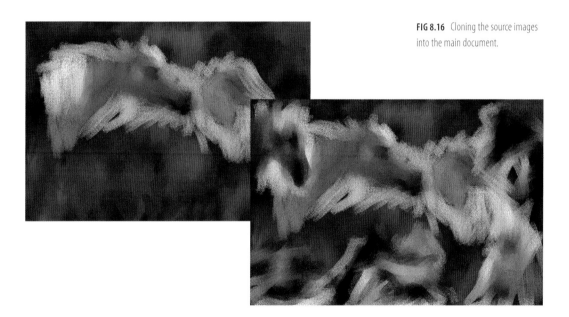

FIG 8.16 Cloning the source images into the main document.

12. Use the same Square Chalk brush, size 146 opacity 100%, Grain 12%, Resaturation 100% and Bleed 50%. Click the Clone Color icon in the Color panel. Clone into the image, the result will be quite rough, which is OK as the intention is to get all the clone sources cloned in roughly. Figure 8.16 shows this stage.

13. Continue to add the other clone sources 1–6 to the picture and clone them roughly in as in Figure 8.16. Remember to save your file at regular intervals.

14. Deselect the Clone Color option so that the brush paints color rather than cloning. Use size 169 opacity 100% and Grain 12%, hold down the Alt/Opt key and select colors from the image and paint in the areas you have not cloned into. Select most of the colors from adjacent areas, but

also take some colors and take them to different parts of the picture, this helps to harmonize the colors. Figure 8.17 shows the picture at this stage.

15. The next stage is to bring in more detail from the clone sources. Create a new layer. Click on Source 1 in the Clone Source panel and using the same brush, size 43 opacity 100%, Grain 15% and with Clone Color active, clone in the picture. Concentrate on the horse and Lucy and try not to bring in too much background, especially avoid going into the empty areas of the clone source as these will show as white. Make the brush smaller to clone details in the face and horse's head, down to 15 initially and then to 3 for the finer details. Figure 8.17 shows the picture at this point.

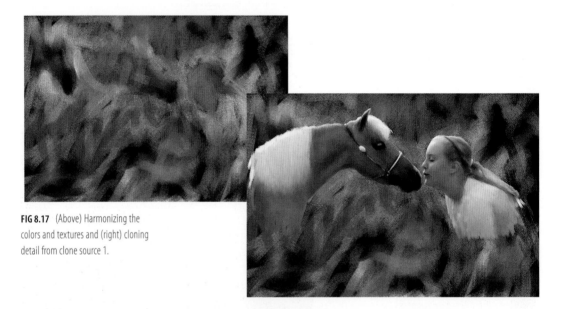

FIG 8.17 (Above) Harmonizing the colors and textures and (right) cloning detail from clone source 1.

16. Create a new layer, click on Clone Source 4 and clone in the horse in the same way as previously. Continue with the other clone sources, make new layers for each.

17. Before starting the next step check over what you have done so far and add extra detail where necessary. If you have cloned too much background it can be removed by using the eraser. Save the file.

18. Select the Square Chalk brush again, size 60 opacity 50%, Grain 15%, Resaturation 0%, Bleed 100%. Untick the Clone Color option. This brush will be used to blend the background. Create a new layer and make sure that the Pick Up Underlying Color icon is active. The icon is the center of the three near the top of the Layers panel and shows as blue when active. With this option turned off, blending on an empty layer would have no effect, with it turned on the blender will pull colors from all the underlying layers.

Applying Paper Textures to a Layer

This technique will apply the textures onto a separate layer rather than putting them directly on the image. The advantage in doing this is that the image remains unchanged and the texture is adjustable at any time as it is not part of the picture.

There are several ways of achieving this, a duplicate copy of the canvas can be made, and the texture applied to this. Reducing the layer opacity will lessen the effect. Any type of texture can be applied and adjusted in this way.

The process shown below will involve making a new layer and applying the texture to that layer.

1. Open 'Poppy.'
2. File>Clone.
3. Click the new layer icon in the Layers panel to make a new layer.
4. In the Color panel select 50% gray (move the RGB sliders until they read 128 for each color).
5. Edit>Fill>Fill with Current Color.
6. Change the Layer Composite Method to Overlay and the gray color will be hidden.
7. Effects>Surface Control>Apply Surface Texture. Select Original Luminance in the Using menu and make the Amount 100%. Click OK.
8. You can reduce the layer opacity to fine-tune the effect.
9. Change the Layer Composite Method to Hard Light and Soft Light and see how the texture looks different each time, for more extreme changes try Multiply and Screen. Figure 7.16 shows the layers panel with the gray layer in Overlay Composite Method.

This technique can use the Paper, Original Luminance and 3D Brush Strokes textures but not Image Luminance, as it is being applied to a layer empty of imagery.

FIG 7.16 The layers panel with surface texture on a separate layer filled with gray and in Hard Light method.

FIG 7.17 The picture before and after changing the layer composite method to Overlay.

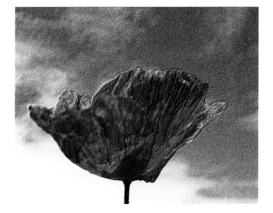

Creating Pictures with Textures

Having made your own texture for use with cloning, it is worth considering other ways in which this technique may be used. In the example which follows the paper texture is created from a clearly recognizable shape and the texture is stamped into a document using colored inks. The first stage is to make a black and white single tone picture and that is done by using the Woodcut effect. There is more about the Woodcut effect in the Special Effects chapter.

1. Open 'Gladioli.'

FIG 7.18 The original photograph and the Woodcut dialog box showing the settings used in this example.

2. Effects>Surface Control>Woodcut.
3. Tick the Output Black option and remove the tick from Output Color.
4. Move the sliders to Black Edge 64.94, Erosion Time 0, Erosion Edge 1.0 and Heaviness 50%. Figure 7.18 shows the settings used.

FIG 7.19 The result of the Woodcut effect being applied and after the unwanted edges have been erased.

5. When the filter has been applied the flower has a lot of black marks around the edges, nothing is visible in the original, but this is actually the

result of some not-so-good masking on the original! The Woodcut effect has picked up these small variations from pure white and applied the filter to them.

6. Use the Eraser from the Toolbox, size 88 opacity 100%, to remove all the black marks which do not belong to the flower.
7. Select>All.
8. Select Capture Paper in the Papers panel menu, type in a name for the paper in the dialog box that appears and click OK. Close the Woodcut picture.
9. Your new paper texture will appear at the bottom of the Paper Libraries panel, click the name to make it ready for use.
10. Make a new document: File>New, width 2783 and height 3374 pixels at resolution 300 pixels per inch.
11. Select the Charcoal & Conte>Square Conte brush, size 149 opacity 12%, grain 1%.
12. Make sure that the Gladioli paper is active and in the Papers panel click the Invert Toggle button, this is highlighted in Figure 7.20. Choose a color in the Color panel. Keep the colors fairly dark, I started with R127, G9 and B141, but it is not critical. Paint until the whole flower is visible.
13. Now paint over again with other colors, use dabbing brush strokes so that the colors blend, rather than running in lines.
14. Texture can be added to this image to give it more depth.

FIG 7.20 The Papers panel after inverting the paper. Note the name of the paper (gladioli) is shown together with the size. The Invert Toggle icon is highlighted.

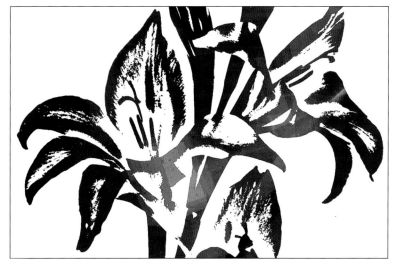

FIG 7.21 After applying the color.

15. Effects>Surface Control>Apply Surface Texture. Amount 200%, picture 100%, shine 100%. In the Using box select Image Luminance.
16. Apply the texture a second time.

There is an alternative version of this picture at the very start of this chapter; in that picture the canvas was filled with black prior to painting and lighter colors were painted onto the canvas. Textures were also applied.

Using Paper Textures for Stamping

Another way to use texture shapes is to apply them like rubber stamps. This is a technique often used by card makers, but making them in Painter means not having to buy lots of individual stamps!

1. Open 'Thistle.'
2. Effects>Surface Control>Woodcut.
3. Tick the Output Black option and remove the tick from Output Color.
4. Move the sliders to Black Edge 16, Erosion Time 20, Erosion Edge 1.0 and Heaviness 50%. Use the Eraser to remove all the black areas around the thistle.

FIG 7.22 Thistle picture as a woodcut.

5. Select the whole picture and in the Papers panel options menu, capture the thistle as a paper texture, name it Thistle 1.
6. Using a square selection, select just the thistle head and capture the texture, name it Thistle 2.
7. Make a new document 3795 × 2740 300 dpi, this is quite a large document but the last stage normally involves cropping so the final picture will be smaller.

FIG 7.23 Painting with the paper texture using different colors.

8. Select the Chalk & Crayons>Blunt Chalk brush, size 127 opacity 6%, grain 12%.
9. Make a new layer.
10. Select the Thistle 1 paper texture in the Papers panel.
11. Select a color and paint in the design. Use dark colors and have the paper scale at 100%. Use the Eraser in the toolbox to remove any unwanted parts of the tile.
12. Make a new layer.
13. Increase the paper scale to 250% and select a different, lighter color and paint again. This will be larger and fainter than the previous layer, move the layer below the first layer and reduce the layer opacity.
14. Make a new layer.
15. Select the Thistle 2 paper texture in the Papers panel, increase the size and paint again. Continue painting more layers at different opacities and colors.
16. The reason for painting on new layers each time is that they can be copied, moved, transformed in size and their opacities changed to get the design just right. If the thistle is not in the right place use the Transform tool from the toolbox to change the size and the Layer Selector tool to move the layer around. Using a large size canvas gives you the space to move the layers around.

FIG 7.24 Thistle, created using the thistle captured paper and different colors.

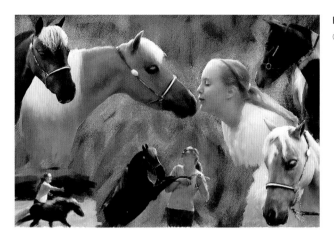

FIG 8.18 All the source images cloned as in Step 17.

19. Blend all of the background, blending particularly where each of the source images join. Use smaller brush sizes and a lower opacity when blending near to the horses and Lucy, try size 17 at 20%. You can also blend any areas of the horses which look too rough, but don't blend too much. Make final adjustments with the tonal controls.

FIG 8.19 The completed picture.

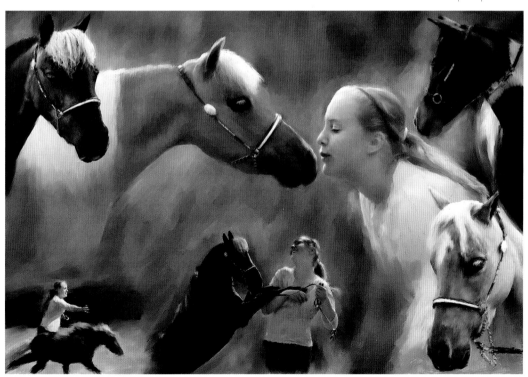

Family History Montage

In recent years there has been an explosion of interest in genealogy and alongside this a desire to collect and display old photographs in imaginative ways; this includes both scrapbooking and creating montages on the computer.

Painter is an ideal tool for this as it allows both the collation of the pictures, and the ability to add some artistic embellishment while leaving the originals intact for future generations.

In this tutorial the montage is made using various aspects of Layers, including Layer masks, Layer Composite Methods and color adjustments.

When you create your own montage the material will vary but the techniques described here should provide you with lots of ideas on how to combine images.

FIG 8.20 Assembling the source material.

The first step is to collect together all the material which you may need, this could include photographs, letters, materials and personal effects which may need to be scanned using a flat bed scanner or photographed. In this case of course I have already made the selection for you.

The next step is to work out a rough plan of the design, it can be tempting to throw things together as you go, but it really helps a lot if you have a plan to start with. The plan does not need to be very detailed and will almost certainly change as you develop your ideas. When you make your own picture, decide on the most important elements which are relevant to the person or family and concentrate on fitting those together, other less important elements can be added in later. There is a tendency to put too much in, so if you have a lot of good pictures it is often better to make a series of pictures, each illustrating a particular aspect. For an example of how this can be achieved, look at my personal website (www.martinanddoreen.co.uk) where my wife Doreen has created a series of panels illustrating her own family history. These were made in Photoshop several years ago, but could also have been made in Painter.

Open all the pictures in a browser, I used Bridge but any browser will do, alternatively you could use the originals and lay them out on the floor. Then

having selected the ones which are the most important to the story sketch out a quick layout on a piece of paper, this will help with the overall design. For this project I opened a blank document in Photoshop and dragged the pictures in and moved them to roughly the correct position, some I resized to fit. After moving things around quite a bit, this gave me a reasonable idea of how the picture might look. Figure 8.21 shows the rough plan; I printed a copy of this to act as a guide. I made lots of adjustments as I built the picture, but the content and overall design is very similar.

FIG 8.21 Rough plan.

A word of warning, I use copy and paste a lot in this tutorial, but unfortunately I have encountered a problem with this in the current version of Painter, if it does not work you can either have both files open on the desktop and use the Layer Adjuster Tool to drag from one document to the other, or save your file and close down Painter, when you open it again it will normally work again.

1. Download the folder entitled 'Family History montage' from the website which contains all the source images.
2. Create a new document in Painter, width 27.7 cm, height 21.0 cm and Resolution 150 dpi, save the file.
3. Open '01 geneva.'
4. Select>All, Edit>Copy.
5. Click back into the new empty document and Edit>Paste to drop in the picture; this fills the whole picture area. Close down the Geneva file.
6. Open '02 children.'
7. Select>All, Edit>Copy and then paste into your montage document and move into position as previously.
8. The white border needs to be removed so use the Magic Wand in the Toolbox. On the Properties bar change the tolerance to 47 and click in the white area. This will select the white and Edit>Cut will delete it.
9. This picture is too large so use the Transform tool from the toolbox to reduce to the size you can see in the finished picture. The Transform tool is hidden behind the Layer Adjuster tool. Hold down the Shift key and click and drag the corner handles to change the size. Holding the Shift key stops the picture from distorting. Click the tick on the Properties bar

to accept the transformation. Other options for scaling and distorting are also on the Properties bar.

10. Activate the Layer Adjuster tool and move the picture down to the bottom.

11. Change the Layer Opacity Method to Hard Light. Using this method removes a lot of density from the layer. It has, however, revealed a black line in the snow on the Geneva layer (Figure 8.22). Remove this by clicking the eye icon off in the children's layer and clicking in the Geneva layer to activate.

12. Using the Rubber Stamp tool from the Toolbox, hold the Alt/Opt key and click in the snow just beneath the mark to set the source point and clone until the mark has disappeared.

13. Reduce the layer opacity of the Geneva layer to 37%.

FIG 8.22 Bringing in the children layer.

14. Return to the Children layer, make a Layer Mask by clicking the icon at the bottom of the Layers panel, this is the fourth icon from the left.

15. Click in the layer mask thumbnail to activate it. Be very sure that you do this every time you make a layer mask otherwise you will find yourself painting into the layer by mistake (it is very easy to do this!).

16. You now need to paint in the layer mask and to do so you need a soft light brush. Sadly there does not seem to be one as a default variant in Painter, but it is easy to make one. Select the brush Cloners>Soft Cloner, set it back to default settings. In the General panel change the Method to Cover and the Subcategory to Soft Cover. Make the size 78 and opacity 20%. Because it is such a useful brush for masks and because you will often use the Soft Cloner for other purposes, I suggest that you save this variant with the name 'Layer Mask brush.' See the Customizing Brushes chapter if you do not know how to save brush variants.

17. Use the new brush you just created and select black in the Color panel. Paint in the image (with the layer mask active you will actually be hiding parts of the layer) leaving only the children visible.
18. It is a good idea to label the layers as you go, this will make it easier later to make the final adjustments, do that now by double-clicking the layer in the Layers panel and naming the layer. Don't forget to save the document frequently!
19. Open '03 Charles.'
20. Copy and paste as before, move into position and resize if necessary.
21. Make a Layer Mask and paint out the edges to make a rough oval. All the masks created will be adjusted later, so there is no need to be too precise at this stage (Figure 8.23).
22. Open '10 watch.'

FIG 8.23 Charles layer after masking.

23. Copy and paste as before, move into position and resize if necessary.
24. Remove the white areas with the Magic Wand as before.
25. Position the layer so that his head is enclosed within the inner part of the watch face.
26. Change the Layer Composite Method to Hard Light and reduce the layer opacity to 47%.
27. Make a layer mask and with the new masking brush, paint out the center of the watch to make the face clear (see Figure 8.24).
28. Open '05 Headed notepaper.'
29. Copy and paste as before, move into position and resize if necessary (see Figure 8.25).
30. Change the Layer Composite Method to Hard Light and reduce the layer opacity to 47%.
31. Create a layer mask and paint along the bottom and right edge to make a soft edge.
32. Open '04 rickshaw.'
33. Copy and paste as before, move into position and resize if necessary.

FIG 8.24 The watch layer.

34. Change the layer opacity to 85%.
35. Create a layer mask and paint out most of the top and right, and also the bottom to reveal the word Genève if that is hidden.
36. Open '06 old car.'
37. Copy and paste as before, move into position and resize if necessary.
38. Change the Layer Composite Method to Hard Light and reduce the layer opacity to 79%.
39. Move the layer until it is positioned just over the six children. Create a layer mask and paint out the area around the top and sides of the car. Soften the lower edge to keep it clear of the children (Figure 8.25).
40. Open '08 Charles and mum.'
41. Copy and paste as before, move into position and resize if necessary.
42. Change the Layer Composite Method to Luminosity and reduce the layer opacity to 67%.

FIG 8.25 Old car layer after masking.

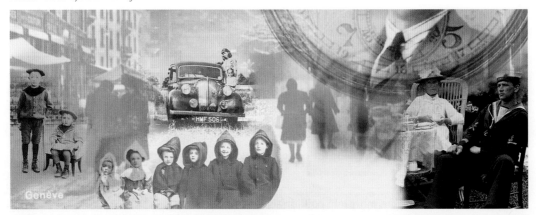

43. Create a layer mask and paint out the space to the top and left of the figure to soften the edges.
44. Open '11 certificate.'
45. Copy and paste as before, move into position and resize if necessary.
46. Change the Layer Composite Method to Darken and reduce the layer opacity to 58%.
47. Create a layer mask and paint out the crest on the left.
48. Open '12 Agnes.'
49. Copy and paste as before, move into position and resize if necessary.
50. Adjust the layer opacity to 66%.
51. Open '09 letter.'
52. Copy and paste as before, move into position and resize if necessary.
53. Change the Layer Composite Method to Darken.
54. Resize it to the size you see in the finished file.
55. Create a layer mask and paint out the edges, also where the letter overlaps the face. Paint lightly over most of the layer to lighten the overall appearance of the text. It should be visible, but not obtrusive (Figure 8.27).
56. Reduce the layer opacity to 75%.
57. Open '13 medallion.'
58. Copy and paste as before, move into position at the bottom left of the montage and resize if necessary.
59. Change the Layer Composite Method to Lighten and adjust the layer opacity to 66%.
60. Create a layer mask and paint out the center of the layer.
61. Because these pictures have come from different sources and have different colors it is usually better to harmonize the colors by adding a color layer.

FIG 8.26 Final Layers panel.

FIG 8.27 Letter and Agnes layers.

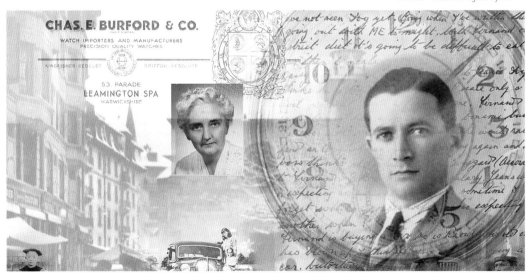

62. Create a new layer.
63. Choose a color in the Colors panel; it should be as close as possible to the sepia color present in the main picture. I used Red 205, Green 161 and Blue 87; this color can be accurately selected by moving the sliders in the Color panel.
64. Edit>Fill>Fill with Current Color.
65. Change the Layer Composite Method to Colorize and adjust the layer opacity to 32%, this will reduce the level of the color to a light overlay.
66. Finally it is time to step back and review the picture and then to adjust the opacities, size and position of the many layers and make any adjustments you feel are necessary. One example of this fine tuning is that the layer for Agnes has a building showing from a lower layer in the stack. This spoils the portrait so to correct this, create a new layer beneath the Agnes layer and then paint on this layer with white until the portrait is clear, the Airbrush>Soft Airbrush would work well for this.

That completes this example of a family history montage, you may well like to try one of your own, I am sure that your relatives would be very pleased to have a copy.

FIG 8.28 Final montage and (right) a detail.

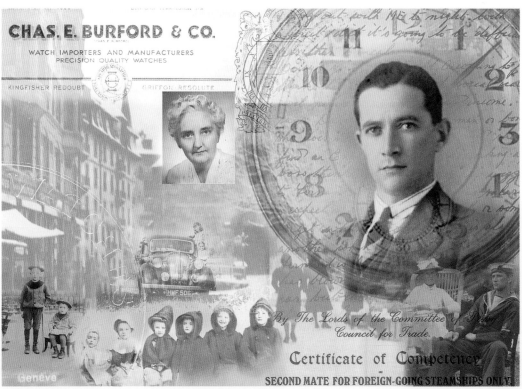

& CO.

CTURERS

ON RESOLUTE

PRECISION

HMF 506

By The Lords of the Committee
Council for Trade.

Certificate of Compet

as

SECOND MATE FOR FOREIGN GOING STEA

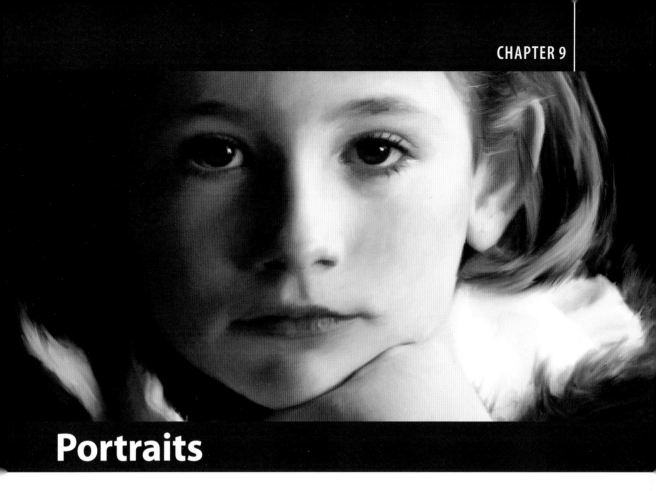

Portraits

In this chapter a variety of brushes are used to create portraits of people of many ages.

Brush categories which I find particularly valuable for portraits are the Pastel and Chalk and there is a step by step example using the Pastel brushes which are great for making light delicate portraits.

Another traditional style of painting is Oils, where the rich textures give a much more substantial finish with some lovely brush textures.

As always when making portraits in Painter it is for you to decide just how painterly they should appear. The step by step examples included here are all fairly close to the original photographs; however, this is just a matter of choice and you can decide whether to make any one more impressionistic by increasing the amount of painting.

219

Cloners: Baby

There are hundreds of brushes in Painter to choose from, but sometimes a picture just needs the simplest of treatment and this is the case here. The result of this exercise will be a light, very delicate interpretation of the original photograph, so before starting to clone the first steps are to significantly lighten the picture.

FIG 9.2 Original photograph.

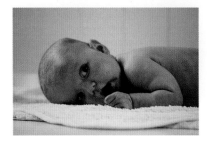

1. Open 'Baby.'
2. Effects>Tonal Control>Correct Colors.
3. Increase the Brightness to 100%; this will make it very light. Should you wish to lighten it further you cannot move the slider any further, so you simply apply the effect a second time.
4. File>Save As, give it a new name.
5. File>Quick Clone.
6. Select the Cloners>Soft Cloner, size 341 opacity 9%.
7. Paint the picture very lightly leaving the edges white.
8. Reduce the brush size to 107 and paint just the eyes and face until it is clear.
9. Effects>Tonal Control>Correct Colors. Increase the Contrast slider to +20%, this will give it a little more definition.
10. Effects>Tonal Control>Adjust Colors. Reduce the Saturation to −25%.

FIG 9.3 The completed picture.

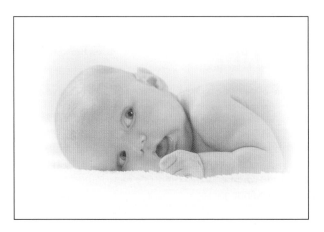

FIG 9.4 Detail from the completed picture (opposite).

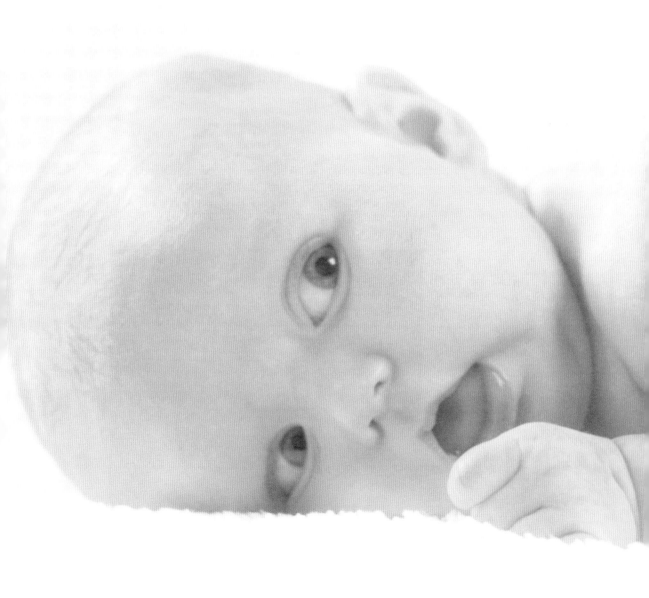

Pens: Jesse

This picture uses the Dry Ink brush which is quite roughly textured when used at a large size, but can reveal a lot of detail at smaller sizes.

1. Open 'Jesse.'

FIG 9.5 Original photograph.

2. File>Quick Clone.
3. Select the Pens>Dry Ink brush, size 41 opacity 100% and click the Clone Color icon in the Colors panel.
4. Paint over the face following the lines of the head and main features.
5. Increase the brush size to 85 and paint all the background.

FIG 9.6 Steps 4 and 5. Painting the face and background.

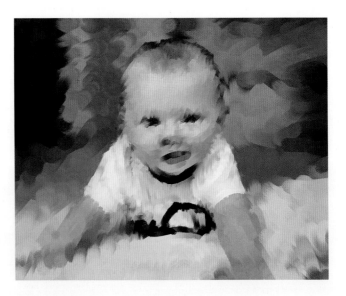

6. Reduce the opacity to 15% and paint over the background again, this will blend and soften the brush marks.
7. Reduce the brush size to 12, increase the opacity to 100% and paint over the face, following the features carefully. Turn the Tracing paper on and off to see where to place the strokes. Use brush size 20 to paint the shirt and emphasize the darker folds of the material.

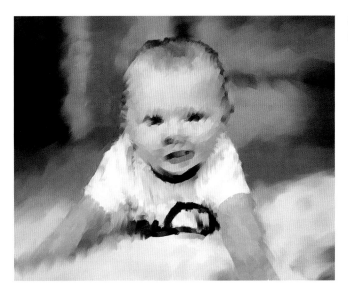

FIG 9.7 Step 6. Blending the background.

8. Reduce the brush to size 8 and the opacity to 63% and bring back some detail in the eyes, nose and mouth. The small brush will paint more detail but will be very hard, so the lowered opacity will soften the brush strokes slightly. Make the picture larger on the monitor and take your time, lots of small light brush strokes are needed to get this stage completed well.
9. Paint the ears with this brush and work to a lesser extent over the hair.
10. Continue over the clothes, just bringing out the folds and the edges of the sleeves.

FIG 9.8 Steps 7 and 8. Painting more detail into the face.

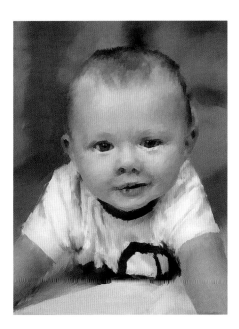
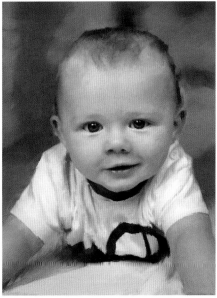

11. Reduce the brush size to 6 and bring some more detail into the eyes.
12. In order to make some final tonal adjustments it is advisable to create a copy of the canvas, so Select>All, Edit>Copy and Edit Paste in Place will do this.
13. Effects>Tonal Control>Adjust Colors, add about 10% Saturation. In Painter 12 the change can be seen on the whole picture which is a great improvement.
14. Effects>Tonal Control>Equalize. Move the sliders to 98.8% Black and 3.9% White. This will brighten the picture. The reason for adding tonal adjustments on a new layer is that you can adjust the opacity later if you find it is too strong.

FIG 9.9 Steps 13 and 14. Improving the tonal balance.

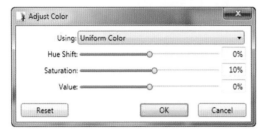
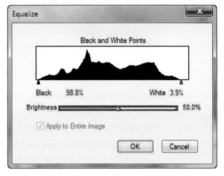

FIG 9.10 The completed picture.

FIG 9.11 Detail of completed picture (opposite).

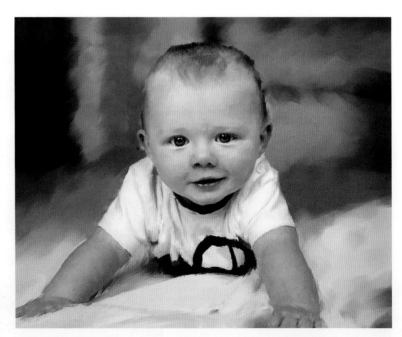

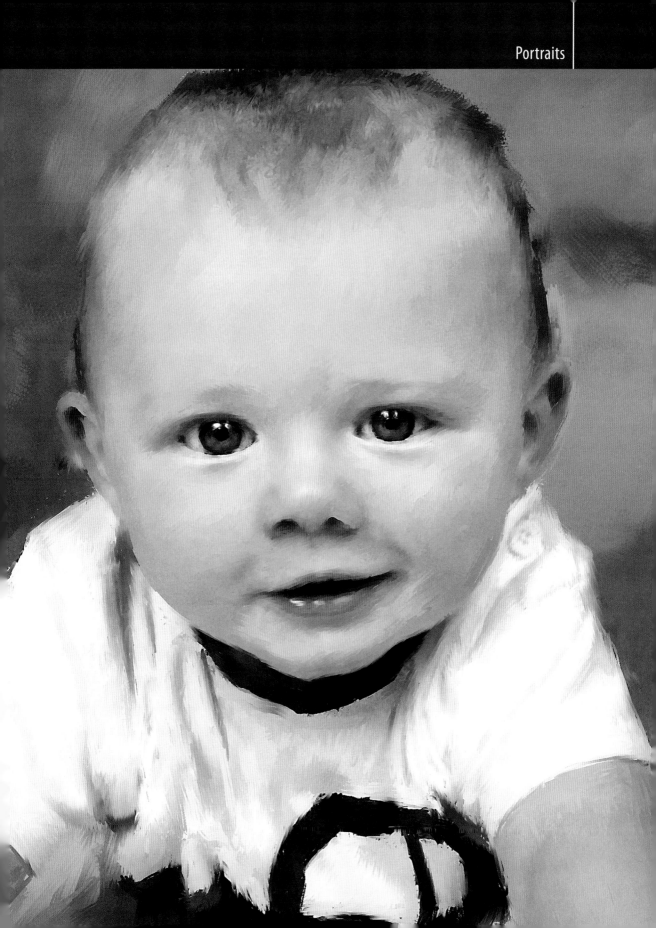

Gel and Layers: Toby

This picture uses the new Gel brushes and their ability to use merge modes. It also includes the use of Layer Composite Methods. The result is a very colorful impression of a child at play.

1. Open 'Toby.'

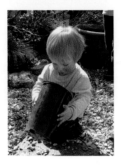

FIG 9.12 Original photograph.

2. File>Quick Clone.
3. Select the Gel>Gel Fractal brush, size 80 opacity 100%. In the General panel (Window>Brush Control Panels) change the Stroke Attributes to Color. Select the Clone Color option in the Colors panel.

FIG 9.13 Left: Step 4.
Right: Step 10.

4. Paint the picture; it will be a loose interpretation of the colors in the picture showing no detail.
5. Now to move the Canvas onto a layer. Select>All then activate the Layer Adjuster tool and click anywhere in the picture area.
6. Right-click the layer and select Duplicate Layer.
7. With the top layer active go to Effects>Focus>Soften. Select Gaussian and 35 as the amount. The intention is to soften the edges a little, but this softens the picture rather too much so reduce the layer opacity to 50%.
8. Create a new layer and change the Layer Composite Method to Screen.
9. Select the Cloners>Soft Cloner, size 150 opacity 20%.
10. Paint the figure but not the background. This will show a rather delicate outline, a little too delicate perhaps so the next step will add some clarity.
11. Create a new layer and change the Layer Composite Method to Soft Light.
12. Paint the figure again with brush opacity 20% and you will see a strengthening of the detail. Make sure not to paint the background as you need to limit the amount of reality!
13. Now to add a bit more mystery to the picture you are going to add some stars.

FIG 9.14 Left: Step 17.
Right: Step 18.

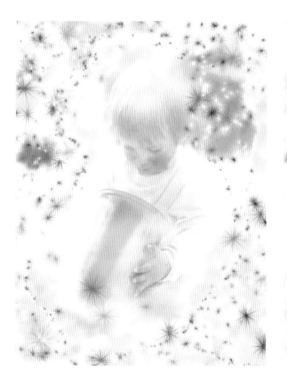
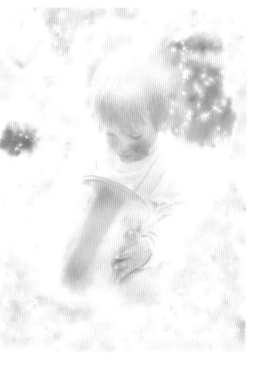

14. Create a new layer.
15. Select the F-X>Fairy Dust brush, size 103 opacity 80%. The Clone Color option should not be checked, select any mid-tone color.
16. Open the Color Variability panel (Window>Brush Controls>Color Variability) and push all three sliders full to the right, this will vary the color, the saturation and the value (brightness).
17. Use several different brush sizes between sizes 50 to 220 to spray stars all around the child.
18. Change the Layer Composite Method to Lighten.
19. Copy the layer and change the Layer Composite Method to Normal and reduce the layer opacity to 25%, this will bring back some of the color.
20. There are two areas which are too dark and distract from the face, one just behind his head and one on the left.
21. Create a new layer.
22. Select the Airbrushes>Digital Soft Pressure Airbrush, size 118 opacity 10%. Select white in the Color panel and paint over those two areas. The opacity is very low so you may need to paint over a few times, it is more controllable to do this in several low opacity brush strokes rather than try to get it right in one stroke.

FIG 9.15 Left: Step 19.
Right: Step 22.

That completes this colorful picture of Toby.

FIG 9.16 Detail from the completed picture (opposite).

Real Watercolor: What's This?

This demonstration uses one of the new Real Watercolor brushes introduced in Painter 12. I particularly like the Fractal brushes as they give beautiful textures. Layers will also be used to give the picture a lightness and delicacy.

1. Open 'What's this?'
2. File>Quick Clone.
3. Select the Real Watercolor>Fractal Wash Fringe brush, size 102 opacity 23%. Click the Pause Diffusion icon on the Properties bar, it is the one to the right of the Grain slider that looks like a Pause button. It is blue when active.
4. Paint over the whole picture, but try not to overpaint too much. This brush makes some very attractive marks.
5. Create a new layer.
6. Select the Cloners>Soft Cloner, size 166 opacity 14%.
7. Paint the figure lightly but not the background, this will bring back clarity to the child.
8. Save the layered file then File>Clone to make a new copy to work on.
9. Create a new layer and then Edit>Fill with Clone Source to make a duplicate of the canvas.
10. Effects>Focus>Soften, use Gaussian and move the slider to 50.
11. Change the Layer Composite Method to Screen, this will make the picture very high key and delicate.
12. Reduce the layer opacity to about 65% to reduce the brightness and allow some of the background colors and textures to show through.

FIG 9.17 Below:
Left: Original photograph.
Right: Step 7.

FIG 9.18 Detail from the completed picture (opposite).

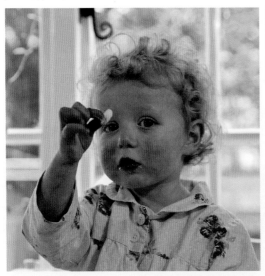

Layers: Amy

This demonstration shows the power of Layer Composite Methods to quickly enhance a picture and shows how to use a variety of techniques to add those all-important finishing touches to a portrait.

1. Open 'Amy.'

FIG 9.19 Original photograph.

2. File>Clone.
3. Select>All, Edit>Copy, Edit>Paste in Place to create a copy of the canvas.
4. Edit>Paste in Place again to make another copy, you should now have three identical layers including the canvas.
5. Turn off the visibility of the top layer and make the second layer active.
6. Effects>Tonal Control>Adjust Colors. Take the Saturation slider all the way to the left to make it monochrome.
7. Turn off the visibility of the monochrome layer and make the top layer visible and active.

FIG 9.20 Picture at Step 10. Left: Mono layer at zero opacity. Right: Mono layer at 100% opacity.

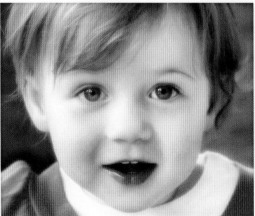
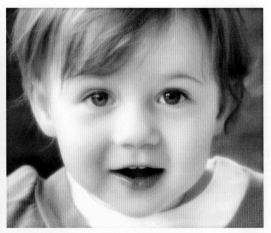

8. Effects>Focus>Soften. Use Gaussian and move the slider to about 50, this will significantly blur the picture.
9. Change the Layer Composite Method to Screen. This will add a delicate glow.
10. Turn the visibility of the monochrome layer back on and by adjusting the layer opacity of the color layer you can control the strength of the color very easily. If you like the full color version make the opacity 100%, or for a delicately colored version make the opacity 50%, or anywhere in between. I left it at 100%.
11. Duplicate the top layer (right-click the layer) and change the Layer Composite Method to Saturation, this will increase the Saturation; adjust the layer opacity slider to reduce the effect if necessary.
12. Adding the extra layers has revealed that the left side of her face is too bright, so to balance the picture you are going to make two tonal adjustment layers as follows, which can be adjusted at any time.
13. Create a new layer and in the Color panel make all of the RGB sliders read 127; this is a mid-gray color.

FIG 9.21 Picture at Steps 11 and 18. Left: After adding the Saturation layer. Right: After using two gray layers to adjust the tones.

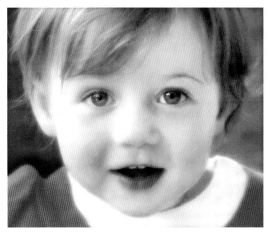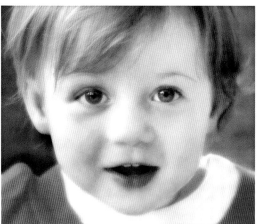

14. Edit>Fill>Fill with Current Color.
15. Change the Layer Composite Method to Overlay, the gray can no longer be seen. Rename it Lighten (click on the word layer in the Layers panel).
16. Duplicate the layer and rename it Darken.
17. Select the Airbrushes>Digital Soft Pressure Airbrush, size 100 opacity 10%.
18. With the Darken layer active, change the painting color to black and paint over the light side of her face. When you paint with black or dark gray in the layer it will darken the layers beneath. This is a very flexible way to adjust tones without having to make selections. If it is too dark you can either paint with a dark gray rather than black, or reduce the layer opacity.

19. In the Lighten layer you do the opposite and paint with white or light gray and the layers below will be lighter. Paint the right side of the face, only a very little is required. Although you could both lighten and darken on the one layer, I find it more flexible to use two layers as you can adjust the layer opacity later.

20. The right side of the face has more yellow than the left and I think the picture would look better if this was balanced, so two more layers are called for.

FIG 9.22 Picture at Steps 23 and 28. Left: After adjusting the color. Right: After using the Just Add Water brush.

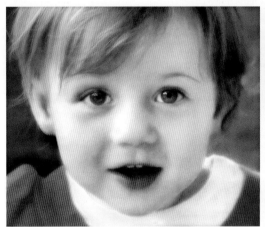
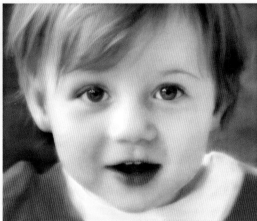

21. Create a new layer at the top of the layer stack and change the Layer Composite Method to Colorize.

22. Select the Airbrushes>Digital Soft Pressure Airbrush, size 100 opacity 45%. Hold the Alt/Opt key and click in the yellow area of her right cheek to select the color. Paint the left cheek. You may not see much change while you paint, but turn the layer visibility on and off afterwards and you will see the change very clearly.

23. Create another new layer and change the Layer Composite Method to Colorize.

24. Do the same again, this time picking the color from the left cheek and painting it into the right cheek to remove some of the yellow. You will need to reduce the layer opacities of both layers to get the right balance.

25. The next step is to soften the hair and clothes with blenders and for this you need to either drop all the layers, or to save the layered file and work on a new one which is the method I prefer.

26. Save the layered file in case you need it later.

27. File>Clone, this will create a flattened version on which you can continue to work.

28. Create a new layer, then Edit>Fill>Fill with Clone Source; this will make a copy of the canvas.

29. Select the Blenders>Just Add Water brush, size 102 opacity 20%, and on the top layer blend the clothes and background. Reduce the opacity to 10% and paint lightly over the face to smooth the skin where necessary. Just Add Water is a great brush for smoothing out blemishes in portraits, always use at a low opacity.

30. Duplicate the top layer and select the Blenders>Grainy Blender, size 20 opacity 100%. Blend the hair following the lines of the hair. This will soften the noise from the dark areas of the digital file.

FIG 9.23 Picture at Steps 30 and 32. Left: After blending the hair. Right: After airbrushing the background.

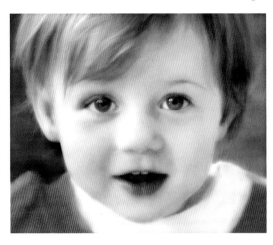 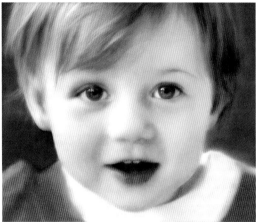

31. Select the Blenders>Blender Bristle brush, size 12 opacity 50%. Hold the Alt/Opt key and click in the lighter colored hair on the left and start painting in the darker area top right. This brush starts to paint with the color selected and then continues to blend it into the existing color, so

FIG 9.24 The Layers panels for both documents.

235

make a stroke and continue without lifting the stylus until the color has been blended. This will add some lighter colors into the darker areas.

32. The background needs some extra work to stop it being distracting, in particular the dark edge above her left shoulder. Select the Airbrushes>Digital Soft Pressure Airbrush, size 63 opacity 20%.

33. Duplicate the top layer again, sample a lighter green from nearby then paint over the darker area. Select colors from several places to avoid the color being uniform. The background on the right hand side is rather too similar to the hair color, so using the same green, paint over the brown until it is a better balance with the other side. Adjust the layer opacity.

34. The catch light in the eye is too photographic and shows the reflection of a window, so you need to paint over this to make a single catch light. Select the Blenders>Blender Bristle brush, size 11 opacity 13%. Identify the brightest part of the catch light and Alt/Opt click to select that color. Paint and blend the catch light until it becomes a single bright catch light in each eye. That completes the picture of Amy.

FIG 9.25 The completed picture (below).

FIG 9.26 A detail from the picture (opposite).

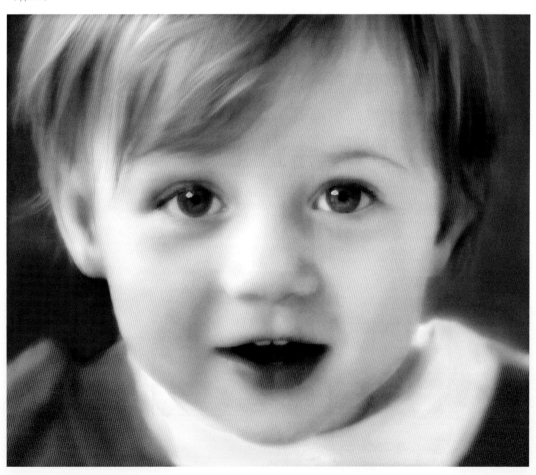

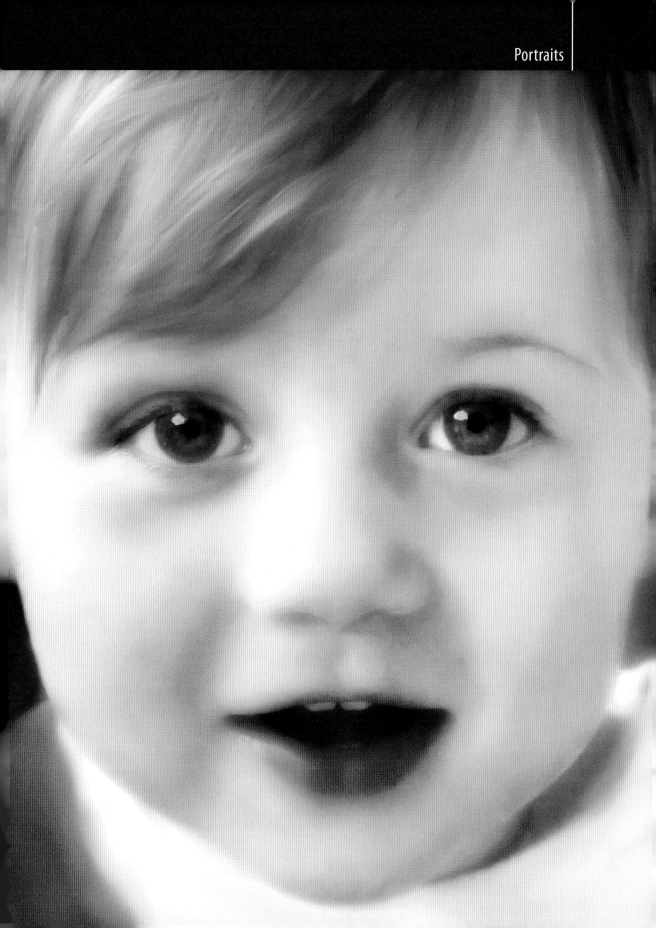

Montage: When I Grow Up

Painter 12 makes cloning from more than one photograph easy, the new Clone Source panel shows all the sources and you can simply click the one you want and continue cloning. The two pictures used here have been prepared in Photoshop, the background has been copied and flipped and the girl resized. This is much easier in Photoshop, but if you are just using Painter, there are examples of how to do this in the chapter on Montage.

1. Open 'When I grow up 1.'

FIG 9.27 Original photographs.

2. File>Quick Clone.
3. Select the French Watercolor paper from the Papers panel.
4. Select the Digital Watercolor>Coarse Dry Brush, size 65 opacity 10%. Select the Clone Color option.
5. Using the Tracing Paper as a guide, paint the background with long brush strokes following the lines of the clothes. The result should be an underpainting with a delicate paper texture and color (Figure 9.28).
6. Select the Cloners>Soft Cloner, size 100 opacity 10%, and clone the dresses in very lightly. Try not to include the hangers or background, just the dresses.

FIG 9.28 Step 6.

7. Open the Clone Source panel (Window>Clone Source). Click the Open Source Image icon and select Open Source.
8. In the Open dialog box select 'When I grow up 2.' Figure 9.30 shows the Clone Source panel at this point.
9. Using the same brush, paint in the child. The picture has a white background which could be a problem in many pictures, unfortunately even if the picture had been cut out previously Painter will not retain transparency under the new system of cloning, which is a great pity, but no doubt this will be improved in future versions. In this case it will help to keep the picture very delicate, so clone some of the white background over the darker areas of the background (Figure 9.29).

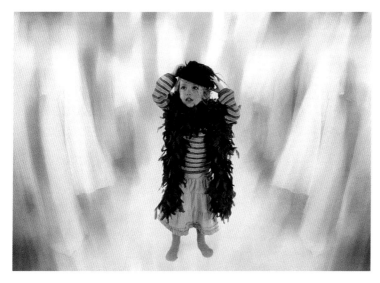

FIG 9.29 Step 9.

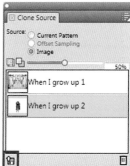

FIG 9.30 The Clone Source panel.

10. Make a copy of the canvas (Select>All, Edit>Copy, Edit>Paste in place).
11. Effects>Focus>Soften, use about 50.
12. Change the Layer Composite Method to Screen and reduce the layer opacity to 45%. This will add additional softness to the picture.
13. The face needs a little more definition, so create a new empty layer and using the same Soft Cloner brush click a few times over her face. Do the same with the feathers and also her feet which need to be darker (Figure 9.31). When you add a figure to another picture you usually need to fix the figure to the ground by adding a shadow and an easy way of doing this is to paint the shadow using an airbrush.
14. Create a new layer. Select the Airbrushes>Digital Soft Velocity Airbrush, size 36 opacity 10%. Change to Clone Color. The light on her face is coming from the front left, so paint from her feet going backwards and to the right. While you paint it will look far too dark and obvious, but you can see where you are painting. When you have finished reduce the layer opacity

FIG 9.31 Left: The Layers panel.
Right: Step 13.

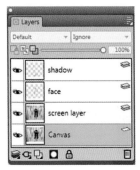

FIG 9.32 Below: The completed picture.

FIG 9.33 Detail from the completed picture (opposite).

to about 15%, depending on how dark you painted. When you look at the picture you should not be aware of the shadow, but when you turn the layer visibility on and off it should look wrong without the shadow.

15. Effects>Adjust Colors, increase the Saturation by 25%.

Pastels: Party Girl

This charming picture of a young girl enjoying a party is a family picture to treasure, and here you will create a version using a Pastel chalk which will suit the painted face. The first steps are to brighten the picture before cloning.

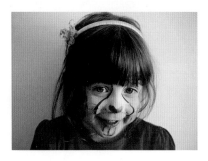

FIG 9.34 Original photograph.

1. Open 'Party girl.'
2. Effects>Tonal Control>Correct Colors. Increase the Contrast to +8% and the Brightness to +17%.

FIG 9.35 Picture at Step 7 after Auto-Painting.

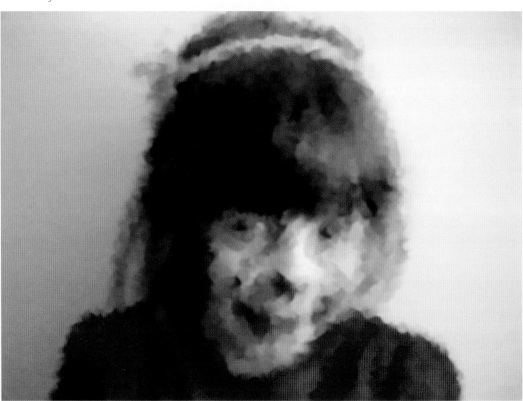

3. Effects>Tonal Control>Adjust Colors. Increase the Saturation to +25%.
4. Save the picture under a new name.
5. File>Quick Clone.
6. Select the Pastels>Artist Pastel Chalk, size 90 opacity 100%. Click the Clone Color option in the Color panel.
7. Open the Auto-Painting panel (Window>Auto-Painting Panels>Auto-Painting) and select Squiggle in the drop down Stroke menu. Make sure that Smart Stroke Painting is not ticked. Click the Play icon and wait while the Auto-Painting does its work and covers the whole of the picture (Figure 9.35).
8. Now you have an Underpainting you can start to bring in more detail by using smaller brushes. Reduce the brush size to 15 and, starting with the eyes, make short brush strokes to bring in the detail. You may find it easier to keep the brush on the canvas and make continuous short strokes. Turn the Tracing Paper on and off regularly to see where the lines in the picture lie. The brush strokes will still look rather rough but will be smoothed off later.
9. When you have finished the face (you will paint it again later) change the brush size to 38 and paint the dress. There is no need to get detail here

FIG 9.36 Picture at Step 9.

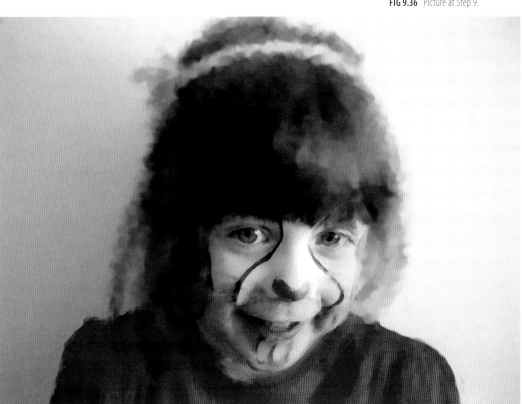

and the painting can remain fairly loose, you just need to get the basic shapes and edges (Figure 9.36).

10. Now to paint the hair, use brush size 15, keep the tracing paper on for a while and paint the hair, following the lines of the hair. When you get to the hair on the right of her face note the way the hair lies, some strands are beneath others so paint the ones underneath first, then the ones on top, that way you get a better impression of depth.

11. Paint the hair each side of the hair band and then paint the hair band with left-to-right strokes first and then some diagonal strokes to show the sections.

12. Reduce the brush size to 6 and paint the decoration on the hair band.

13. Using the same brush pick out highlights in the hair and also darker areas. Paint the edges of the hair, this will remove the fuzziness at the edges and make it appear more natural. When you are using a small brush like this you need to be careful not to overdo it, if you bring back too much detail it may end up looking too much like the original photograph. If you do find it looks too photographic, increase the size of the brush to about 21 and reduce the Grain from the default 23% to 12% which will emphasize the texture of the pastel.

FIG 9.37 Completed picture (below).

FIG 9.38 Detail of completed picture (opposite).

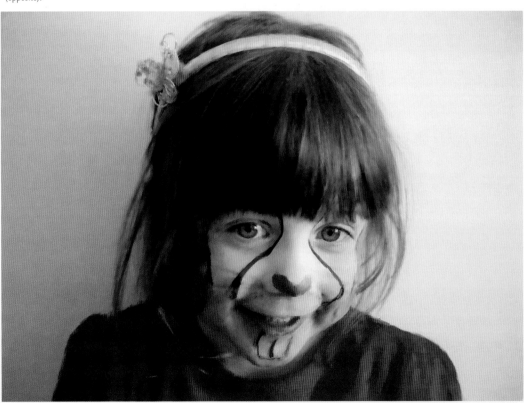

Oils: Pensive

In this picture of a young girl you will use a Wet Oils brush from the Cloners brush category. Before making a clone the paper color will be changed from white to dark brown, this is an option easily missed and is useful for adding a base color on which to paint.

1. File>Open 'Pensive.'
2. Select the Cloners>Wet Oils Cloner, size 54 opacity 50%.
3. The brush is in the Cloners category, therefore it is all ready to use for cloning and the color picker in the Colors panel is not available, so go to the Colors panel and deselect the Clone Color Option, this allows you to select a color. Hold down the Alt/Opt key and click in the dark brown background of the image, the use of the Alt/Opt key temporarily activates the eyedropper. The Main Color indicator in the panel will show dark brown.

FIG 9.39 Original photograph.

FIG 9.40 Picture at Step 8.

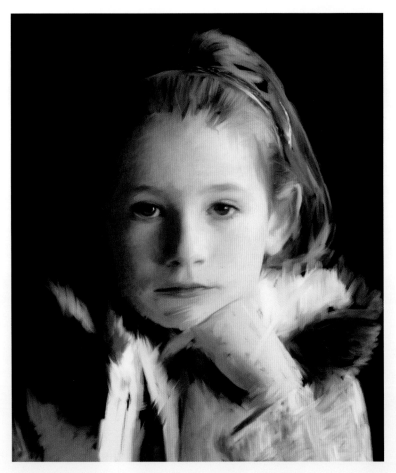

4. Canvas>Set Paper Color. Although nothing appears to happen, the background color has changed from white to dark brown and this will be evident in the next step.

5. File>Quick Clone. A new document has been created and Tracing Paper should be showing the source image, turn the Tracing Paper off for a moment and you will see that the paper color of the empty document is brown.

6. Turn the Tracing Paper back on, make sure that you are still using the Wet Oils brush and reactivate the Clone Color option in the Colors panel.

7. Paint over the background, there is no need to cover every part as the brown background will fill any gaps.

8. Reduce the brush size to 20 and opacity to 50%, paint the girl and the clothes, at this size the brush marks will be very rough and more detail will be added in the next steps (Figure 9.40).

FIG 9.41 Picture at Step 10.

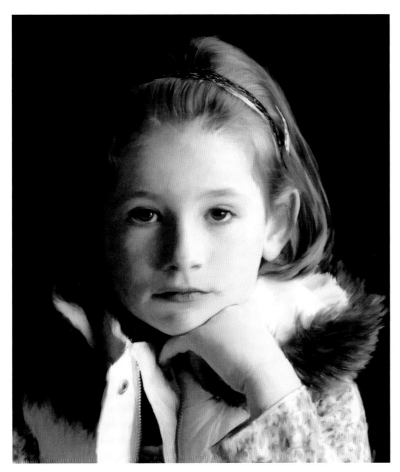

9. Reduce the brush size to 10 and paint more detail in the face and clothes, the slower you move the brush, the more detail is revealed. When you paint the hair make sure that you follow the direction that the hair flows in. Use circular brush strokes when you come to the floral coat.

10. Reduce the brush size to 5 and increase the opacity to 100% and start to add more detail in key areas, paint over the eyes very slowly and drag out the eyelashes. Work over the hair, concentrating on brighter and darker strands of hair to add texture (Figure 9.41).

11. The face is not very smooth, so increase the brush size to 15 and make the opacity 15%, this will work as a blender. Use circular polishing brush strokes to smooth the cheeks and forehead.

12. Reduce the brush size to 1.4 and make the opacity 100% to pick out highlights in the hair and also in the fur edging. The small size and high opacity will show these brush strokes clearly and this adds texture and detail to the picture.

FIG 9.42 Finished picture (below).

The picture below and opposite shows the rather serious and delicately colored portrait.

FIG 9.43 Detail from finished picture (opposite).

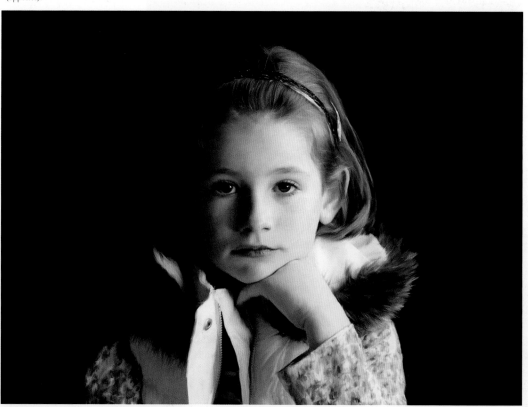

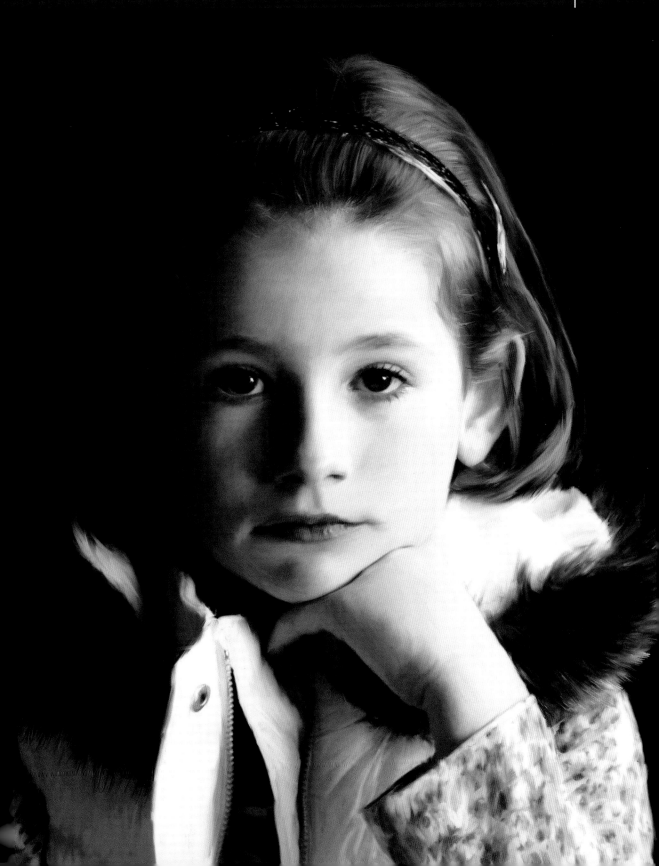

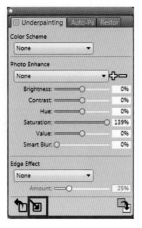

FIG 9.44 The Underpainting panel with the Apply Underpainting icon highlighted.

Creating a Boldly Colored Portrait

Taking the finished picture from the previous tutorial as the starting point, you could produce a very different and striking alternative presentation by adjusting the color and tonal range.

1. Open the final version of 'Pensive' from the previous tutorial.
2. Create a copy of the Canvas (Select>All, Edit>Copy, Edit>Paste in Place).
3. Open the Underpainting panel (Window>Auto-Painting panels>Underpainting).
4. Move the Saturation slider all the way to the right (139%), this will dramatically increase the color, you will notice that the color breaks up very badly in places, it is particularly obvious on her forehead as you can see in Figure 9.45. Click the Apply icon which is at the bottom of the panel.
5. With the highly colored layer active, go to Effects>Focus>Soften, use Gaussian and move the slider to 80%. This will make it extremely blurred.
6. Change the Layer Composite Method of this layer to Colorize, this will apply the color as a color wash over the layer below. This is a useful technique for spreading color over a monochrome picture. You could also use Color as the Layer Composite Method which gives a different, usually darker result.

FIG 9.45 At Step 4 after boosting the saturation and prior to applying blur.

7. Finally move the Brightness slider in the Underpainting panel to 100%; this will (paradoxically) darken the background. If you find the color too strong you can reduce the layer opacity or perhaps apply a layer mask and paint out specific areas. If you save this picture as a PSD file you will need to drop all the layers first and save as a flattened version, this is because the Colorize layer is not compatible with Photoshop.

FIG 9.46 Detail from completed picture (opposite).

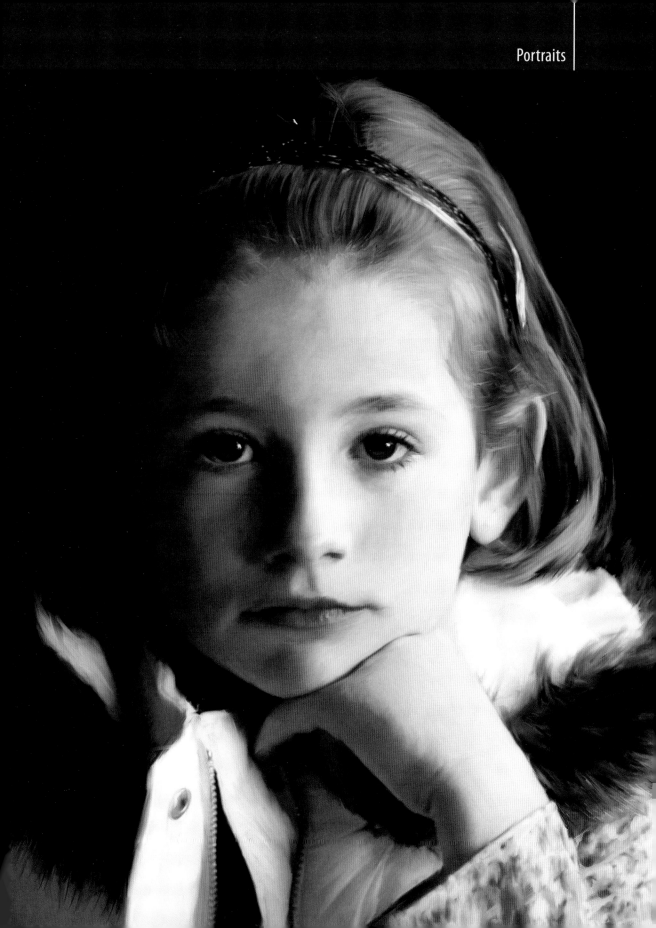

Oils: Family Group

This family group will be painted with brushes from the Oils category which give an attractive brush stroke texture. The demonstration also shows how to change a distracting background.

1. Open 'Family'.

FIG 9.47 Original photograph.

2. Effects>Tonal Control>Adjust Colors. Increase the Saturation to +30%.
3. Effects>Tonal Control>Correct Colors. Increase the Contrast to +11% and the Brightness to +7%.
4. Save As>give it a new name.
5. File>Quick Clone.
6. Select the Oils>Smeary Round brush, size 98 opacity 100%.
7. Click the Clone Color icon in the Color panel.
8. Paint the background using short brush strokes; paint all of the area but not the family. It does not matter if you paint over the edges of the figures.

FIG 9.48 At Step 8 after painting background and at Step 9 after painting over dark colors.

9. The dark furniture on the right is distracting so you can paint over this. Untick the Clone Color option to allow the brush to paint rather than clone, then hold down the Alt/Opt key and click in the picture to select a color from the left hand side. Holding down the Alt/Opt key temporarily changes the tool from a brush to an eyedropper and allows a color to be selected; once the key is released the brush will be active again. Change the colors regularly so that the area you paint varies in color.

10. Change to the Oils>Soft Flat Oils brush, size 60 opacity 100%, Resaturation 10%, Bleed 80% and select Clone Color.

11. Paint the figures, this brush is very smeary, especially at this size, the slower the brush moves the clearer the picture becomes, so you can take advantage of this characteristic to get some useful rough strokes in the clothes while keeping the faces fairly clear. After the first paint cover the figures will be fairly smeary, you should still follow the natural lines of the clothes. Figure 9.49 shows the picture at this stage.

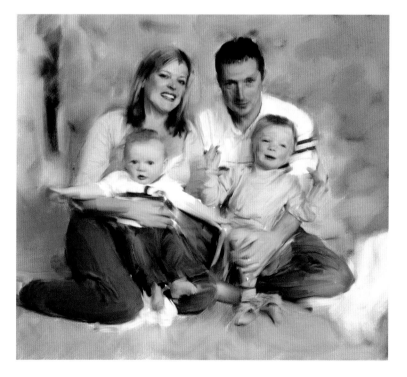

FIG 9.49 At Step 11 after the first painting stage is completed.

12. Reduce the brush size to 40 and paint the faces, starting with the one top left. Sweep the brush down the hair to get a lovely smooth finish then move the brush very slowly over the face to reveal the details clearly. In the area under the chin you will need to make slow circular brush strokes to get the dark-to-light transition looking good. Continue with the other faces.

13. Now for the clothes, to keep these very painterly, move the brush in short strokes and fairly fast, all the time looking for shapes and folds in the material to run your brush over. Use brush size 30 for the clothes.

14. When you get to the hands and arms, they need to be reasonably clear, so use a slower brush stroke.

15. Paint the blanket on the right and some of the base, keep the brush moving quickly and just get the general impression.

16. Reduce the brush size to 10 and clarify the facial details and hands.

FIG 9.50 At Step 16 before repainting the background.

17. The background needs some more work, as the color is rather too strong and the figures will stand out more with a slightly cooler color. Use the Oils>Smeary Round brush, size 65 opacity 50% feature 9.9, untick the Clone Color so that the brush paints color and select lighter tones from the background color on the left.

18. Paint over the background, the 50% opacity will ensure that some of the existing color will show through, which will give it an interesting texture.

19. You are likely to have painted over parts of the figures while painting the background, so you will need to go over the edges again to restore the detail. Use the Soft Flat Oils, size 10 opacity 60%, Resaturation 20%, Bleed 70% and Feature 3.4. You will need to alternate between cloning and painting color, remember to always use the eyedropper to select a nearby color in the painting so that it matches.

FIG 9.51 Detail from the completed picture (opposite).

20. As you can see, if you want to change the background in any picture you can usually paint over it quite easily.

Cloners: Best of Friends

This brush is very easy to use and being in the Cloners brush category it is already set up for cloning from photographs. For this demonstration the Feature slider is being considerably increased, which will make the bristles more prominent and the result will be rather less solid than with the default brush.

1. Open 'Best of Friends.'
2. File>Quick Clone.
3. Select the Smeary Bristle Cloner from the Cloners brush category, size 72 opacity 100% and Feature 16.2. Increasing the Feature slider will emphasize the bristles in this brush.
4. Paint over the whole of the picture, leaving some empty space at the edges. Use a crosshatch brush stroke, as you can see in Figure 9.53 this will leave an interesting texture in the outer areas which are not being painted in more detail.
5. Reduce the brush size to 32 and the Feature to 7.7 and, using the Tracing Paper as a guide, carefully paint over the main features of Lucy and the horse. If you are using a tablet, hold the pen vertically to avoid the brush marks spilling in the wrong direction.
6. When you paint the hair, make sure that you follow the correct direction, do the same with the detail on the horse.
7. When the picture is finished, create a copy layer (Select>All, Edit>Copy, Edit>Paste) and go to Effects>Focus>Sharpen to sharpen the picture. Select Gaussian, amount 3.0 and the other sliders on 100%.

FIG 9.52 Original photograph.

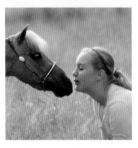

FIG 9.53 Picture at stage 4.

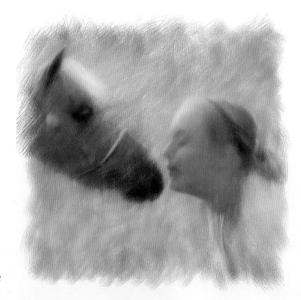

FIG 9.54 Detail of completed picture (opposite).

Acrylics: Devika

This demonstration uses the Captured Bristle brush from the Acrylics category; this is a very useful brush and one I use a lot. It gives an attractive brushy finish when used in Clone Color method; however, in this case some of the properties have been changed and it is using the Cloning Method and Grainy Hard Cover Cloning Subcategory. This allows the grain to be seen more clearly. The Grain slider works in conjunction with the opacity, the lower the Grain slider, the more grain is shown.

1. Open 'Devika.'

FIG 9.55 Original photograph.

FIG 9.56 The Paper Libraries panel, this is the List view which shows the names and thumbnails.

2. File>Quick Clone.
3. Select the Acrylics>Captured Bristle brush, size 77 opacity 17%.
4. Open the General panel (Window>Brush Control Panels>General) and change the Method to Cloning, the Subcategory to Grainy Hard Cover Cloning and the Grain to 13%.
5. Open the Paper Libraries panel and select French Watercolor paper. If you have difficulty in identifying the papers by the thumbnails, open the panel options menu and under Paper Library View, select List. In the Papers panel change the Paper Scale to 200%.
6. Using Tracing Paper as a guide, paint over the head and shoulders, brush outwards to include the background, use a diagonal stroke on the background but leave the edges clear. Hide the Tracing Paper and fill out the background, but leave the edges white again (Figure 9.57).
7. Continue painting the face to increase the density of color, try to get the face as smooth as possible (Figure 9.58).
8. Reduce the brush size to 35 and paint the facial details again, the eyes and the jewelry in particularly need to be clear.
9. Reduce the brush size to 20 and increase the opacity to 40%. Paint the eyes, mouth and jewelry to bring out more contrast (Figure 9.60).

FIG 9.57 Step 6.

FIG 9.58 Step 8.

10. Now to adjust the tones, the face needs a little more contrast and the eyes need brightening. Make a copy of the canvas. Select>All, Edit>Copy, Edit>Paste in Place.
11. Make sure you save your picture now, I find that the Layer Mask function is unreliable in the initial release of Painter 12 and often closes the program down, so just in case …!
12. Select the Chalk>Blunt Chalk brush, size 93 opacity 100%.
13. Effects>Tonal Control>Correct Colors. Increase the contrast slider to +14% and the Brightness to +13%. This has lightened the background too much, so create a layer mask, click the mask to activate it then Edit>Fill with current color and select black in the Color panel. This will hide all of the adjustment.
14. Change the color to white and paint in the picture to reveal the adjustment. Paint all of the face; you will see the white appear in the mask when it updates the preview.

FIG 9.59 The Layers panel.

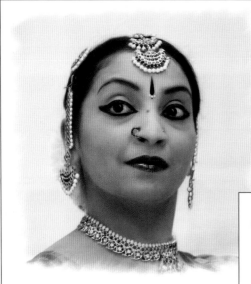

FIG 9.60 Step 9 (above).

FIG 9.61 Step 15 (right).

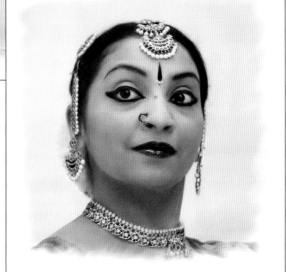

FIG 9.62 Apply Surface Texture dialog box.

FIG 9.63 Detail from the finished picture (opposite).

15. Make another copy of the canvas as previously and move it to the top of the layer stack.

16. Effects>Tonal Control>Correct Colors. Increase the contrast slider to +33% and the Brightness to +21%. This has lightened the whole of the picture, but you only want to lighten the eyes, so fill the mask with black as previously. Paint with white again, this time just the eyes. This should add contrast and brightness just to the eyes; it is probably too much, so reduce the layer opacity to about 55% (Figure 9.61).

17. Save the file, then File>Clone to make a copy document.

18. Copy the canvas and the next step is to add a light texture based on the image.

19. Effects>Surface Control>Apply Surface Texture. Select Image Luminance from the drop down menu and make the amount 50%.

Chalk: Gerry

In this tutorial one of the Chalk brushes is used, they are attractive brushes to use for cloning as they have a distinctive texture and will show the paper texture when required.

1. Open 'Gerry.'

FIG 9.64 Original photograph.

2. File>Quick Clone.
3. Select the Chalk>Square Chalk, size 100 opacity 100% grain 12%.
4. Click the Clone Color option in the Color panel.
5. Open the Auto-Painting panel (Window>Auto-Painting Panels>Auto-Painting) and choose Pressure Modulate in the Stroke box. Turn off the tracing paper and press Play. Allow the auto-painting to paint the whole picture; this is a quick way to provide an Underpainting. Press the Stop icon to stop the painting. I find that the Auto-Painting process stops quite often and freezes the program; however, pressing the escape key frees it easily and then you can press Play again. Figure 9.65 shows this stage.
6. Reduce the brush size to 34 and using the Tracing Paper, paint the hat, the white line on the rim will be clarified later with a smaller brush.
7. Continue with the face and clothes, at this stage the details are not clear, the intention is to get down a quick rough painting.
8. Reduce the brush size to 14.6 and paint the face again; this will start to reveal more detail. Make the brush strokes short and follow the lines in the picture. One of the basic techniques for clarifying detail is to use the Tracing Paper as a guide and paint each side of a line, for example the hat or ears, this will reduce the spreading that happens with the thicker brushes.
9. Continue to paint the clothes, there is no need to show much detail here as it is the face that matters but emphasize a few details such as the buttons, the lapels of the jacket and the edges of the shirt.

10. Reduce the brush size to 7 and add highlights. Paint around the edge of the hat to show the backlighting and then paint the face, this time you will be able to define far more detail. Use short brush strokes and vary the direction, but still keep to the lines of the face. The beard is a little difficult as it tends to go gray, but highlights will be added later with a very small brush.

FIG 9.65 Left: Step 5 after Auto-Painting.
Right: Step 7.

 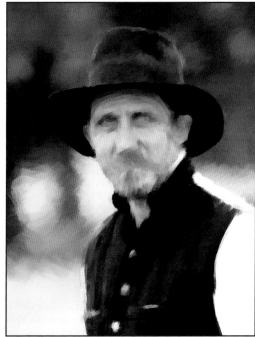

11. Before the highlights are added, the highlights in the background are too bright so the next steps show how to tone them down.
12. Create a new layer.
13. Change the brush size to 100 opacity 20% and untick the Clone Color option. Alt/Opt click in the picture to sample a color, choose a green similar to that which you want to paint with and paint over the highlights. Change colors regularly and paint over all of the background to keep a consistent texture. The low opacity means that the color will mix with the existing color. Paint over the edge of the man so that the background texture does not change. Because you are painting on a new layer the unwanted paint will be removed at the next step.
14. Create a layer mask and click the mask to make it active. Change the brush size to 24 and the opacity to 100% and select black in the Color panel.
15. Paint in the mask to remove any green from the edge of the figure. If you remove too much, select white and paint again.

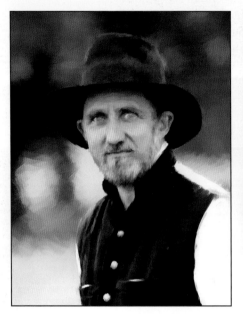 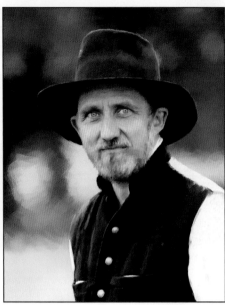

FIG 9.66 Left: Step 8.
Right: Step 9.

16. Create a new layer on the top of the stack. Return the brush to Clone Color and make the size 2 and the opacity 100%. Select a light color from his beard, and using the tracing paper paint Gerry's moustache, following the lines of the hairs. Hide the tracing paper and you will see that the hairs are a little too obvious, so change the brush to Clone Color again and paint over again; this blends in the hairs rather better.

17. Repeat the same process with the rest of his beard to finish the picture.

FIG 9.67 Left: The Layers panel.
Right: Step 13 showing the
background painted over the figure.

FIG 9.68 Detail from the completed
picture (opposite).

Sargent Brush: Merry Wives

This brush has a distinctive stroke and the result is very painterly and far removed from photography. It is not an easy brush to use, but with patience it can create some striking pictures.

1. Open 'Merry wives.'
2. File>Quick Clone.
3. Select the Artists>Sargent brush, size 93.3 opacity 22%.

FIG 9.69 Left: Original photograph. Right: Step 5.

4. Click the Clone Color option in the Colors panel.
5. Paint quickly over the picture, this will provide a roughly painted underpainting as in Figure 9.69.
6. Reduce the brush size to 20.4 and paint the figures. Keep the brush strokes short as the brush drags color very easily. Use the Tracing Paper to see where to paint and check regularly what is happening, remember that you can change the opacity of the Tracing Paper by using the slider in the Clone Source panel. Try the setting at 82% and you will see what you are painting more clearly.

7. Clean up the edges as you go along, paint each side edge to get a good line.

8. Figures 9.70 and 9.71 show the picture at this stage and, as you can see, the clothes are starting to look pretty good but the faces are not showing any detail. So for the next stage the brush needs to be smaller to bring in more details.

9. Reduce the brush size to 8 and paint over the face and clothes, this size will bring in sufficient detail to the clothes, concentrate on the places where colors or shapes change. Reduce it to 4 to bring in the laces and smaller details.

FIG 9.70 Revealing the detail in Steps 6 to 8.

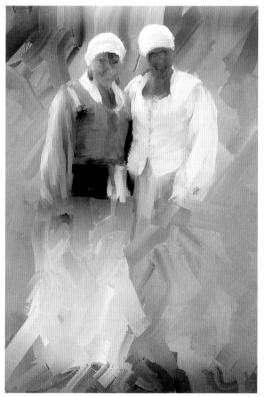
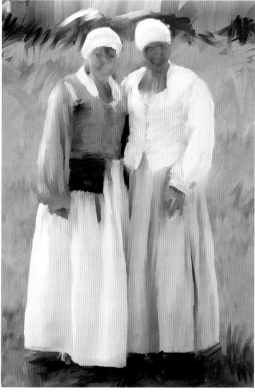

10. The faces will need more clarity and it is very difficult to get fine detail with the Sargent brush, so you can swop to another brush to make it easier. Select the Cloners>Bristle Oils Cloner, size 7 opacity 20%.

11. Create a new layer and paint the faces and hands. This will hide all the Sargent brush marks, so reduce the layer opacity to 50% so that it blends better.

FIG 9.71 Detail at Step 8.

12. Create another new layer and this time just paint the eyes, nose and mouth of both ladies; these need to be clear.

13. The background needs finishing, the top is very bright and contrasty, so return to the Sargent brush (you can use the Recent Brushes panel to quickly return to a brush used previously) size 20 opacity 22% and untick the Clone Color option.

14. Select colors from the greens in the middle background and paint over the top area; sample new colors and tones at regular intervals so that

FIG 9.72 Detail at Step 9.

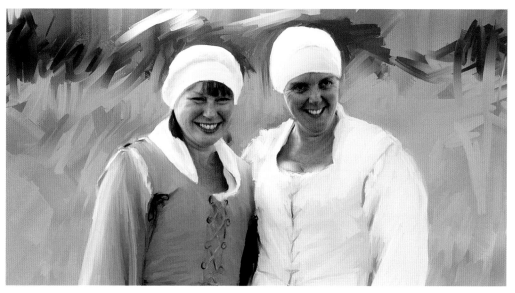

FIG 9.73 The background at Step 12.

there is an attractive texture. Normally I would recommend that you paint on a separate layer to do work like this; however, the Sargent brush only paints on the canvas.

15. Save the picture and then File>Clone to add the finishing touches to a new document.
16. Create a copy layer from the canvas (Select>All, Edit>Copy, Edit>Paste in Place).
17. Effects>Tonal Control>Equalize, move the black slider to 90.9 and the white slider to 0.00.

FIG 9.74 The background at Step 15.

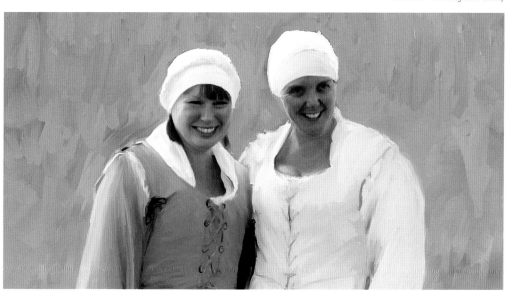

18. The dresses could benefit from a small increase in saturation, so go to Effects>Tonal Control>Adjust Colors and increase the Saturation by 10%. This affects the background as well, so create a layer mask and using the Markers>Blunt Tip brush, size 114 opacity 16%, paint in the mask using black. Paint over all the green background so that the effect is only on the figures. The effect is subtle, but worthwhile.

That completes the picture of these two ladies enjoying a re-enactment event for the first time; the title of the picture comes from the Shakespeare play The Merry Wives of Windsor.

FIG 9.75 The completed picture.

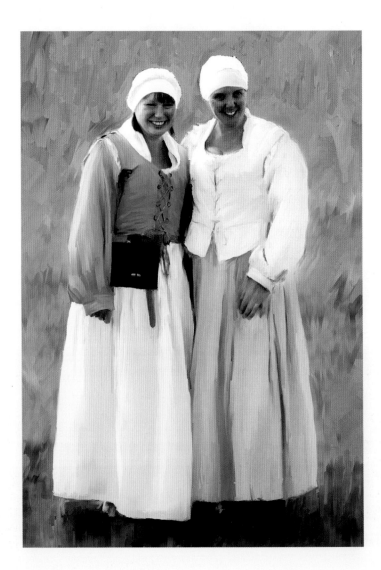

FIG 9.76 Detail from completed picture (opposite).

Acrylics: Harley Man

In this demonstration you will use just one brush, the Acrylics Real Wet brush and gradually bring out the detail present in the photograph without removing the brush strokes, which will give it a painterly finish. The brush is easy to use and is also very fast, but the step by step demonstration will take some time to complete as there is a lot of detail in the original photograph.

1. Open 'Harley Man.'

FIG 9.77 Original photograph.

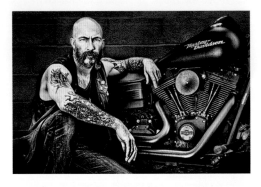

FIG 9.78 Step 6. The first rough painting.

2. File>Quick Clone.
3. Select the Acrylics>Real Wet Brush, size 50 opacity 24%.

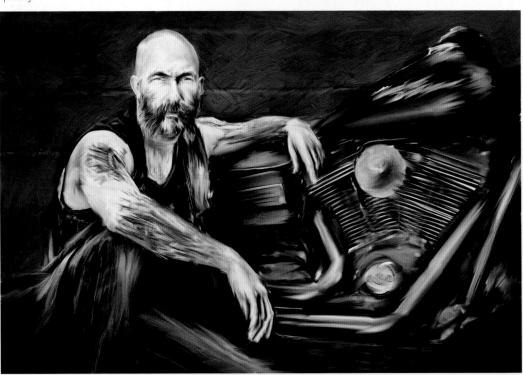

4. Select the Clone Color option in the Color panel.
5. Start by painting the background, paint in a variety of directions to give a less regular impression. Use Tracing Paper to see where to paint and then hide it to check the brush strokes.
6. Continue to paint the rest of the picture, this brush is fast so keep the brush moving and follow the lines in the picture. No need to worry about detail at this stage. Use the Tracing Paper to see the source picture. Figure 9.78 shows this stage.
7. Now to start adding detail, reduce the brush size to 15 and enlarge the picture on screen. Use the Tracing Paper, turning it on and off continually to check how your brush strokes look.

FIG 9.79 The face at Steps 1, 6, 9, 16, 19 and 24.

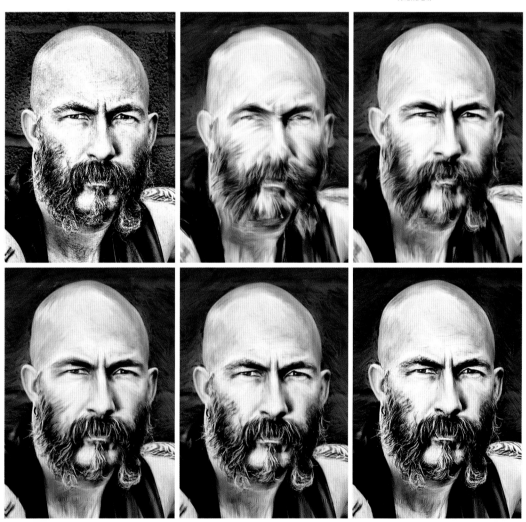

8. Take your time and remember that this brush smears the detail, avoid pulling the dark areas into the light. Start with the face, this is the most important and requires a lot of care. When you come to the eyes you can get clearer detail by moving the brush very slowly, as the brush finish depends upon the speed at which you move the brush.

9. You will find it easier if you make single brush strokes in the same direction, generally moving from the center of the face outwards, but in all cases following the lines of the face. This should resolve the face much better but you will go over it again later, so don't attempt to get it perfect!

FIG 9.80 The clothing at Steps 6, 10 and 25.

10. Start painting the clothing, follow the lines and shape of the material, pull and push the brush to get the flow of the folds. The further away from the face, the less detail is required.

11. Continue on to the motorbike and as before follow the lines very closely, slow down the brush when you want to bring in extra detail, particularly in the reflections.

12. When you get to the large pipes it is better to make the brush larger again to get a smooth sweep, make a few long strokes along the whole length of each pipe. Try size 35 and then reduce the brush down to 15 to continue. Pause the brush over the nuts and bolts to show them more clearly.

13. All that is left still in rough shape are the arms of the biker and we need to paint these very carefully, the tattoos are an important part of the biker's personality and have to be recognizable. Reduce the brush size to 8 and very slowly paint the tattoo, making sure not to drag one color into another.

14. Increase the Resat slider on the Properties bar to 50%, this will allow more detail and less smearing.

15. Increase the brush size to 21 and paint the hands.
16. Reduce the brush size to 6 and the saturation to 20 and go back to the face. The beard is wiry so paint the white hairs, keeping the brush on the canvas for several strokes, that way the detail shows through better. Use a variety of brush strokes, some short and straight, others circular. Often small circular strokes are better for indicating a beard and also for removing very obvious larger brush marks.
17. Change the size to 12 and the opacity to 50% and paint the head, the reduced opacity will soften and blend more, which is in keeping with the smoothness of his head.

FIG 9.81 The tattoo at Steps 6, 14 and 25.

18. Use the same brush to repaint the hairs on his chest and also to clean up parts of the arms if they are still a bit rough.
19. Make the brush size 12, opacity 100% and Resat 20% and work over the rest of the picture bringing out any lines which have been missed and generally adding the final touches to the picture. You should not be trying to get every detail back, just the ones which contribute to the design.
20. The jeans are difficult. I found the best way was to reduce the opacity to 20% and then paint lines both down and across following the weave of the cloth; this gave the impression of the cloth better than painting in one direction.
21. It is important to get all the badges and Harley logo clear, so increase the Resaturation for these.
22. To finish off the picture the tones need adjusting and it is better to do this on a new layer, so with the canvas active, Select>All, Edit>Copy and Edit>Paste in Place and this will create a copy of the canvas.
23. Go to Effects>Tonal Control>Brightness and Contrast and add a little more contrast and darken it slightly, this makes it more dramatic.

24. Right-click the layer and select Duplicate Layer, go to Effects>Focus>Sharpen. I used 3% Amount and 100% for the other sliders, but this will depend upon your output medium.

FIG 9.82 The motorcycle engine at Steps 6, 14 and 25.

FIG 9.83 The completed picture (below).

FIG 9.84 (Opposite) Detail from the completed picture.

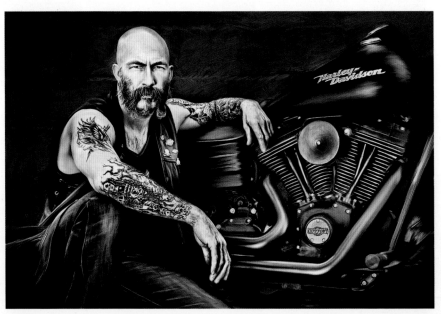

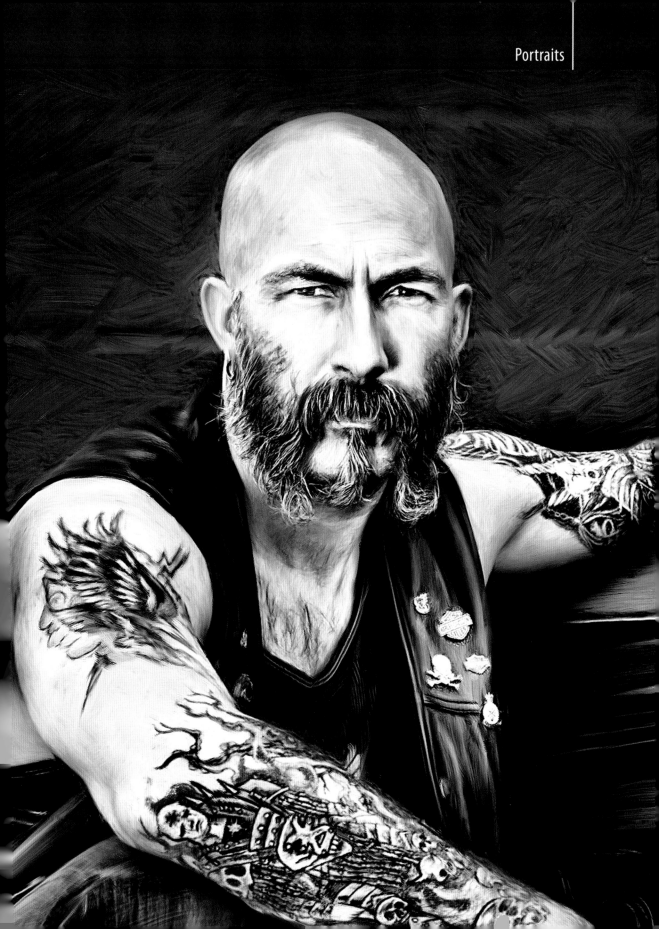

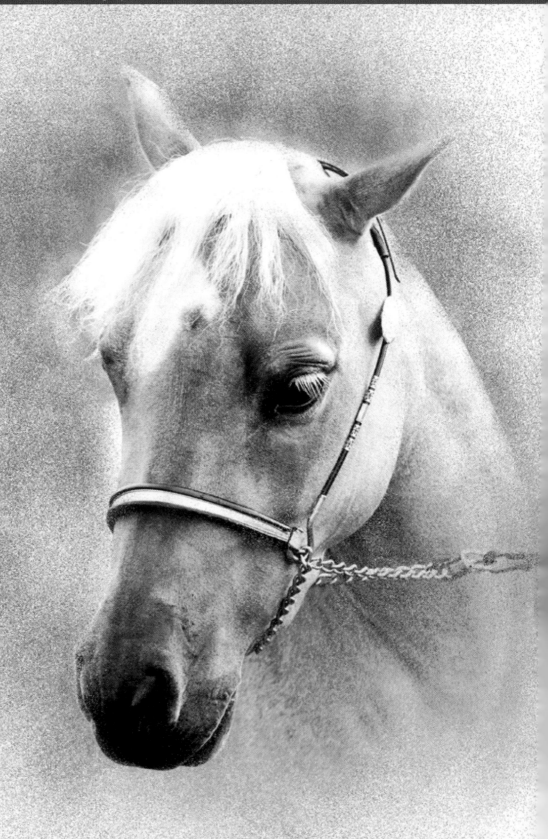

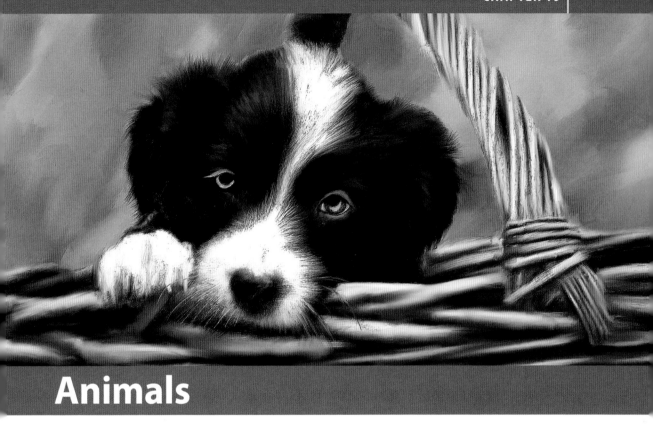

Animals

Animals are always very popular subjects for both photography and painting, and in this chapter are a wide variety of techniques and brushes to use to transform your photographs.

Tutorials include using a smeary brush to get a smooth finish to dog hairs and a palette knife to get some distinctive marks. The Sargent brush takes a lot longer to use than most, but the end result is worth it for the interesting textures you can achieve.

The new Real Watercolors are used for a portrait of a cat; these brushes can produce some very beautiful textures. Finally, I will show you how to change a picture with a bland background to a colorful portrait using several different brushes and blenders to create the picture.

Painter 12 for Photographers.
© 2012 Martin Addison. Published by Elsevier Ltd. All rights reserved.

Smeary Bristle Brush: Dog

The brush used for this demonstration is in the Cloners brush category and is an easy-to-use brush which gives some very attractive brush strokes, ideal for animals.

1. Open 'Dog.'
2. File>Quick Clone.
3. Select Cloners>Smeary Bristle Cloner.

FIG 10.2 Original photograph.

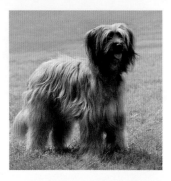

4. Reset Brush to the default settings.
5. Select size 48.2 opacity 30%.
6. Clone the dog, roughly following the lines of the hair, clone over the edge to include the background. Use the Tracing Paper for this stage.
7. Roughly fill in the background, at the bottom of the picture use vertical paint strokes to allow an impression of grass to show.
8. Change the brush size to 25 and enlarge the picture to around 75% magnification, enough to see the head of the dog clearly.
9. Paint over the dog, this time following the lines of the hair very closely. When you paint around the eyes, paint the darker areas first then do

FIG 10.3 Steps 6 and 7.

the lighter hair which hangs over the eyes afterwards. This will establish which pieces of hair are actually on top.

10. Switch the Tracing Paper on and off constantly to see where you need to paint and what you have already painted, this is the only way to get it looking good. If you haven't already set up a one-key shortcut for Tracing Paper I suggest you do so now, it is very easy and allows you to hold the pen/mouse in one hand and turn the Tracing Paper on and off with the other. See the Painter basics chapter for how to customize your keyboard shortcuts.

11. Continue all over the dog, paint the hairs that go over the background by sweeping out the brush outwards.

FIG 10.4 Hair shown in original photograph, Step 6 and Step 23.

12. In the areas under the chin the hair goes straight down, but there are other hairs on top which sweep round to the right. Paint the downwards hairs first and then lightly sweep over the brush to include the loose hairs.

13. The hairs on the back are longer so make longer brush strokes to emphasize the length of the hair. Look for every darker or lighter variation and make sure you pick these out. Continue down the legs.

14. Make the picture full screen again and paint some additional grass in at the base, but leave the other areas diffused.

15. The background grass is a little too insistent, so to tone it down slightly first make a new layer, then go to the Airbrushes>Soft Airbrush, size 149 opacity 4%. Pick a light color from the dog's back, I used Hue 109 Sat 113 value 178 in the Color panel. Paint all over the background, including close to the dog so as to reduce the green, but don't paint

over the grass at the base. The color is likely to be too strong, so reduce the layer opacity to about 60%. This step will harmonize the color of the background with the dog.

16. To add the finishing touches to the dog, return to the previous Smeary Bristle Cloner brush; reduce the size to 6.0 and the opacity 100%. Paint over parts of the face, picking out light strands of hair, this will add definition and contrast to the head.

17. Open the Underpainting panel (Window>Auto-Painting panels) and increase the Saturation to about 52%.

18. In the Layers options panel menu select Drop All to flatten the layers.

FIG 10.5 Head shown at Steps 7, 12 and 23.

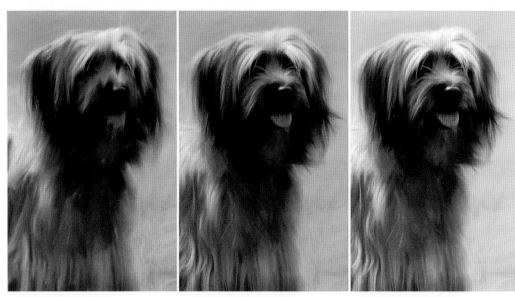

19. Make a copy of the layer by Select>Select All, activate the Layer Adjuster tool in the Toolbox and click in the picture area. This will move the picture from the Canvas onto a layer; then right-click the layer and select Duplicate Layer.

20. With the duplicate layer active, Effects>Equalize, move the Black slider to 100% and the White slider to 12%.

21. Add a Layer Mask by clicking on the mask icon and activate the mask by clicking on the mask in the Layers panel.

22. In the Color panel, move the cursor position to the Black corner and then Edit>Fill>Fill with Current Color, which will hide all of the adjustment.

23. Select the Tinting>Basic Round brush and change the painting color to White. With the layer mask active paint over the face of the dog, this will brighten the face. Adjust the layer opacity if required.

FIG 10.6 (Opposite) Detail from completed picture.

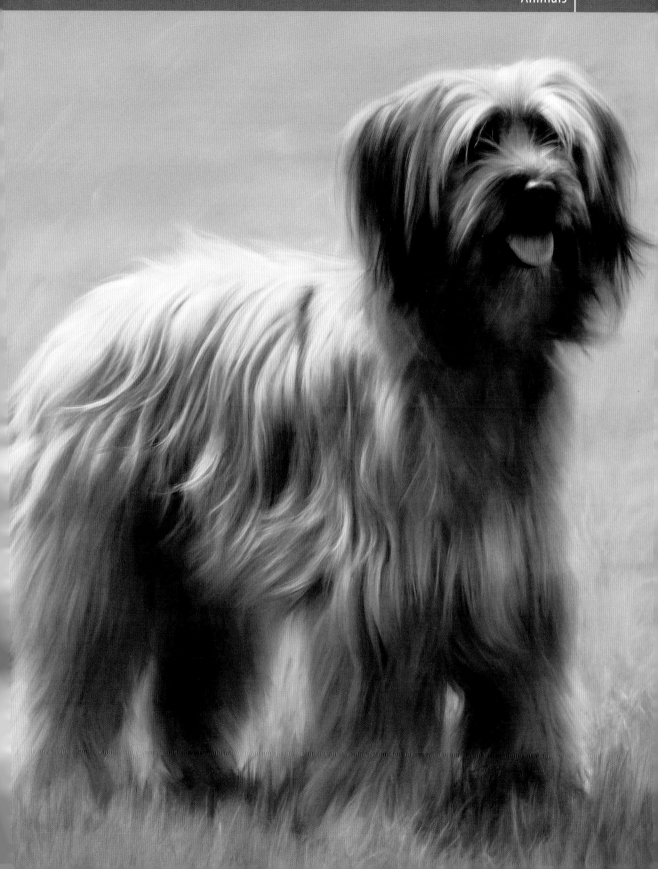

Loaded Palette Knife: Horse

Palette knives leave very distinctive marks and this will give this picture an attractive texture. This particular knife reveals more detail when you use it slowly.

1. Open 'Horse.'

FIG 10.7 Original photograph.

2. File>Quick Clone.
3. Select the Palette Knives>Loaded Palette Knife and return it to the default settings (size 55.9 opacity 100%, Resaturation 14%, Bleed 78%).
4. Click the Clone Color option in the Color panel.
5. Brush over the horse and nearby background, this can be done quite quickly as it is just to establish the basic shapes.
6. Paint over the horse again, this time going more slowly, paint in the direction that the hairs lie and just paint in single strokes. You will see that one color is dragged into another, so be careful when you meet a change in color or tone.
7. Reduce the brush size to 25 and make the picture larger on screen. Paint over the head again, getting the eyes clear. The brush can leave some rather ugly marks at times, but a few more careful brush strokes will remove them.

FIG 10.8 The head at Step 5.

8. Reduce the opacity to 40% and work over the head again; use a light touch to blend the shapes. Use the Tracing Paper to check on the original.

9. When the head is completed you can finish off the background. If you like the rough hewn edge of the palette knife you can leave it as it is, or you can work on it further. If you prefer a softer edge, select the Real Blender Flat from the Blenders category, use size 40 opacity 100% and paint around the edges, this blender drags one color into another so you will need to work the blender brush in several directions to get a good finish. Reducing the opacity to 30% will soften the finish even more.

FIG 10.9 Head shown at Steps 5, 6 and 10.

10. You may like to adjust the tones, perhaps by adding a little more contrast or brightness.

FIG 10.10 Completed picture.

FIG 10.11 (Overleaf) Detail of completed picture.

285

Sargent Brush: Boxer

In this project the brush used is one that breaks up the original very strongly, but after the initial painting the details will be brought back without losing the distinctive brush strokes of the variant. This is not an easy brush to use and it will take quite a while to complete the picture, but it will give a very distinctive finish which is completely different to the original photograph.

1. Open 'Boxer.'

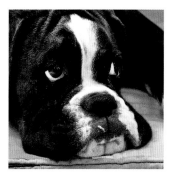

FIG 10.12 Original photograph.

2. File>Quick Clone.
3. Select the Artists>Sargent brush, size 56.2 strength 22%.
4. Use the Clone Color option in the Color panel.
5. Paint over the whole photograph, follow the lines of the hair at all times. This will result in a very rough first step as you can see in Figure 10.13.

FIG 10.13 Picture at Step 5.

6. Reduce the brush size to 20.4 and paint over again, pay special attention to following the lines of the hair and the variations of light and dark. It is important to remember that this brush drags one color into the next, so take care not to drag light areas into dark and *vice versa*. The best way to avoid doing this is to make short brush strokes and using only one tone or color.

FIG 10.14 Picture at Steps 5 and 6.

7. Reduce the brush size to 10 to add more detail. Start with the eyes and carefully define the shapes, enlarge the image on screen to see clearly and switch Tracing Paper on and off to check your progress.
8. When you have done the eyes, move on to the white of the nose, this is a difficult part to paint; you will need to pull the white in amongst the black and *vice versa* to get the right mix of tones.
9. Pick out the ear on the right by running the brush down the edge and then use the brush in the other direction, pulling away from the line on each side, this removes the hard line but emphasizes the edge.

10. Make the brush smaller again to 5 and paint carefully over the eyes, then over the edges of the white nose, work the brush backwards and forwards over the edge always following the hair direction, this size brush will pick up small white or dark hairs and drag them out. Continue over selected parts of the head, picking out areas of light and dark.

FIG 10.15 Picture at Steps 7 and 10.

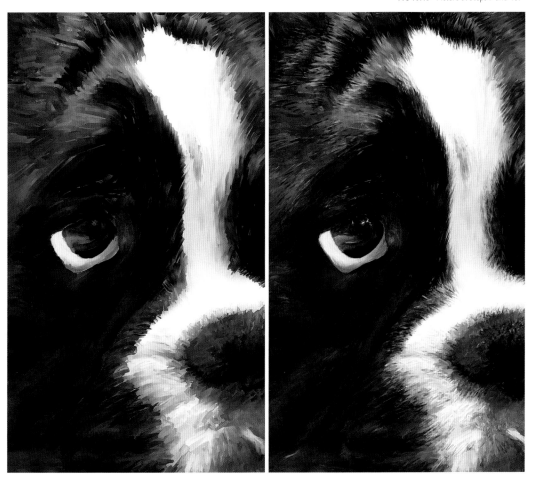

11. At this stage it can get addictive and it is difficult to know when to stop, if it is now 3.00 am I guess you should stop and get some sleep! Seriously, every time you reduce the brush size, you are painting less and it is usually better not to be tempted to overpaint too much, but is your choice.

12. I think this picture could benefit from adding some textures; this is covered in more detail in the Paper Textures chapter. It is better to apply this to a copy layer so that your original remains unaltered, so create a copy layer (with the Canvas active, Select>All, Edit>Copy and Edit>Paste).

13. Go to Effects>Apply Surface Texture and select Image Luminance, Amount 30%, Picture 100% and Shine and Reflection 0%. This will add an appearance of depth to the brush strokes.

14. Now to add a canvas texture, create another copy layer then select Artists Canvas in the Papers panel and increase the Scale to 200%.

15. Go to Effects>Apply Surface Texture and in the top box select Paper, Amount 50%, Picture 100% and Shine and Reflection 0%. If either of these textures is too intrusive you can reduce the layer opacity.

FIG 10.16 Completed picture (below).

FIG 10.17 (Opposite) Detail of finished picture.

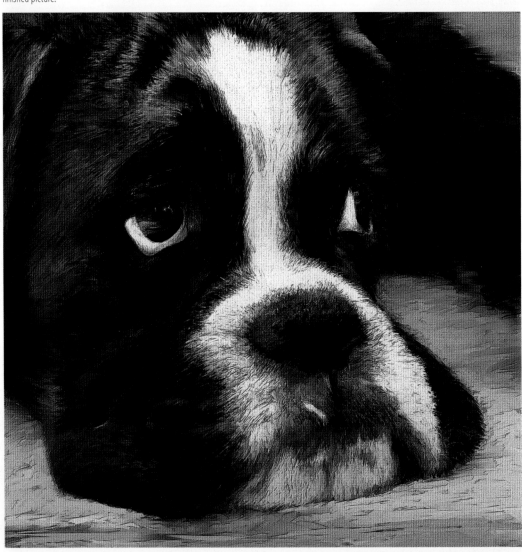

Fractal Dry: Black Cat

This is one of the new brushes in the Real Watercolor brush category introduced in Painter 12. It has a very distinctive and attractive texture and although detail is difficult to bring out easily, it does arrive eventually.

1. Open 'Black cat.'

FIG 10.18 Original photograph.

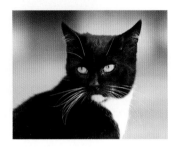

2. File>Quick Clone.
3. Select the Real Watercolor>Fractal Dry brush, size 86 opacity 30%.
4. Open the General panel (Window>Brush Control panels) and select Real Dry Cover in the Subcategory, this will stop the brush from building up color too quickly.
5. Select Clone Color in the Color panel.

FIG 10.19 Picture at Steps 6 and 7.

6. Paint all over the cat and background, leaving the outer edges unpainted. Use the Tracing Paper to see where the edges are.
7. Reduce the brush size to 46 and paint over again to add some more detail, especially in the eyes and face.
8. Increase the size to 121 and opacity to 100% to paint around the background; this will separate the white bib from the background. Now leave the opacity at 100% and reduce the brush size to 10 and paint in the eyes and nose to bring out some more detail. Work over the ears too.

FIG 10.20 Picture at Steps 8 and 9.

9. Reduce the brush to 3.9 and paint over the whiskers, follow the white lines very carefully and then paint some of the darker areas between the whiskers. If you find that there is too much contrast, brush over with brush size 20 and 20% opacity to blend; then go over the hairs with the small brush again.
10. The picture at this stage can be seen in Figure 10.21 and you could leave it as this rather delicate interpretation, alternatively you might prefer to experiment with a darker version. Right-click the layer and

select Duplicate Layer. Make sure that the duplicate layer is in Gel Layer Composite Method. Adjust the layer opacity to get the right density. As you see in Figure 10.22 the simple act of duplicating the layer and blending it with the layer below can change the appearance quite dramatically.

FIG 10.21 The completed picture.

FIG 10.22 The completed picture after duplicating the layer in Step 10.

FIG 10.23 Detail from the completed picture (opposite).

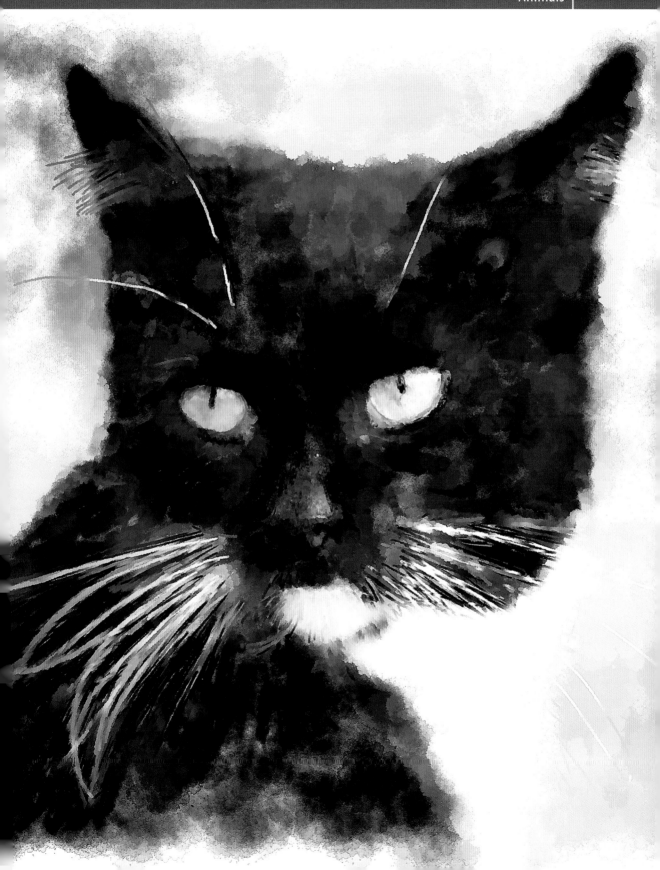

Blenders: Basket Case

The original photograph of this puppy in a basket is very appealing, but the bland gray background robs the life out of the picture, so the tutorial shows how to replace this with a colorful background and integrate the two.

1. Open 'Basket case.'

FIG 10.24 Original photograph.

2. File>Clone.
3. Select the Artists>Sargent brush, size 160 opacity 22%.
4. Before you start work on this I recommend that you create a custom palette and add each new brush as you use them, this helps to switch back and forth with ease. Hold down the Shift key and drag out the first brush, this will create the palette; add others by dragging them onto the palette in the same way.
5. Hold down the Alt/Opt key and click in the basket to sample a color, and then paint in the picture. Keep sampling different tones and select some similar ones from the Color panel. This brush will destroy the whole of the picture and will form a base on which to clone.
6. Select the Blenders>Grainy Blender, size 105 opacity 100%.
7. Blend the whole of the picture but don't blend out all the variation, just the hard lines.

FIG 10.25 The first underpainting at Step 5 and the blended picture at Step 7.

8. Create a new layer and select the Cloners>Smeary Bristle Cloner, size 32 opacity 100% and Feature 5.4.

9. Start cloning the puppy, keep the brush on the canvas and work across the head. Try not to get too much of the gray background in. Use the Tracing Paper to see where the edges are and follow the lines of the hair. Continue with the basket as in Figure 10.26.

10. Swop to the eraser in the Toolbox, size 49 opacity 20% and dab around the edges of the puppy to remove any gray areas. Return to the brush.

FIG 10.26 Cloning the puppy at Step 9 and the basket at Step 10.

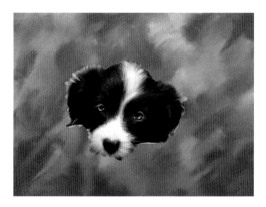 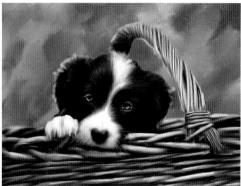

11. Create a new layer on top of the stack and click the Pick Up Underlying Color icon, highlighted in Figure 10.28. The icon is blue when it is active.

12. Use the Grainy Blender size 2 opacity 100% to pull out the hairs around the puppy. Use the Tracing Paper to see where the hairs stand out and drag the brush from the puppy out to the background. This time there will be no gray to cause problems as you are not cloning. The option to pick up the underlying color means that the blender will blend color from the layers below.

13. Use the brush to define the face better, particularly where the white hairs meet the black ones.

FIG 10.27 Pulling the hairs out from the edges as in Step 12. The picture on the right shows the difference.

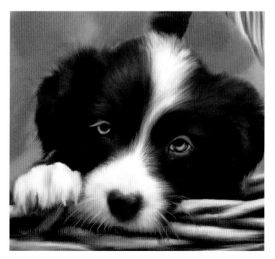 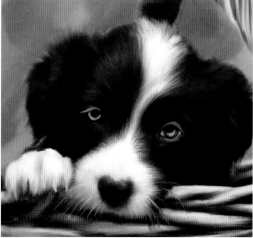

FIG 10.28 The Layers panel at Step 19 before creating a copy by cloning.

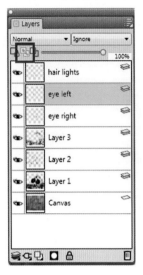

14. Change the brush size to 18 and smooth some of the rougher edges in the basket and handle.
15. Create a new layer and change to the Acrylics>Dry Bristle, size 3.8 opacity 100%. This brush adds color to the picture when it is first applied and then, without lifting the brush from the canvas, continue moving the brush and it will blend the added color into the existing colors. This is useful for adding highlights and darker areas. Use it to enhance the eyes, sample a light color from the eye and in the Color panel, move the color point slightly higher in the display. Paint this in the same area and blend in, this will brighten the area. Do the same with the darker areas of the eye but this time move the color point lower to make it darker and therefore add contrast.
16. Turn the Tracing Paper on and off to see the original picture. By making these adjustments on separate layers you can turn the visibility on and off to see the result and also reduce the layer opacity if necessary.
17. Even though the brush blends the color, you may still need to blend it further, change to the Blenders>Grainy Blender size 3 opacity 100%, this will blend the colors very well.
18. Paint some of the whiskers in the same way, dragging them out from the nose area.
19. When you have finished the picture it will need some tonal adjustments, save the layered file and then File>Clone to get a new flattened copy to work on.
20. Create a new layer then Edit>Fill>Fill with Clone Source. This allows you to add tonal adjustments to a separate layer which makes it easy to compare the original with the adjusted layer.
21. Effects>Surface Control>Apply Surface Texture. Select Image Luminance in the Using drop down menu and Amount at 50%. This adds a subtle texture to the brush strokes.
22. Duplicate the layer (right-click) and Effects>Tonal Control>Correct Colors. Move the Contrast slider to 22% and Brightness to 6%; this should add additional contrast without blocking in the blacks.

FIG 10.29 The completed picture.

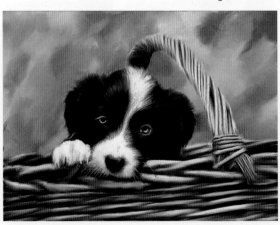

FIG 10.30 Detail from the completed picture (opposite).

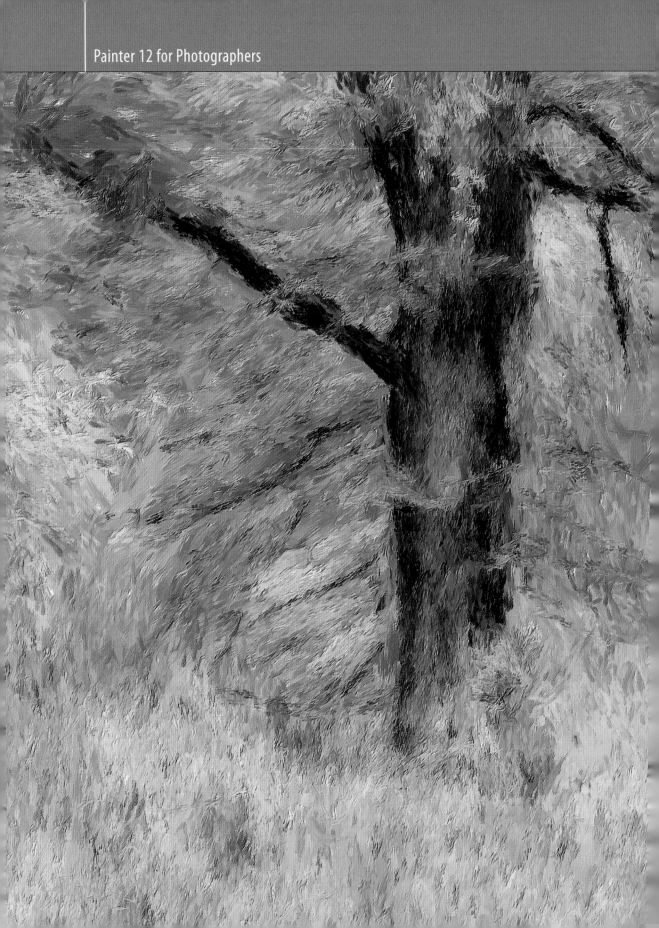

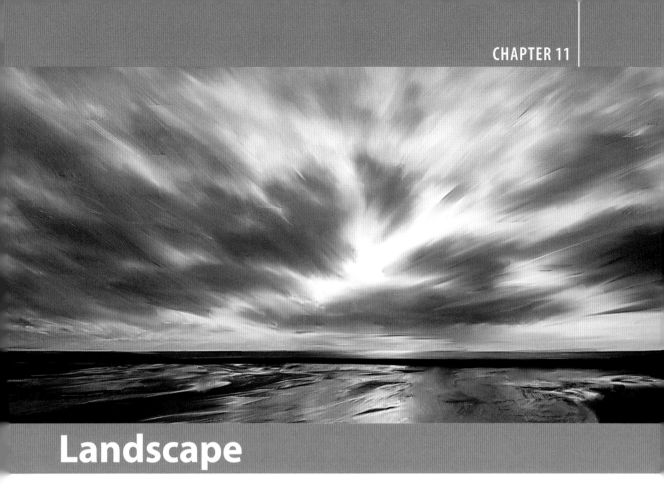

Landscape

The landscape has been one of the most popular subjects for artists throughout the ages and this chapter on landscape covers a wide variety of subjects from wide open vistas to intimate details.

You can, of course, use any type of brush to paint the landscape, so the examples chosen in this chapter only scratch the surface of what is possible, the interpretation too can be traditional or modern and everything in between.

The step by step examples in this chapter aim to introduce you to a variety of techniques and styles from which you can create your own paintings of the landscape.

Impressionist: Autumn Colors

This brush from the Artists brush category is easy to use and gives a very painterly finish; the brush strokes are very distinctive and by starting with large brushes and gradually getting smaller the detail can be shown.

1. Open 'Autumn Colors.'
2. File>Quick Clone.
3. Select the Artists>Impressionist Brush, size 74 opacity 100%.
4. Select the Clone Color option in the Color panel.

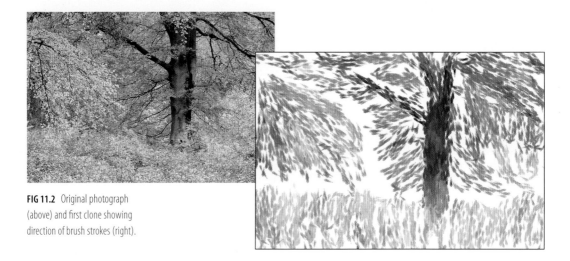

FIG 11.2 Original photograph (above) and first clone showing direction of brush strokes (right).

5. Use the Tracing Paper and paint the scene following the direction of the tree trunk and the branches. Figure 11.2 shows the early rough sketch.
6. Continue painting with this brush until virtually all of the white canvas is covered.
7. Reduce the brush size down to 30 and paint over again, concentrating on the branches and other features. This will bring out finer detail, so make sure that the brush strokes follow the features.
8. Reduce the brush size down to 10 and paint again. When you are painting from large sizes to smaller ones I often find that reducing the size by about 50% works quite well. Painting all over at this size would take a very long time, which is why the underpainting with a larger brush is so important.
9. When I had finished this I noticed that there was one bright piece of sky showing which I found distracting, so to hide this deselect the Clone Color option in the Color panel, Alt/Opt click in the painting on a suitable color and then paint over the bright area.
10. Make a copy of the Canvas (Select>All, Edit>Copy, Edit>Paste in Place) and then go to Effects>Tonal Control and select Equalize. Bring the

Black slider in to 94% and the White slider to 10%, this will brighten the picture.

FIG 11.3 Brush strokes at Steps 6, 7 and 11.

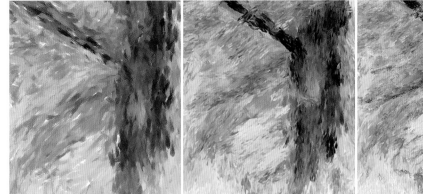
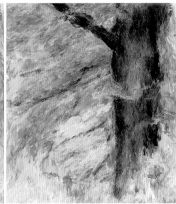

11. This is a good picture to add some surface texture, so go to Effects>Surface Control>Apply Surface Texture. In the Using box select Image Luminance and make the Amount slider 32%. The texture looks strange on screen and you will need to view it at 100% enlargement to see how it will look (Window>Actual Size).

FIG 11.4 The completed picture.

Dry Bristle Watercolor: Old Tree

This step by step example uses the Dry Bristle brush which is one of the easiest traditional watercolor brushes to use when cloning. It does not build up to black as quickly as many other watercolor brushes and because the diffusion process is only very modest, it is also much faster.

1. Open 'Old Tree.'

FIG 11.5 Original photograph.

2. Open the Underpainting panel (Window>Auto-Painting panels>Underpainting) and in the Color Scheme drop down menu select the Sketchbook Scheme, this will make the colors muted which will suit the picture.
3. File>Quick Clone.
4. Select the Watercolor>Dry Bristle brush, size 28 and opacity 4%.
5. Click the Clone Color option in the Color panel.
6. Clone in the old tree; the Sketchbook color scheme has increased the contrast quite considerably so the coverage will be uneven. Figure 11.6 shows the picture at this point.

FIG 11.6 The first stage of painting the tree trunk.

7. Increase the brush opacity to 16% and bring some additional texture into the white areas of the tree trunk.

FIG 11.7 Building the density at Step 8.

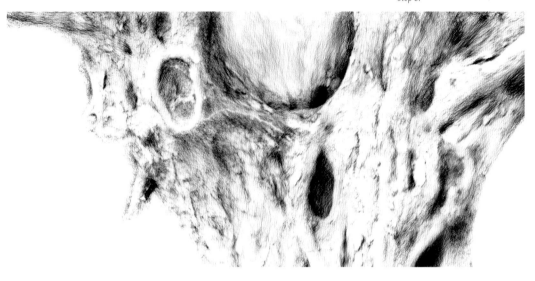

8. Create a new Watercolor layer and move it below the layer on which you have been painting. You create a new Watercolor layer by clicking and holding the new layer icon in the Layers panel.
9. Increase the brush size to 48 and make the opacity 3%.
10. Paint the background using horizontal brush strokes, keep it a light texture. The reason for painting this on a new layer is that if necessary, the layer opacity can be reduced to make the background lighter.

FIG 11.8 Adding the background at Step 10.

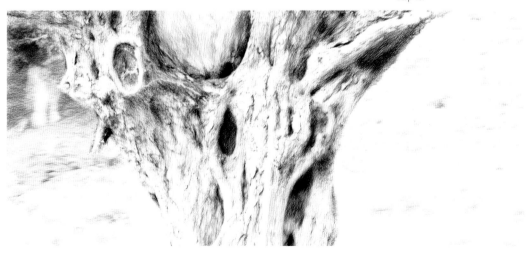

11. Create a new Watercolor layer and place it in between the two existing layers. Paint the daffodils in short vertical brush strokes using the same brush size and opacity. Keep them fairly light and if necessary reduce the layer opacity, Figure 11.9 shows the result.
12. Create a new Watercolor layer and move it to the top of the layer stack.
13. Use brush size 11 opacity 10% and paint parts of the tree trunk to define the edges.
14. Adjust the opacity of the layers to balance the picture.

FIG 11.9 The daffodils are painted in the background in Step 11.

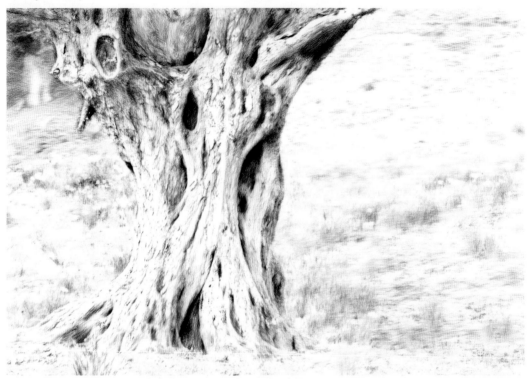

15. If you intend to open this in Photoshop you will need to drop all the layers first as the Gel layer composite method which Painter uses for watercolor layers is not recognized by Photoshop and will not translate correctly.
16. At this stage I decided that the lower part of the tree trunk was too light, due to the contrast added by the color scheme chosen at the start. My solution was to open the original photograph in Painter, apply the color Sketchbook scheme as before and then darken the picture considerably using the sliders in the Underpainting panel.
17. Return to the picture you are working on and in the Clone Source panel click the Open Source icon and select the name of the original image that you have darkened and clone in the detail you need.

FIG 11.10 (Opposite) Detail from the finished picture.

Flat Oils: Black Crag

This landscape will use a brush from the Oils category to create a fairly realistic landscape.

1. Open 'Black Crag.'

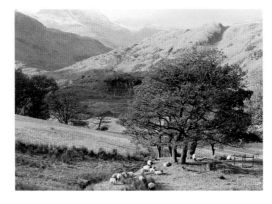

FIG 11.11 Original photograph.

2. File>Quick Clone.
3. Select the Oils>Flat Oils 30.
4. Brush size 52.2 opacity 80%, Resaturation 10%, Bleed 70% and Feature 3.8%.
5. Click the Clone Color option in the Color panel.
6. Paint the mountains and sky; the brush strokes should follow the contour lines, so the mountain on the right should be painted diagonally from the top right. Move the brush quickly, this will ensure that the image is smeared which is the aim, particularly in the background areas. Continue painting down to the trees (Figure 11.12).

FIG 11.12 Painting the background mountains.

7. Reduce the brush size to 30 and paint in the trees. Use short brush strokes and once again keep the brush moving quickly to avoid too much detail being shown (Figure 11.13).

FIG 11.13 Tree detail.

8. Paint the middle ground between the trees, the brush you are using is flat, so use this feature to paint the hillside in levels using the flat side in parts and the narrow side in others to create a variety of textures. This option is available with most flat brushes, provided that you are using a pressure-sensitive pen. Figure 11.14 shows the cursor and brush dab when angling the pen towards you and to one side.

FIG 11.14 Painting with a pressure-sensitive pen at different angles with a flat brush will result in different angled brush strokes. You will need a pen that supports this feature.

9. Paint the trees on the left in the same way and then the grassy slope. This should be done with long horizontal brush strokes interspersed with a few vertical strokes to indicate taller grasses (Figure 11.15).

FIG 11.15 Detail showing central area and trees.

10. The grass in the lower part of the field is much taller and rough, paint this with vertical brush strokes and with the brush angled to use the narrow edge. Keep the brush moving quickly to create a rough texture.

11. Paint the smooth grass bottom right with long horizontal strokes.

FIG 11.16 Detail of the sheep and trees.

12. Reduce the brush size to 20 and paint the sheep, don't make them too clear, allow some oily smudges to show.
13. Continue using this brush and put extra detail throughout the picture, in particular follow the lines of the tree branches. Paint on the narrow edge of the brush to get the best result.
14. Make a copy of the Canvas (Select>All, Edit>Copy, Edit>Paste in Place).
15. Effects>Surface Control>Apply Surface Texture. Choose Image Luminance and Amount 45%. This will add extra definition to the brush marks. Having this on a separate layer will allow you to reduce the opacity if necessary.
16. It would be appropriate to add a canvas texture prior to printing. Make a copy of the layer you have just created (right-click the layer and select Duplicate).
17. Select Artists Canvas in the Papers panel, then Effects>Surface Control>Apply Surface Texture. Choose Paper and Amount 86%. The canvas texture is not applied to the final picture here as it does not reproduce well when printed this small.

FIG 11.17 (Below) The completed picture.

FIG 11.18 (Overleaf) Detail from the completed picture.

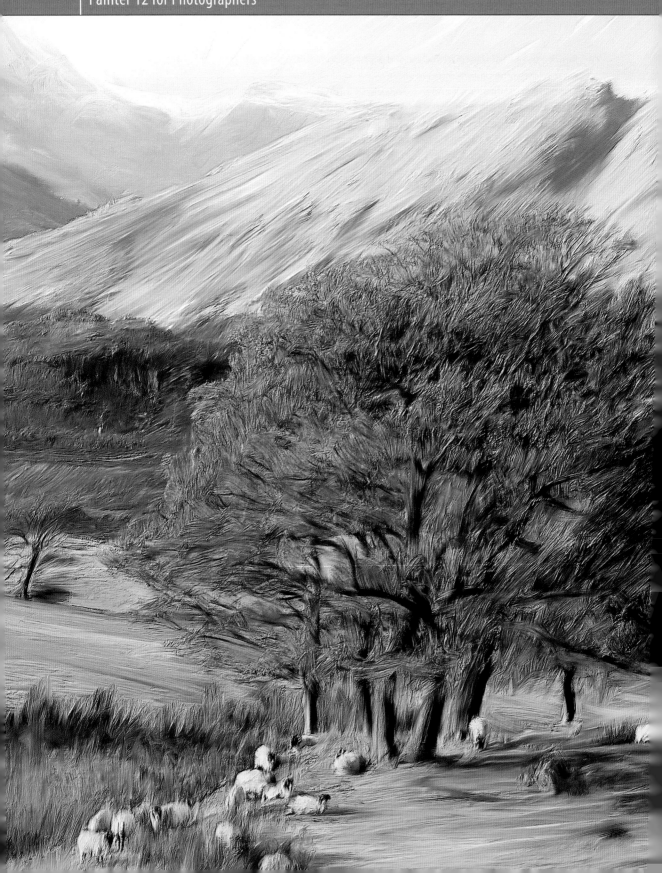

Pastels: Worcester Cathedral

In this step by step tutorial you will discover ways in which to transform a photograph into an artistic impression using brushes from the Pastels brush category to both clone and paint.

1. Open 'Worcester Cathedral.'

FIG 11.19 Original photograph.

2. File>Quick Clone.
3. Select the Pastels>Variable Oil Pastel brush, size 80 opacity 11%, resaturation 2% and bleed 92%.
4. Select the Sandy Pastel Paper in the Papers panel.
5. Hide the Tracing Paper as this will not be used until later. Do not click the Clone Color option as the early stages will involve painting a background into which to clone.
6. Paint all the picture using medium size brush strokes, select colors from the Color panel to paint with, mainly light yellows and warm tones for the top half and darker browns and blues for the lower part. Keep all the colors light. After putting a reasonable amount of color onto the paper, keep the brush on the page and blend the new color with the color on the canvas. The intention is to create a mix of colors which vary across the picture (Figure 11.20 and 11.21).

FIG 11.20 Painting the background 1.

7. When all the picture area is covered change the brush to Blenders>Soft Blender Stump, size 80 and opacity 46%. Blend the entire picture; you should have a diffused picture with plenty of color variation, light at the top and darker at the base (Figure 11.22).

FIG 11.21 Painting the background 2.

8. Make a copy of the Canvas. Select>All, Edit>Copy, Edit>Paste in Place.
9. Return to the Pastel>Variable Oil Pastel, click the brush reset icon to return to the default settings, then in the General panel change to Method: Cloning, Subcategory: Soft Cover Cloning, brush size 60 and opacity 100%.
10. Pull the brush upwards from the bottom; this will create streaks out of the colors. Continue over the entire picture.

FIG 11.22 Blending the background.

11. Select the Chunky Oil Pastel, then in the General panel change to Method: Cloning, Subcategory: Soft Cover Cloning, brush size 60 and opacity 13%.
12. Turn the tracing paper on and lightly clone in the cathedral and some of the trees, don't clone in the lower parts of the picture. Turn the tracing paper off when you have finished (Figure 11.23).

FIG 11.23 Cloning in the Cathedral.

13. Make a new layer in Colorize mode and change back to the Variable Oil Pastel, click the brush reset icon to return to the default settings, brush size 150 and opacity 5%.
14. Select a light orange in the Color panel and paint over the whole of the picture, this will overlay a texture on the picture and also lighten the image (Figure 11.24).

FIG 11.24 Creating a color overlay.

15. Reduce the layer opacity to around 50%.
16. I decided that the top was too yellow in color and needed to be lighter, if you need to do this follow the next three steps.
17. Make a new layer.
18. Return to the Variable Oil Pastel brush, size 105 and opacity 5% and deselect the Clone Color option.
19. Select white in the Color panel and lightly paint over the top part until most of the color has been hidden. Adjust the layer opacity to get the right level; I reduced it to around 50%.
20. Make a new layer.
21. Select a new brush Cloners>Soft Cloner, size 190 and opacity 3%.
22. Lightly brush in the cathedral until you can see detail in the top of the tower.
23. Adjust the layer opacity to keep the effect subtle, I reduced it to 54%.
24. Add a Brightness and Contrast layer by clicking the Dynamic Plug-ins icon in the Layers panel. Move the top slider a little to the right and the bottom slider a little to the left; this will intensify the colors and contrast. Adjust the layer opacity if required.

FIG 11.25 (Below) Finished picture.

FIG 11.26 (Facing page) Detail from finished picture.

Pencils: Six Cold Crosses

The introduction of the range of Real hard media brushes, and in particular the Real pencils, has transformed the way that pencil drawings can be made in Painter. The brushes work so much more like their real life equivalents, in particular the flexibility that a traditional pencil has which allows it to be used at various angles, getting a sharp point when it is held vertically and shading when held at a shallow angle; this is now possible in Painter. What's more there is a new Hard Media panel in which the pencils can be customized to your choice.

To make full use of these brushes you need a pressure-sensitive pen with tilt control; without that you may find it difficult to follow this demonstration.

The photograph used for this demonstration was taken on a camera which has been converted to use just the infrared spectrum. This produces light and delicate tones in monochrome which should work well with the pencil clone technique.

1. Open 'Six cold crosses.'

FIG 11.27 Original photograph.

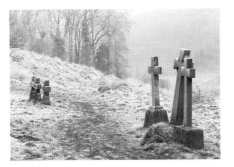

2. File>Quick Clone.
3. Select the French Watercolor paper from the Papers panel.
4. Select the Pencils>Real 6B Soft Pencil, size 108 opacity 5% and Grain 100%. If you are using a mouse, try doubling the brush size to get a similar result. Click the Clone Color option in the Color panel.
5. Starting in the top right area sketch a light tone across the right side of the picture, hold the pen at a shallow angle to allow the delicate shading to cover the area smoothly. You will need to use various angles and directions to get a good even cover. Paint down and over the large crosses, but only lightly outline the crosses at present.
6. Paint the background trees with the same brush, use the pen at an angle as before but use short strokes in a circular direction. This should bring out an impression of the trees.
7. Continue painting down the picture until the whole area is covered with a light tone (Figure 11.28).
8. Change to the Pencils>Real 4H Hard Pencil, size 32.2 opacity 10% and Grain 100%.

FIG 11.28 The whole picture covered in a light tone in Step 7.

9. Click the Clone Color option in the Color panel.
10. Paint the large crosses, angle the brush strokes differently on each of the sides of the cross, this will help separate the sides.
11. Build up the density of the crosses in stages until they are quite clear. Try not to define the edges of the crosses by painting downwards, rather continue to work across the face of the crosses until the edge appears.

FIG 11.29 Adding detail to the crosses in Step 11.

The crosses are covered in lichen, so they will remain mottled. Remember that detailed pencil drawings are not usually quick to make, so you will need patience to get a good result.

12. Increase the brush opacity to 27% and paint over again, concentrating on the edges, especially the light tops. Hold the pen vertical to get a fine edge.

13. Now paint the small crosses in the same way. Start with 10% opacity and then increase it to around 30%. The pen can be held at various angles but the best detail is when the pen is held vertical and the line is very fine.

FIG 11.30 Picture at Step 13.

14. The crosses are now clear and the background and grass need to have more detail so that the two areas can be integrated. Keep the size at 32.2 and opacity at 10%.

15. Starting from bottom left paint the grass working across to the right-hand side. Keep the brush at a slight angle and paint so that the brush strokes are roughly vertical. When you come to the path make the brush strokes less vertical, as there is little grass there.

16. Reduce the brush opacity to 5% and paint the remainder of the grass; because there is little density in the original photograph the cloning will look light.

17. Paint the trees in the background. Use the pen vertical to get the outlines of the tree trunks and branches, then paint over again with the pen at an angle, this will soften the lines.

18. Increase the brush opacity to 70% and holding the pen vertically to get a fine point, paint the edges of the large crosses to add some contrast and bring out the frost on the tops and sides.

FIG 11.31 Detail of small crosses.

19. Finally you may wish to add a little contrast to the picture, if so go to Effects>Tonal Control>Brightness/Contrast and move the top slider a little to the right.

FIG 11.32 The completed picture.

Palette Knives: Seascape

This is more of a seascape or a cloudscape than a landscape, but I have included it in this section. The demonstration shows how using a palette knife can change the style of the painting quite considerably.

1. Open 'Seascape.'

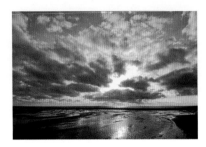

FIG 11.33 Original photograph.

2. File>Quick Clone.
3. Select the Palette Knives>Loaded Palette Knife, size 90 opacity 100%. Click the Clone Color option in the Color panel. The Loaded Palette Knife is one of the few Palette Knives which picks up color from a clone source, most of the others just move color around.
4. With the Tracing Paper turned on, paint along the horizon line as in Figure 11.34.
5. Paint outwards from the sunburst and from the center at the base as in Figure 11.34. Move the palette knife quickly to get a smooth movement.

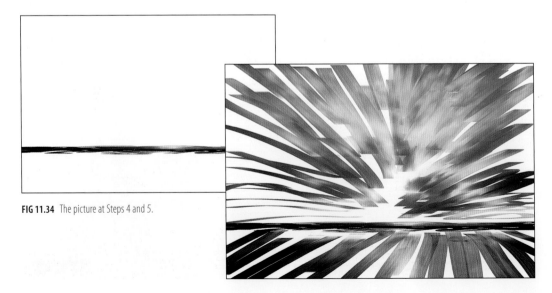

FIG 11.34 The picture at Steps 4 and 5.

6. Continue to paint in the same directions until all the area is covered as in Figure 11.35.

7. Now paint over the sand with less speed and, following the lines in the sand, bring out the different tones in various areas (Figure 11.35).

FIG 11.35 Left: Step 6.
Right: Step 7.

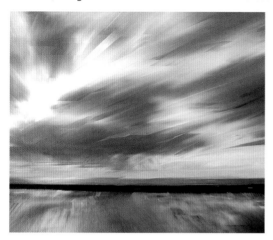 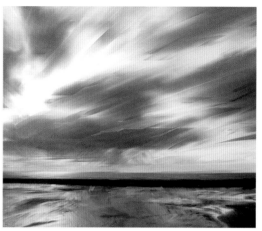

8. Change to the Palette Knives>Oil Palette Knife, size 32 opacity 60%. This brush will blend parts of the image rather than cloning or painting. Use it to soften any areas which have ugly marks left by the earlier brush strokes.

FIG 11.36 The completed picture.

Special Effects

At the heart of Painter is the vast range of brushes and art materials, which have been explored in earlier chapters, but the program also has a range of special effects and this chapter explores a selection of them.

The Effects menu contains many different special effects under the headings of Focus, Surface Control and Esoterica and these are applied as filters to your picture.

The Dynamic Plug-ins are available from the Layers Menu or from an icon at the bottom of the Layers panel. The list of Plug-ins includes a range of effects which in many cases are applied to a separate layer which can be adjusted later, as long as you save the file in RIFF format. One of the most fascinating effects in the Plug-ins is Kaleidoscope, this creates wonderful patterns as the viewer is moved over the picture, so easy to make and enjoy.

What is common to them all is the ability to make photographs look very different indeed.

Woodcut

The Woodcut effect creates a very creditable woodcut from a photographic original; generally pictures with simple shapes work best. The process creates both monochrome and color images.

1. Open 'Lynx crop.'
2. Effects>Surface Control>Woodcut.
3. Remove the tick from the Output Color box and use the following settings: Black Edge 40, Erosion Time 4, Erosion Edge 2.0, Heaviness 50%. The result is shown on the left in Figure 12.3.
4. Colored versions can also be created; open the same picture and add the tick back in the Color Output box, leave the other settings unchanged. This will produce the version on the right in Figure 12.3.

FIG 12.2 Original photograph.

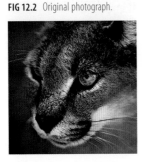

The color can be controlled in various ways; with Auto-Color ticked the woodcut will be colored using the selection of colors shown in the preview window.

The quantity of colors to be used can be altered by using the N Colors slider, usually it is more effective to use a limited range of colors, but try moving the slider to see the difference.

Instead of using the default set of auto colors, you can also choose another color set on which to base the colors. Tick the Use Color Set option, open the Color sets panel and load a color set, see the Using Color chapter for information on importing and loading Color Sets.

FIG 12.3 The results after using the monochrome and color options.

Apply Screen

When the Apply Screen effect is used, the original luminance values are split into three tones, three colors can then be chosen in the dialog box which will be applied to the picture.

1. Open 'Tulip.'
2. Effects>Surface Control>Apply Screen. Enter Threshold 1 at 86% and Threshold 2 at 29%.
3. Select Paper in the Using box.
4. Click on the color swatch in the middle and choose a color. You can change all three colors if you wish, but leaving white and black as the endpoints usually creates greater impact.

FIG 12.4 Original photograph.

Threshold 1 slider controls the balance between the two right-hand color swatches, while Threshold 2 controls the left slider.

The source of the surface texture can be changed in the Using box in the same way as the Apply Surface Texture was described in the chapter on Paper Textures.

FIG 12.5 The Apply Screen dialog box and two pictures created with different settings.

Distress

Distress is in the Effects>Surface Control menu and can make powerful graphic statements from your photographs. Most of the detail will be etched away and replaced with heavy grain. A clear strong picture is needed to get the best out of this effect.

The sliders interact with each other to get a balance of detail and overall exposure. Some of the sliders require very small movements to make a dramatic difference.

FIG 12.6 The Distress dialog box.

As in many other effects dialog boxes, Distress can be based on either the current paper texture or the Luminance of the picture.

The sliders control the size and amount of the edges, the smoothness of the image and the amount of grain added.

Threshold alters the amount of black and has a very powerful effect on the result. Remember that for fine adjustments of all sliders you can click the small arrows at each end.

Open 'Horse.' Make a clone copy (File>Clone). Apply the Distress effect using Grain as the source. Other settings are Edge size: 12.0, Edge amount: 50%, Smoothing: 3.0, Variance: 97% and Threshold: 44%.

FIG 12.7 The Distress effect applied to a photograph. Color from the original has been overlaid on the second version.

To create the colored example, apply the Distress effect, make a new layer and then copy the original photograph on the top layer (Edit>Fill>Fill with Clone Source). Change the layer composite method to Colorize, this will add the color in the black areas created by the distress effect.

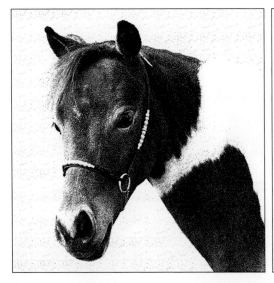
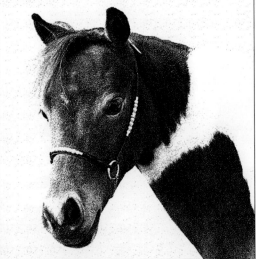

Quick Warp

The Quick Warp effect (Effects>Surface Control>Quick Warp) does exactly what the title says, it warps the photograph in various ways, and it does it quickly!

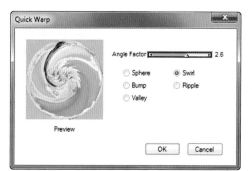

FIG 12.8 The Quick Warp dialog box.

There are five options in the Quick Warp dialog box.

Sphere turns the picture into a circle, as below, it also distorts it in many other ways depending on the Power and Angle settings.

Bump expands the center of the picture.

Valley squeezes the image to the center.

Swirl turns the picture clockwise or anti-clockwise from the center.

Ripple can create the effect of a whirlpool, depending on the position of the two sliders.

FIG 12.9 Quick Warp Sphere has been applied to 'Six Cold Crosses' and both Sphere and Swirl to 'Blossom.'

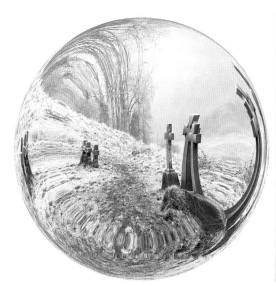

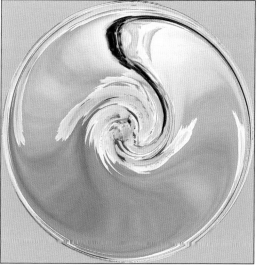

Sketch

The Sketch effect reduces a color photograph to a line drawing. It can be used on its own, or in many cases the effect can be mixed back into the original photograph to give a delicate colored effect.

1. Open 'Victorian building.'

FIG 12.10 Original photograph.

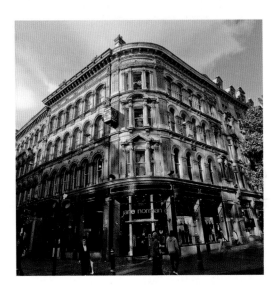

FIG 12.11 The Sketch dialog box.

2. File>Clone.
3. Make a copy of the Canvas on which to apply the Sketch effect (Select All, Edit>Copy, Edit>Paste in Place).
4. Effects>Surface Control>Sketch. Enter the following settings: Sensitivity 4.0, Smoothing 1.42, Grain 0.00, Threshold High 34%, Threshold Low 100%.
5. Figure 12.12 shows the Sketch effect applied on the building layer. The amount of noise in the background depends largely on the Threshold sliders, how you balance those two and the Smoothness slider will define the amount of detail in the sketch. The sketch effect as applied on this picture is not successful on its own, but it provides a starting point to make a more satisfying picture.
6. Change the Layer Composite Method of the Sketch layer to Overlay, this will change the picture considerably, lightening and putting edge lines over the original.
7. Right-click the layer to make a duplicate copy in the Layers panel.

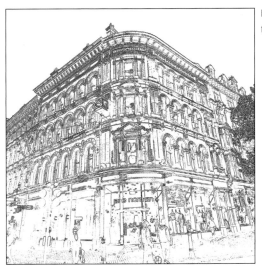

FIG 12.12 The Sketch effect applied to the picture.

8. Figure 12.12 shows how this extra layer, which is also in Overlay method, strengthens the effect. Reduce the opacity of the layer to about 36% to bring back a little more color. Reduce the opacity of the layer below if necessary.

FIG 12.13 Adding two copy layers in Overlay Layer Composite Method.

Glass Distortion

Glass Distortion creates distortions of the original photograph based on a variety of sources. The effect is available from Effects>Focus>Glass Distortion.

In the Glass Distortion dialog box shown in Figure 12.14 the first option box is Using, and the choice of where the texture comes from is identical to the Apply Surface Textures dialog box covered in the Paper Textures chapter. The choices are Paper, 3D Brush Strokes, Image Luminance and Original Luminance. As the Paper option is based on the huge range of papers supplied with Painter the choice is very wide.

Map options are Refraction, Vector and Angle Displacement. The last two work in conjunction with Image Luminance in the Using box, which will result in powerful distortions of the image; you may have to increase the Amount to see the difference.

Softness smooths the distortions.

Amount increases the overall effect.

Variation distorts the pattern into less recognizable patterns.

Direction works in conjunction with the Angle and Vector Displacement options.

The Puppy photograph had the Image Luminance option applied with the Amount 2.12, Variance 11 and Direction 154 degrees.

The Blossom image has used the paper option; the paper choice was New Streaks, which has pulled the texture to the right.

FIG 12.14 The Glass Distortion dialog box.

FIG 12.15 Two photographs altered with the Glass Distortion effect.

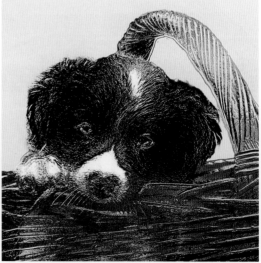

Liquid Lens

Liquid Lens is definitely one of the fun effects in Painter, it does what it says; it turns your precious photograph into liquid and then distorts the picture by using the various controls.

Open a picture and bring the Layers panel on screen. At the bottom of the panel click the second icon from the left which has the shape of a plug and in the drop down menu which appears select Liquid Lens.

The icons in the dialog box distort in particular ways when painted in the picture.

The first icon top left simulates the effect of a droplet falling into water, select the icon then click and drag in the picture to increase the distortion.

FIG 12.16 The Liquid Lens dialog box.

The two icons top right twist the image to the right or left.

The two icons immediately below these will make the picture bulge or contract.

The eraser icon removes any distortion, returning the picture back to its original state.

The brush icon will distort as the brush is dragged over the picture, this is like the distortion brushes found in the brush selector.

The sliders modify the options and will alter the amount of distortion, the smoothness, the brush size and how the dabs are spaced.

The four buttons along the bottom of the palette will clear the picture of distortion, reset the sliders to their default setting and OK accepts the effect. The less obvious button is called Rain, which simulates droplets of water falling on top of your picture.

FIG 12.17 Two photographs distorted by the Liquid Lens.

Bevel World

Bevel World is another Dynamic Plug-in that can be used to make bevels of all types, whether simply to add a border to a picture, or to make a creative montage.

1. Open 'Mannequin.'
2. Copy the Canvas (Select>All, Edit>Copy, Edit>Paste in Place).
3. On the top layer make a square selection with the Rectangular Selection tool from the Toolbox.
4. Select>Invert Selection.
5. Edit>Cut, this will remove the area around the selection.
6. Duplicate the layer (right-click the layer) and turn off the layer visibility.
7. Make the middle layer active and click the Dynamic Plug-ins icon in the Layers panel. Select Bevel World.
8. Move the sliders to see what bevels are possible; click OK when you have found a suitable style.
9. Turn on the visibility of the top layer. Make it active and change the layer composite method to Color and reduce the opacity to 61%. This will strengthen the colors.
10. Click on the canvas, and in the Underpainting palette reduce the amount of Saturation, Value and Brightness to dull the outer area.

FIG 12.18 The Bevel World dialog box.

The puppy picture was created with the same method except for the selection being circular and a different bevel being chosen.

FIG 12.19 The Bevel World Dynamic Plug-in has been applied to these photographs.

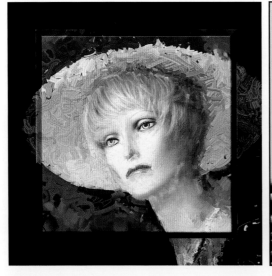

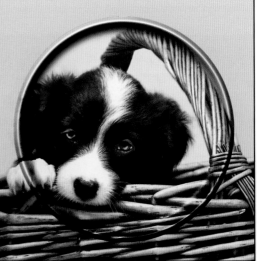

Burn

Burn is a Dynamic Plug-in layer (Layers>Dynamic Plug-ins>Burn) which means that the layer can be reactivated at a later date and the settings changed, you must however save the picture in Painter's RIFF file format.

1. Open 'Hellebore.'
2. The burn effect will be based on a selection, so Select>All to burn the edges of the whole picture. You can make a selection with the lasso or one of the other selection tools if you require only a part of the picture to be burnt.
3. Bring the Layers panel on screen and click the second icon from the left, with the shape of a plug. In the drop down menu select Burn.
4. When the dialog box appears leave the settings unchanged and click OK.

A new dynamic plug-in layer will have been created, hide the Canvas layer to see the burnt edges. The sliders can be changed to adjust the edge effect and by clicking in the color swatch the color used may also be changed.

This effect is very slow to update, so I suggest you use a small file to experiment with and then use a full size file.

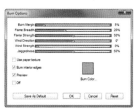

FIG 12.20 The Burn dialog box.

FIG 12.21 The Burn effect applied at different settings.

Kaleidoscope

Kaleidoscopic images are great fun and with Painter they are incredibly easy to make. Try this out with some of the photographs from the website or try one of your own, the steps are below.

1. Open any picture you have downloaded.
2. Bring the Layers panel on screen and click the second icon from the left, with the shape of a plug. In the drop down menu select Kaleidoscope.
3. In the dialog box change the size to between 600 and 1000 pixels, the default size is 100 which is too small for most pictures.
4. Turn off the visibility of the Canvas layer.
5. Click and drag the kaleidoscope and move it around the picture, the pattern changes constantly as it is moved.
6. When you find a design you like simply crop to the size of the kaleidoscope, drop the layer and save the picture.

FIG 12.22 The Kaleidoscope dialog box.

Every time the kaleidoscope icon is clicked a new layer is made, this means that you can apply the kaleidoscope effect on top of an existing kaleidoscope layer, thereby making even more complex designs.

The patterns on these two pages have been created using photographs from the download site which accompanies this book. See if you can work out which pictures they were created from.

FIG 12.23 The Kaleidoscope effect.

Index

Check us out at
masteringphoto.com

MasteringPhoto, powered by bestselling Focal Press authors and industry experts, features tips, advice, articles, video tutorials, interviews, and other resources for hobbyist photographers through pro image makers. No matter what your passion is—from people and landscapes to postproduction and business practices—MasteringPhoto offers advice and images that will inform and inspire you. You'll learn from professionals at the forefront of photography, allowing you to take your skills to the next level.

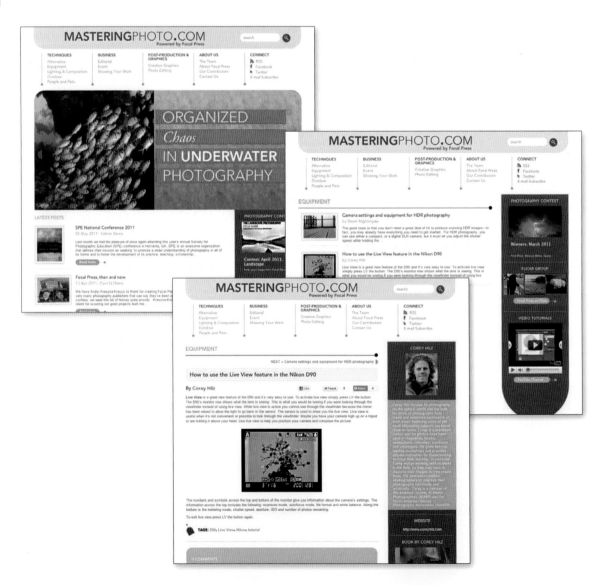